في ذكرى

مارك لينز

Gingko-St Andrews Series

Series Editor
Ali Ansari

Nationalism in the Architecture of Modern Iran

Niloofar Kakhi

GINGKO

First published in 2024 by
GINGKO
4 Molasses Row
London SW11 3UX

ISBN: 978-1-914983-14-6
eISBN: 978-1-914983-15-3

Typeset in Times by MacGuru Ltd
Printed in Europe

www.gingko.org.uk

Contents

Throughout the text, no diacritics are used for words for which there is no more commonly used English equivalent or substitute. For example, words such as iwan or toman appear without diacritics and in Roman. Diacritics are used for technical terms and common nouns, such as chāhār tāq, and these also appear in italics. Names and proper nouns appear throughout without diacritics, except in the case of the Arabic and Persian letters Ayn and Hamza.

Acknowledgements

The publication of this book would not have been possible without the support, guidance and confidence of inspirational teachers, mentors, family members, and colleagues, all of whom helped me immensely through to the last steps of what has often been called my ambitious endeavour. I am always grateful to my PhD supervisor at the Architectural Association, Dr Marina Lathouri, and my external supervisor, Dr Vida Norouz Borazjani, who patiently guided me at every step of this research until it became a successful thesis. I would also like to sincerely thank Professor Nasrine Seraji and Professor Ali Ansari, who looked through that thesis, gave influential guidance towards its future development, and suggested the publication of this book – a publication that would not have happened without the help and mentorship of Professor Ansari.

I am grateful for having the opportunity to complete this research at two esteemed institutions: the Architectural Association School of Architecture and the Institute for Iranian Studies at the University of St Andrews. It was within these two intellectual spheres that each facet of this interdisciplinary research developed. I am grateful for the help and guidance of Dr Saeed Talajooy and Dr Parmis Mozaffari at the University of St Andrews. I am deeply thankful for the ceaseless help of library and archives staff at both institutions, especially Ms Aileen Smith, Ms Beatriz Flora and Ms Simine Marine, who helped me with the what must have seemed at times an excessive amount of inter-library and international material requests. I thank Mr Max Fincher for proofreading the first draft of my work. I also thank the Organization of Libraries, Museums and Document Center of Astan Qods Razavi for their generosity and help with some rare publications, which greatly assisted the development of this research. The

Canadian Centre for Architecture was the third home for the development of my researches, and I am thankful for the generosity of this institution and Ms Philis Lambert for granting the AA-CCA fellowship, along with the Architectural Association.

I would also like to thank GINGKO for their help and support for publishing this book, especially Dr Barbara Schwepcke and Harry Hall for accepting my proposal and Jacky Colliss Harvey for going through the manuscript meticulously and polishing it to perfection. It has been a great pleasure working with everybody at GINGKO.

I thank colleagues, veteran architects, and former teachers: Dr Khosrow Afzalian, Professor Nader Ardalan, Dr Sirous Bavar, Dr Mohammad Mansour Falamaki, Ms Aliyeh Ghaem Maghami, Ms Marjan Ghaem Maghami, Dr Talinn Grigor, Dr Pamela Karimi, Dr Nadir Lahiji, Mr Hamid Mirmiran, Dr Ali Mozaffari and Mr Saman Sayyar, who shared their experiences and knowledge and discussed their projects with me to the benefit of my researches. I would also like to thank Dr Morteza Kakhi in particular for initiating my interest in Iranian studies and cultural research before this project began.

This journey and the resulting book would not have happened without the kind and generous support of my family members. I am forever grateful for their kindness.

<div align="right">

September 2018
Tus, Khorasan

</div>

Introduction

This book provides an historical framework against which to examine the key architectural challenge in modern Iran – that is, how to design a building that represents Iranian identity and ultimately, how to strike a balance between Iran's rich pre-modern architectural heritage and the requirements of a modernised society. To this end, I approach the question of the architectural representation of Iranian identity within the context of nationalism and under the influence of the politics of nationalism since the early twentieth century in Iran – two factors that have made Iranian architecture greatly dependent on the revival of historic forms. By giving an historical survey of this discourse, this book shows how, despite many disciplinary and political changes, the architectural representation of national identity in Iran has maintained its intrinsic historicism, and hence its 'conflictual' relationship with modernity in the present day. It constructs an historical platform for further critical assessments of this architectural representation, and revisits the neglected importance of the present as a means to express a collective and more inclusive approach to national identity in contemporary architecture.

The rise of nationalism, with its strong dependence on history and archaism on the one hand, and the escalation of the desire for modernisation on the other, overlapped in early twentieth-century Iran. This caused dichotomies and conflicting approaches to architectural design, stemming from these differing attitudes towards the past and the notion of heritage. Nationalist architecture, deeply influenced by the past and the increasing archaeological interest in ancient Persia, displayed an excessive use of visual references to the historic architecture of Iran, while early modernist architecture looked beyond political and cultural boundaries and sought

to dissolve these historical ties with traditional architecture. The divergence between these two approaches, and their increasing distance from the principles of traditional and vernacular architecture, has polarised the discipline, and necessitated the pursuit of balance. Since the establishment of the Faculty of Fine Arts at the University of Tehran in the 1940s, and the increase in international connections within the discipline of architecture, many academics and architects have addressed this issue, and each has increased the many-layered nuances in its definition. This makes it even more important to pinpoint the initial question of the representation of the Iranian identity.

With such concerns at the core of this book, various aspects of architectural knowledge and historiography, of cross-fertilisation and the influence of international architectural discourses, of the development of architectural education and of the design of key architectural projects are discussed in its four chapters. I argue that the architectural characteristics of nationalist architecture in early twentieth-century Iran, and its conflicting relationship with the forces of modernisation and modernist architecture, have greatly influenced the future of the practice in terms of the representation of national identity. I also argue that this is the result of the fusion of several forces: first, the rise of political interest in the past; second, the expansion of historical knowledge, particularly in the field of archaeology, which has profoundly influenced architectural histories; third, the appropriation of an architectural language, namely Beaux-Arts architecture, that has enabled the direct transmission of archaeological knowledge into the field of design; and finally, an education system that has facilitated the continuation, development and resilience of this approach, beyond sociopolitical upheavals, into the present day.

Architectural Challenges in Modern Iran

In 1969, the government of Iran published a promotional report on recent extensive reforms in the country. In this, along with a celebration of Iran's historical and cultural heritage, and the impressive developments underway especially in the urban and construction sectors,[1] it uncritically

1 Iran 1969, 2.

acknowledged a division within the discipline of architecture. After condemning the 'decline' of the discipline under the Qajar dynasty (roughly 1789 to 1925), the report mentioned two distinct design approaches: one, glorifying the ancient past, was 'to revive ancient Iranian styles', while the other was 'to adopt contemporary Western designs, and to combine them with the traditional'[2] in order to realise 'the promise of a new life'.[3] This division in architectural practice implied a strong sense of attachment to a distant and politically appealing past, while acknowledging the necessity of importing modern architectural advancements from the West to further the modernisation of Iran. What is also evident here is the emergence of a division between the immediate past and the actual conditions of the present, and an urge to create a balance between historical values and a forward-looking vision of modernisation.[4]

The modern history of architecture in Iran is an arena in which the forces of modernity and an historicist understanding of authenticity and identity have challenged each other constantly. Architecture has had this pivotal question on its agenda for the last century: how to adapt to the effects of ever-necessary modernisation while maintaining a sense of cultural affinity and continuity in the built environment that represents Iranian identity. The rise of this architectural debate corresponds with the rise of nationalism in late Qajar- and early Pahlavi-period Iran. The modern basis of what is considered as authentic Iranian architecture is the representation of an official definition of national identity, the details of which have been framed and continuously modified since the establishment of the Pahlavi monarchy as the first modern Iranian nation-state in 1925.[5] The

2 ibid., 95.
3 ibid., 4.
4 It is important to remember that during the first half on the twentieth century the study of traditional and vernacular architecture and its techniques was mostly neglected in Iran, while the study of monumental architecture was at the centre of attention. The wish to combine 'ancient Iranian styles' and 'contemporary Western designs' with the 'traditional' was a fairly new aspect of architectural discourse in the 1960s. This book will address such transitions in architectural theory in Iran in the third chapter.
5 The architectural representation of the state, kingship, and the presence of political power in the built environment has an extensive pre-modern history in Iran. Nonetheless, this book looks at the question of the representation of identity as a

main characteristic of this nationalist approach can best be understood by comparing it to its contemporaneous and opposing force – architectural modernism – which was primarily imported from the West and which, more importantly, rejects any reliance on history.[6]

As the rate of construction increased in the 1930s, architects used each of these diverging design approaches for specific building types. Modernist architecture was mainly used for modern institutions such as cinemas, railway stations and newly emergent administrative organisations such as the Ministry of Industry in Tehran. Simultaneously, historicist nationalist architecture – better known as National Architecture – was mainly used where political power had a stronger presence, for example in monumental administrative and public buildings, especially in politically significant urban areas. It was generally employed to represent the state and its version of national identity in public space. The visual revival of historical styles (especially of the Achaemenid (c.705–329BCE) and Sassanian (224–651CE) dynasties) in such projects was seen as a way to demonstrate authenticity and national identity, creating a distinctive appearance for buildings such as Tehran's Police Headquarters, the Ministry of Foreign Affairs, and the Museum of Ancient Iran (Museh-ye Iran-e Bastan). Arguably, the visual characteristics of these buildings failed to correspond with the modernising reforms of their times and its representative architecture, which essentially opposes such stylistic revivals; and nor did they reflect the actual conditions of Iranian society of this period.

This kind of historicism, with its particular political roots, sits between two of the three architectural definitions of the term given by the architectural historian and critic Alan Colquhoun, in his essay "Three Kinds

contemporary concern of the discipline, and as it has problematised other powerful disciplinary forces of the time. For an extensive study of pre-modern forms of the representation of power in Iranian architecture, see Sussan Babaei and Talinn Grigor, eds, *Persian Kingship and Architecture: Strategies of Power in Iran from the Achaemenids to the Pahlavis* (London, 2015).

6 It is not suggested here that modern architecture rejected or did not acknowledge history. The contradiction is between the different readings of historical architecture, and in this sense, it rejected direct reference to and imitation of the past, particularly in its symbolic and decorative aspects. See Hilde Heynen, *Architecture and Modernity* (Cambridge, MA, 1999), 8–14.

of Historicism"[7]: 'a concern for the institutions and traditions of the past' in its nationalist scope and 'the use of historical forms' in its architectural terms.[8] Such historicism and visual reliance on the past was the main characteristic of the most significant architectural projects in Iran until the late 1970s, and was inspired mainly by Safavid and occasional examples of vernacular architecture. This book sees such an historicist approach to architectural representation as a consequence of simultaneous socio-political changes in twentieth-century Iran, and unfolds how the politics of nationalism has played a key role in shaping this design approach.

In many respects, architectural discipline inherited the same conflicts that can be seen in many other aspects of life during this period – that is, the conflict between modernity and tradition. What puts architecture at the heart of this conflict is its strong communicative potential. It is more socially involved than many other forms of art, which gives it great political significance. It is important therefore to understand how historicist design has endured and evolved in the face of growing criticism, and how even after the revolution of 1979 it continued to be seen as the way to convey ideological messages in public spaces.[9] This book provides an historical survey for the discourse of nationalist architecture in the context of Iran between 1905 and 2015, and unfolds the details of what it has meant to design a building that bears an Iranian or (as it has been described in the post-revolution era) an 'Islamic-Iranian' identity.

As much as modernising reforms were necessary to move the country forward, and architectural practice needed to keep pace with these same reforms, architectural modernism has hardly been considered as part of the architectural heritage in modern Iran.[10] It was widely practised in specific programmatic and functional projects, yet it was mostly ignored in terms of its social or potentially its national significance until the second half of

7 Alan Colquhoun, 'Three Kinds of Historicism' in Alan Colquhoun, ed., *Modernity and the Classical Tradition: Architectural Essays 1980–1987* (Cambridge, MA and London, 1989), 3–21.
8 ibid., 3.
9 In the post-Revolution era, National Architecture has transformed almost beyond recognition, but for the most part has maintained its historicist character and its challenging position towards disciplinary developments.
10 See Mokhtar Taleghani 2002.

the twentieth century, when selective aspects of modernity gradually began to be incorporated into the architectural discourse on identity. From this point, the historicism of the previous decades was repeatedly challenged in favour of creating a timelier balance, even though the exact nature of such a balance is still an unsettled question to this date. This book also highlights such challenging moments, when architects and theoreticians have aimed to incorporate a more forward-looking and contemporary approach to the architectural representation of national identity in Iran.

The case of Iran shows great similarities with other Middle Eastern countries, and demonstrates the active role of many internationally renowned Western architects, urban designers and theoreticians whose projects and thoughts have travelled outside the context of Western architecture. This book explains their role, along with that of Iranian architects in the development of architectural styles, and particularly the representation of national identity in Iran. It traces the influence of architectural trends and traditions (such as the Beaux-Arts tradition, Postmodernism and Critical Regionalism) which, by associating architecture with a cultural and geographical context, have tried to shape this relationship. It also explores how various regional, national and cultural boundaries overlapped in the development of this discourse.

In recent years, valuable publications have thrown light on aspects of the modern history of architecture in Iran, advocating the recognition of modern architecture as part of the architectural heritage,[11] or giving an all-inclusive introduction to every design approach practised in modern Iran[12] or, in particular, explaining the political history of the creation of a number of significant national monuments.[13] Nevertheless, in order to tackle the present issues, it is necessary to re-address the primary architectural challenge and focus on the course of its development up to the present day, while reflecting various important influential factors.

To this end, the chapters of this book follow a chronological order, divided according to period. Within them, however, a variety of concurrent and inter-related subjects are discussed. In order to reflect the effects

11 Ibid.
12 See Bani Masoud 2010 and Ghobadian 2013.
13 See Grigor 2009.

of short-term events on the overall process of disciplinary development, the thematic focus of each chapter is on examples of the most influential works of the time with regard to their representation of national identity. I also provide more recent photographs of the buildings where possible, to stress the importance of seeing architecture through time.

The first chapter gives an introductory account of the conditions of the built environment and the characteristics of political architecture during the Qajar era in Tehran. It looks at urban developments in the capital after the Constitutional Revolution (1906) as the first stage in the development of a debate that gradually spread across the country.[14] It then describes the early theoretical developments of Iranian nationalist architecture, which were also cultivated at the heart of nationalist circles outside Iran, as well as the initial phase of related architectural and urban transformation during the early years of the Pahlavi monarchy up to 1934.

The second chapter follows the increase in the political and cultural significance of Iran's historical heritage and the gradual transmission of knowledge from the field of archaeology to architecture, with a specific focus on the visual appearance of historic buildings. Focusing on the reign of Reza Shah Pahlavi (1925–41), it unfolds what became the fundamental characteristics of National Architecture as part of a discussion of architectural and urban developments in the capital and across the country.

The third chapter follows the development of this discourse during the reign of Mohammad Reza Shah Pahlavi (1941–79), when architectural discipline found autonomy and a heightened cultural significance after the establishment of the University of Tehran in 1935 as the first modern academic centre for architecture in Iran. The discourse on National Architecture developed significantly during this period, and became much more nuanced. These are the central themes of this chapter, together with the influence of the Beaux- Arts in the construction of an academic system

14 Although historicism in Iranian architecture has an older history than 1905 (Achaemenid visual references, for example, have been used in the design of several private buildings), such a revival of archaic forms, especially in public buildings sponsored by the government, can only be associated with the politics of nationalism since 1906. The Constitutional Revolution is an historical turning-point that influenced future political events which in turn enriched the theoretical background of National Architecture.

in Iran and the rise of modernism during the early 1950s. It recounts the academic developments and disciplinary conflicts between the forces of modernity and those of historicism in the creation of a national architectural identity. This chapter also shows how the expansion of international connections gradually redirected the question of representation from that of mere historicism and how, by the 1970s, it had gradually come to diverge from the official and purely political definition of national identity. During this period, disciplinary developments occasionally surpassed the political forces exerted on architecture as part of the visual representation of national identity, while Postmodernism bridged the gap between the two and briefly settled some of the conflicts in architectural practice.

The question of representation today is as influenced by the early Pahlavi period as it is by the socio-political changes that followed the revolution of 1979. The revolution and the establishment of the Islamic Republic created a new significance for the political role of architecture in introducing a new regime and its official understanding of national identity through new interventions in the built environment and architectural theory. This transition is explained in the third chapter, as 'National Architecture' was replaced by the notion of 'Islamic-Iranian Architecture'. It explains the academic changes of the time as a result of the Cultural Revolution (1980–87) as well as how the rise of Postmodernism facilitated the return of historicism into the discourse on nationalist architecture. This chapter also brings to light instances where historicism was tackled as the only way to address national identity in the built environment, and tracks disciplinary developments up to 2015 as it introduces some of the more influential recent projects.

As an architect, I have constructed my argument based on political histories, and drawn on social theories relevant to the subject yet outside a strict definition of architectural discipline.[15] It is important therefore to explain to readers my use of the terms 'nationalism' and its relationship to

15 I draw on the concept of nationalism found in the works of Anthony D. Smith, Ernst Gellner and Eric Hobsbawm; and following John B. Thompson, I regard nationalism as an ideology that serves the relations of power. Additionally, the concept of history and the construction of collective memory are based on Paul Ricoeur's definitions, whose account of narrative identity is also considered as the main reading for the use of the term throughout this study.

architecture, and Conflictual Modernisation, as they form the theoretical background for this book.

Nationalism and its Architectural Representation

The early roots of nationalism are often considered to have developed in the late eighteenth century, during the French Revolution. The historical sociologist, Anthony D. Smith, identifies the earliest social and political use of the concept in the works of the German philosopher Johann Gottfried Herder (1744–1803) and the French counter-revolutionary cleric Abbé Augustin Barruel (1741–1820), while the earliest English use of the concept in 1836 went as far as to suggest the divine roots of certain nations.[16] Smith describes nationalism as 'an ideology that places the nation at the centre of its concerns and seeks to promote its well-being'.[17] He clarifies this statement by drawing attention to three key aspects of the concept: autonomy, unity, and identity. The notion of autonomy is closely linked to the idea of 'collective unity', and pursues the 'abolition of internal customs, barriers and regional institutions and cultures', replacing them with a 'centralized economic and political territory and a single public culture'.[18] The second aspect, of autonomy, requires the nationalist unit to be distinguishable from other groups, and for it to establish a territorial unity.[19] (Territorial unity in this sense is defined as requiring members to feel a bond of solidarity, and to act collectively on matters of national importance.[20])

As for national identity, the general meaning of the concept of identity 'denotes sameness of an object over time, the persistence of a specific pattern over a finite period'.[21] Here Smith distinguishes national identity through its concerns with the appropriation of a 'collective character' and an 'historical-cultural basis'.[22] In summary, the definition of national iden-

16 See Smith, 2010, 5–9.
17 ibid., 9.
18 ibid., 29.
19 ibid., 29.
20 ibid., 29.
21 ibid., 30.
22 The former looks for a way to define a discernible character for the members of a

tity is determined by tracing the 'roots' and 'character' of a nation. In this regard, disciplines such as history, archaeology, anthropology, and linguistics – aided by the development of printing[23] – provide the necessary framework. Although greatly indebted to the past and to history, this definition of national identity has a strong connection with the present state of a nation. An important aspect of national identity defined in this way is that the sameness and the appropriation of the past are in favour of defining a shared quality only for the sake of the present. Accordingly, the definition of identity is not merely a case of representing sameness, but to borrow from Paul Ricoeur, there is a consideration of 'self-ness' at stake too.[24] This is mentioned here because the following chapters demonstrate the tensions between these two aspects of national identity in its architectural representation in Iran, and show to what extent the reliance on the 'historical-cultural basis' has overshadowed the search for defining a present 'collective character'.

In terms of the architectural representations of nationalism, the dependence on historical heritage is evident and justifiable before the rise of architectural modernism. Raymond Quek has explored eighteenth-century Palladianism and neoclassicism as an early form of state architecture in Western countries such as Britain, France, and the United States; one that has indirectly influenced the design of similar civic buildings across the globe.[25] This can be an acceptable architectural approach to projects that have a significant reliance on the past. However, it becomes questionable after the rise of architectural modernism transformed the discipline and its relationship with the architecture of the past. Some examples of this from

nation; it even strives to create and cultivate one. The latter implies that there exists a 'distinct historical culture, a singular way of thinking, acting, and communicating, which all the members share', and which non-members do not and cannot share. In this case, the nationalists are obliged to 'rediscover the unique cultural genius of the nation and restore to a people its authentic cultural identity.' See Smith 2010, 30–31.

23 See Benedict Anderson, *Imagined Communities: Reflections on the Origin and Spread of Nationalism*, 2nd edn (London, 2006), 39–48.

24 Self-ness in this regard does not oppose changes over time. See Paul Ricoeur, *Oneself as Another*, trans. Kathleen Blamey (Chicago, 1992), 3–4.

25 Quek also acknowledges here that such architectural practices are not real national architecture. See Raymond Quek, Darren Deane, and Sarah Butler, eds, *Nationalism and Architecture* (Farnham, 2012), 8.

the late 1920s to late 1930s include the Lincoln Memorial, the National Gallery in Washington D.C., Albert Speer's design for *Welthauptstadt Germania*, the Stalinist style of architecture that extends the historicist architectural representation of a national identity almost until the Second World War, and the collection of buildings that covered the former Parade Ground of Tehran during the 1930s.

From an urban point of view, the urban design and housing scholar Lawrence Vale sees such political interventions by newly established sovereign powers, especially in those urban enclosures he describes as 'capitol complexes',[26] as their introduction into the public domain. They often 'manipulate' architecture in the design of government buildings to represent their own identity and superiority in comparison with previous regimes.[27] To borrow from the renowned sociologist John B. Thompson, this kind of architecture has a communicative and ideological role as it produces 'symbolic forms', which 'mobilize meaning' and 'establish and sustain the relations of domination'[28] as they exclusively promote the official definition of national identity. Additionally, these examples represent the establishment of an architectural tradition that at the dawn of architectural modernism maintained the historicist approach of the nineteenth century, and adopted a classical or (in the case of Iran) a pre-Islamic appearance.

26 Concentrating on the design of a post-colonial locus of power in many countries after the Second World War, Vale identifies two approaches: first, those states that marked their independence with the design and construction of a new capital city, and second, those that created new parliamentary complexes within or adjacent to an existing capital, which he calls 'capitol complexes'. In Vale's view, the idea of the capitol, which originates from that of the citadel and usually refers to buildings that house the government's lawmakers, refers to a distillation of a new capital in its programmatic and symbolic essence. To Vale, there is a difference between a traditional capital and capitol complexes. The new complex is, in fact, a network of government buildings and often public buildings such as museums and libraries, which 'is designed to house the means of government and to communicate this government visually to the governed'. See Lawrence J. Vale, *Architecture, Power, and National Identity*, 2nd edn (London, 2008), 11.
27 Vale, op. cit., 3–62. This point is especially evident in the case of the development of the Parade Ground (Maidan-e Mashq) of Tehran during the 1930s, which undermined the significance of the Qajar urban locus of power, Tup-khaneh Square, as the public and governmental centre in the capital.
28 See John B. Thompson, *Ideology and Modern Culture* (Cambridge, 1990), 7–8.

The simultaneity of such opposing design approaches in the twentieth century is an inevitable characteristic of nationalism, which starts in the industrial age and has been described by the social anthropologist and philosopher Ernst Gellner as a 'violent' and 'conflict-ridden'[29] period of transition, as he relates the emergence of nationalism to the conditions of modern industrial societies.[30] Gellner sees industrial society, 'a society whose productive system is based on cumulative science and technology',[31] as giving people 'a prospect of the kind of standard of living'.[32] Here, a kind of cultural homogeneity, which is fundamental to nationalism, is the key to such concomitance. As early industrialism was connected to 'population explosion' and 'rapid urbanisation'[33] and consequently to an inevitable need for standardisation,[34] 'nationalism steps in as an effect of industrial social organisation.' As Gellner puts it, 'it is not only the effect of the imposition of this new social form'.[35] In this light, it is possible to imagine modernist architecture – and even paradoxically the International Style, with its universal appearance and strong connection to the conditions of an industrialised society – as a suitable answer to the needs of a modern society and an appropriate response to the nationalist aspect of such a society, especially as it would represent a 'collective character' and a sense of 'self-ness'. Perhaps in this sense, the sort of collective identity introduced in Sant'Elia and Marinetti's famous Futurist manifesto,[36] or in the Iranian case by the first articles by the Society of Iranian Professional

29 Gellner 1983, 39–40.
30 ibid., 138.
31 ibid, 39.
32 ibid, 39.
33 ibid, 42.
34 Following from this point, Eric Hobsbawm locates the 'national question' at the intersection of politics, technology, and social transformation. Therefore, nations exist 'as functions of a particular kind of territorial state [...] in the context of a particular stage of technological and economic development', where standardised means of unification including an official language and mass schooling can survive. See Eric J. Hobsbawm, *Nations and Nationalism since 1780: Programme, Myth, Reality*, 2nd edn (Cambridge, 1992), 10.
35 Gellner 1983, 40.
36 Antonio Sant'Elia, Filippo Tommaso Marinetti, 'Futurist Architecture,' in Ulrich Conrads, ed., *Programs and Manifestoes on 20th-Century Architecture*, trans. Michael Bullock (London, 1970), 34–9.

Architects (Anjoman-e Arshitektha-ye Irani-ye Diplomeh) in the first volume of *Architecte* in 1946,[37] could be understood in accordance with the metanarrative of nationalism, as both emphasise the contemporary characteristics of their societies, their taste and liberation from the past. However, nationalism in an industrialised society has other conflicts, which prevent it from the taking up the straightforward appropriation of architectural modernism as a means of communication.

Nationalism, as seen by the historian Eric Hobsbawm, is bound to the invention of traditions.[38] While the ratio of such historical reference differs from one society to another, it becomes an essential factor in countries with a critical need to represent national identity. In the case of Iran, and the formation of a national identity by focusing on historical sites and rituals, the architectural scholar Ali Mozaffari questions the instantaneous invention of identity narratives and emphasises the study of their 'pre-existing cultural context'.[39] It is, in fact, such historical roots that continue to give form not only to the nationalist ideology of Iran but also maintain the primary characteristic of its architecture, regardless of disciplinary transformations. As nationalism, in this case, is distanced from the objectives of an industrial society and tends towards the more ideological aim of defining a nation and distinguishing it from others, the gap between nationalism and the current state of society deepens. In such cases, the use of history to formulate a narrative identity becomes a significant factor. Therefore, architectural modernism as the indicator of an industrial, modernised society is often alienated from the representation of national identity.

37 See Iraj Moshiri, *Hadaf-e Ma* (*Our aim*), *Architecte* 1 (July-August 1946), 1–2.; Manuchehr Khorsand, 'Anjoman-e Arshitektha-ye Irani-ye Diplomeh,' ibid., 3; Vartan Hovanesian, 'Masael-e marbut be me'mari dar Iran' (The issues concering architecture in Iran) *Architecte* 1 (1946), 5–8.
38 See Eric J. Hobsbawm, *The Invention of Tradition* (Cambridge, 1983).
39 Mozaffari examines to what extent ideological inventions are influenced by pre-exciting cultures, and how and under what circumstances they are ideologically manipulated. Ali Mozaffari, *Forming National Identity in Iran: The Idea of Homeland Derived from Ancient Persian and Islamic Imaginations of Place* (London, 2014), 2.

Conflictual Modernisation

Early twentieth-century architecture in Middle Eastern countries show-cased the existence of two prevailing design approaches. One used tra-ditional, historical forms for design, and the other gravitated towards the international transformation of the discipline, favouring abstraction in design by deleting historicist tendencies. Whether collaborating or con-flicting, the two approaches have formed the modern built environment in these countries.[40] Between the two, the representation of national identity gravitates towards the revival of historical forms; the visual references for which may have been initially introduced through Orientalists and Western archaeologists and art historians.[41] A gap begins to appear not only between traditional modes of architectural production and new design trends, but also between what such states seek to display as their historical identity and the new phases of their development as they enter them.

In fact, full integration of architectural modernism into the social and cultural fabric of non-Western countries outside the immediate context of modernity has been only one aspect of the greater socio-political chal-lenges of the project of modernisation. As an historian, Jacques Le Goff sees such challenges as stemming from the reluctance of these countries to remain under the influence of the Western powers; hence the distinc-tion and the selective adoption of technological, economic, and material modernisation on the one hand and social modernisation on the other.[42] This has resulted in various modes of modernisation depending on the conditions of each traditional society and their relationship with the West.

For such cases, Le Goff distinguishes three types of modernisation. First, a balanced form, in which the progress towards modernisation is not opposed by traditional or ancient values. Second, a conflictual type in which the process of modernisation affects different and separate parts of the society, and in this process, creates serious conflicts with the ancient traditions of the society. Third, a hesitant modernisation, which takes

40 Isenstadt 2008, 17.
41 ibid.
42 Le Goff establishes his argument by looking at similar consequences of imperialism and colonialism during the nineteenth and twentieth centuries in non-Western countries, and the emergence of a strong sense of nationalism based on opposition to an external power. See Le Goff 1992, 37.

various forms and is only selectively accepted by traditional society.[43] He identifies most Islamic countries as examples of Conflictual Modernisation, where to a great extent modernisation was associated with Westernisation, creating fundamental issues with existing traditions.[44] Within these categories, it is those countries facing Conflictual Modernisation in which this problem is most acute. Modernity in such countries, says Le Goff, 'does not function as a creative process but as acculturation or a transaction between the archaic and imported'.[45] Therefore the on-going process of modernisation happens mainly through conflict due to the strong existing sense of cultural identity in these countries, no matter how the latter is interpreted or invented.

To a great extent, Iran represents a case of Conflictual Modernisation. For the Iranian philosopher Ramin Jahanbegloo, Iranian society has faced modernity as a 'semi-colonised' society, with an ambiguous attitude that on the one hand accepts the positive values of modernity and on the other, has become its victim. The challenge of adaptation to various aspects of modernity in Iran is not simply that of the opposition between the values of modernity and those of the traditions that have shaped political and cultural developments for the last 150 years.[46] According to Jahanbegloo, this ambiguity occurs because creating the balance between existing traditions and modernity requires examination and critical assessment of old concepts and values.[47]

This challenge intensified with the establishment of the Pahlavi monarchy and the almost simultaneous start of the process of modernisation and nation-building in the country. The reign of Reza Shah was a period of long-anticipated reforms and a time for drastic socio-political changes

43 ibid.

44 Without entering into the details of this conflict, it can be said that historically, it appears in three forms: in the nineteenth century as a reaction to European imperialism, whether colonialist or not; after the Second World War in the framework of decolonialization and the emergence of the Third World; and in the 1970s with the boom in the oil market. *Le Goff* 1992, 38.

45 ibid., 39.

46 Ramin Jahanbegloo, ed., *Iran: between tradition and modernity* (New York, 2004), x.

47 ibid., xi.

in Iran,[48] with a strong sense of departure from the immediate past. This was also the period of the rise of nationalism as the supporting ideology of the new government.

Most of the nationalist elites and the veteran constitutionalists who facilitated the accession of Reza Shah Pahlavi to the throne in 1925 were protagonists of modernising reform. These individuals united in forming the Revival Party (Hezb-e Tajaddod) during the late Qajar and the early Pahlavi eras, and later occupied high-ranking governmental positions.[49] Begun in the early 1920s by a group of young Iranian intellectuals, mostly educated in Europe and the veterans of the Constitutional Movement, the Revival Party aimed to secularise society; to separate religion from politics; to cancel the numerous concessions of economic resources to foreign powers; and to industrialise and modernise the country. It sought to expand educational facilities for everyone, including women; to replace local languages with Persian as the national language; to create career opportunities for the talented; to build a well-disciplined army and well-administered systems of bureaucracy and taxation; to replace foreign capital with native capital; and to settle the Iranian tribes.[50] The party became one of the main supporters of Reza Khan and facilitated his advancement from minister of war to the last prime minister of the Qajar court and ultimately the new shah of Iran.

Focusing on the cultural aims of architectural projects in this period, the art historian Talinn Grigor has suggested that most of the former members of the Revival Party pursued their secularist objectives through the cultural activities of the Society for National Heritage, including the construction of memorial mausolea for Iranian poets and scientists as 'national pilgrimage sites'. Their desire for the cultural revival of ancient Iran was further demonstrated by the use of historical prototypes and icons in most such landmarks, while their advocacy of rapid modernisation and progress can be seen in the construction of modern institutions such as banks, museums,

48 Stephanie Cronin, ed., *The Making of Modern Iran: State and Society under Reza Shah 1921–1941* (London, 2003), 1–2.
49 See Ervand Abrahamian, *Iran Between Two Revolutions* (Guildford, 1982), 120–23.
50 ibid., 122–23.

and a national railway system.[51] Such common beginnings could have been a point of coalition between the two forces, yet became instead a moment of divergence and the beginning of conflict. The specific characteristic of Conflictual Modernisation as Le Goff describes it seems to have been a preliminary condition in this case, with regards to the simultaneity of the two projects of modernisation and nation-building.

This may not be so much of a socio-political contradiction, but when it comes to the case of architecture, the tension intensifies and has remained a pivotal disciplinary challenge. Architectural practice in twentieth-century in Iran is highly politicised, and mainly regarded as a parallel stream to the political changes of the time. The architect and scholar Mina Marefat considers the history of architecture in Iran as the story of powerful patrons who wanted to record their glories in urban, architectural forms.[52] Similarly, the architect Amir Bani Masoud argues that a true understanding of the artistic and architectural developments during the reign of Reza Shah is only possible through the understanding of cultural and social reforms of that period.[53]

The 1930s marks the arrival of early modern architecture, along with the emergence of an Iranian interpretation of the Beaux-Arts tradition as 'National Architecture'. The project of nation-building and its representative architecture provoked the main conflict with architectural modernism, while vernacular architecture was pushed to the margins of the discipline and to private construction projects. Although the study of the history of Iranian architecture was on the rise during the early twentieth century, it only served to feed the development of National Architecture, as if the contemporary collective identity of a modernising society had been concealed behind a new mask of history. It hardly benefited the

51 Grigor 2005, 53.
52 Mina Marefat, 'The protagonists who shaped modern Tehran,' in Adle 1992, 95–127.
53 Within architectural circles the long-term goal of the Shah was known to be rebuilding Iran according to Western paradigms of progress, which required him to remove existing obstacles of religion and custom. The drivers of the dramatic architectural changes of the early twentieth century are considered to be secularist, archaistic nationalism, modernisation and the rise of a sense of cultural inferiority to the West, all of which are closely related to each other. See Bani Masoud 2010, 184.

development of traditional architecture, or even the creation of a balance between traditional and modern architecture. Various design approaches had been assigned exclusively to particular categories and functions and often limited the work of prominent architects of the time to the design of specific types of building. The creation of such a balance was briefly achieved during the 1960s and 1970s, both in theory and in a few actual projects. The architectural approach of these decades continued in the post-Revolution era, while facing further ideological, cultural, economic, and (more recently) environmental challenges, which continue to occupy the discipline today. This multiplicity of approaches, especially with regards to nationalist policies and their architectural appearances, makes the case for this historical investigation into the nature of both architectural modernisation in Iran and of nation-building.

1
Architecture, the Rise of Nationalism and the Early Reforms

Qajar Tehran

The city of Tehran was originally one of the neighbouring villages to the city of Rey. In the sixteenth century, Shah Tahmasb Safavi constructed a town wall and bazaar and transformed the village into a city.[1] (Rey itself, which has more than six thousand years of history, is now a southern part of modern Tehran.) In the mid-eighteenth century Karim Khan (1751–94), the famous founder of the Zand dynasty, assumed power, rebuilt the city walls and the governmental citadel (arg), to which he added administrative and private quarters and an audience chamber.[2] However he chose Shiraz as his actual capital, and it was not until the late eighteenth century, under the Qajar dynasty, that Tehran became Iran's capital city.

The founder of the Qajar dynasty, Aqa Mohammad Khan (1742–97), succeeded in reuniting Iran for the first time since the Safavids by defeating the Zands in Shiraz and Isfahan in the mid-1790s and stabilising Iran's state and borders. This stability was interrupted during the reign of Fath 'Ali Shah Qajar by the Russo-Persian wars of 1813 and 1828.[3] The former led to the Treaty of Golestan, by which Iran lost Azerbaijan, Daghestan and Eastern Georgia to Russia. The latter led to the Treaty of Torkamanchay, by which Iran lost the rest of the Caucasus, had to pay a war indemnity

1 Madanipour 1998, 4–7.
2 Scarce 1991, 903.
3 Keddie 1999, 19.

and had to grant Russia the right to trade throughout Iran without custom tariffs. In addition, all disputes between Russian and Iranians were to be heard in the Russian consulate by a Russian judge. The conflict with Russia led to a significant increase in European influence in Iran, particularly from Britain and France, each of whom were trying to preserve their own interests in the country, and resulted in several trade treaties that further weakened the position of Iranian merchants and producers, yet intensified connections with the West. 'Abbas Mirza (1789–1833), the crown prince and designated successor to Fath 'Ali Shah, was the only Qajar reformist who attempted to make use of these European connections, to modernise his army.[4] To this end, he employed foreign advisers and sent students to Europe, paving the way for future modernising reforms in the country.

As the capital city of the Qajar dynasty, Tehran represented political power in the built environment, and became a showcase for the challenges within Iran of dealing with both Western modernity and Western architecture. It thus provided the ground upon which National Architecture established itself, and from which its long-lasting effects upon modern Iranian architecture were disseminated throughout the country. Generally speaking, architecture in Iran during the Qajar era retained many traditional aspects, especially in what it took from the Safavid era, even as it also displayed the influence of multiple contemporaneous Western trends. This Western influence however remained mainly on the level of façade decoration, rather than that of spatial configuration.[5] A similar influence is also evident in the urban reconfigurations of Tehran from 1891, where it is much more evident than in other cities in this period.

Despite the political turbulence of his reign, Fath 'Ali Shah, who was concerned with his royal image, managed to leave a small architectural mark by constructing royal mosques (Masjed-e Shah) in Tehran, Qazvin, Zanjan, and Semnan.[6] As with the majority of the buildings during the Qajar era, the design of these mosques could be seen as a continuation of Safavid architecture, which had been the prominent architectural tradition

4 Ibid., 21–5.
5 Scarce 1991, 901 and 927.
6 Scarce, J, 1991, 911–12.

in Iran since the sixteenth century.[7] In Tehran, the shah facilitated limited urban development by adding public utility buildings while maintaining Safavid design characteristics, retaining the bazaar and the governmental citadel as the main urban focal points within an organic street network.[8] A new gate was also added to the southern part of the city walls.[9] In the enclosed governmental citadel in the northern part of the city, Fath 'Ali Shah added more palatial buildings such as the 'Emarat-e Badgir. This building is found on the south side of the citadel , and consists of four windcatchers (*bādgīr*) on the corners, connected to a seating area with a pool (*howze-khāneh*) that was itself connected to a qanat. The whole provides a pleasant seating area for summer days.[10] By this time, the Arg was serving as an enclosed governmental centre, including palace accommodation and service buildings, as well as a maidan, later known as Maidan-e Arg. The Arg was connected to a public *maidān* – Sabzeh Maidan – on its southern side, while the bazaar and the jāmi' (the grand mosque) were on the east side of the Maidan-e Arg. Fath 'Ali Shah's successor, Mohammad Shah (1834–48), followed a similar path both in politics and urban development.[11] The capital did not change drastically under his rule, although its population continued to increase within the confinement of the old city walls.

The transformation of Tehran began during the reign of Naser al-Din Shah (1848–96). In the early decades of his reign, the Arg was further developed, and one of the most significant additions at this time was

7 For example, in the case of mosques, their spatial configuration generally follows the two-iwan (porch) or the four-iwan modes. Qajar architecture however, shows a degree of 'eclectic revival of selected elements,' not only from Safavid, but also from Sassanian and even in some cases Achaemenid references. This is evident in the proportional aspects of designs as well as their decoration. Here, elements such as minarets and the iwan may play a more visual role than in pre-Qajar examples. See Robert Hillenbrand, 'The role of tradition in religious architecture,' in Bosworth 1983, 352–66.
8 Habibi 1999, 128.
9 Bani Masoud 2010, 93–4.
10 Zoka 1970, 278.
11 'Abbas Mirza died on the way to reclaim Herat in 1833, and his son Mohammad succeeded to throne. Mohammad's reign witnessed a number of public protests by Iranian merchants, who were growing weaker due to the increasing number of foreign trade agreements, and by religious minorities including Ismai'lis and Babis.

the construction of the palace of Shams al-'Emarah (1865–7), which was designed by Dust Ali Khan Mo'ayyer al-Mamalek and built by Ali Mohammad Kashi.[12] After studying images of European buildings,[13] the shah had expressed an interest to Mo'ayyer al-Mamalek in having a tall palace from which he could view the city and its environs.[14] The building was constructed on five floors, with only the first floor allocated for everyday use.[15] In a way, more than anything else, it seemed to be constructed simply for the pleasure of creating it,[16] as a monumental building representing a combination of Iranian and European elements.[17] The overall five-storey form may distantly refer to the Safavid palace of 'Ali Qapu in Isfahan, while its central clock tower was inspired by European architecture. The fusion of the two architectural traditions is also evident in the polychrome decorative tiles, where Persian arabesque strapwork and Victorian garlands of roses are combined.[18]

This hybridisation of European and traditional Safavid references is evident throughout the Qajar era in royal retreats and private houses such as 'Emarat-e Farah Abad, 'Emarat-e Sorkheh Hesar, the houses of Mo'ayyer al-Mamalek and Sardar As'ad, and most significantly, Takiyyeh-e Dowlat (demolished 1947), which was the largest theatre constructed in Tehran and had clear formal references to the Albert Hall in London.[19] These examples all show the arrival of new trends in architecture, mostly in terms of formal and decorative imitations of European examples. New round arches, together with European details of ornamentation and pediments were all seen as desirable during the Qajar era. This change in taste filtered down from royal patronage to small groups of affluent merchants and those who had been educated in Europe, and who influenced fashions

12 See: Bani Masoud 2010, 91, and Zoka 1970, 270.

13 J. Scarce, 'The royal palaces of the Qajar Dynasty; a survey,' in Bosworth 1983, 339.

14 Dust Ali Khan Mo'ayyer al-Mamalek, Yaddashtha-i az Zendegani-e Khosusi-e Naser al-Din Shah (Notes on Naser al-Din Shah's personal life) (Tehran, 1982), 43.

15 Mokhtar Taleghani 2002, 119–23; and Bani Masoud 2010, 93.

16 Bani Masoud 2010, 93.

17 ibid.

18 J. Scarce, 'The royal palaces…,' Bosworth 1983, 339.

19 For a detailed and illustrated list of these buildings see Bani Masoud 2010, 73–171.

طهران عمارت بادگیر سلطنتی

101.a: The main façade of the Emarat-e Badgir in
the Golestan Palace complex, Tehran.

101.b: The façade of Shams al-Emarah on the east side
of the Golestan Palace complex, Tehran.

102: Takiyyeh-e Dowlat and its surrounding neighbourhood
in Tehran as it was in the late Qajar era.

in architecture,[20] as at the time only a few Iranian architects had travelled abroad to study European architecture and its techniques. In most cases, photographs, postcards and oral descriptions were their main source of inspiration.[21]

More drastic urban developments came into being in Tehran after the establishment of Dar-al Fonoun[22] the first Westernized higher education institute in 1851 by Mirza Taqi Khan Amir Kabir, the reformist prime

20 Mohsen Habibi, *The intellectual trends in contemporary Iranian architecture and urbanism (1979–2003)*, (Tehran, 2006), 20.
21 M. Marefat, 'The protagonists who shaped modern Tehran', in Adle 1992, 98–103.
22 Dar al-Fonun was the first modern higher education college in Tehran, established initially to further military and related technical developments. For further details see Iranica: 'Dār al-Fonūn', [Accessed: 15 December 2016].

minister.[23] The influence of Dar al-Fonun and its European teachers on the development of Tehran is unparalleled during the Qajar period. In 1855, Augustus Kriziz, the Austrian teacher of the institute, drew a detailed map of Tehran, known as the Naqsheh-ye Dar al-Khalafeh-ye Tehran (the 'Map of the House of Government of Tehran'). Comparing this map with that produced by Il'ya Nikolaevich Berezin, a Russian Orientalist, in 1852, reveals how the expansion of the city was limited by its old walls even as its population increased. In 1869 the institute organised the first Western-style population and housing census, confirming the urgent need for expansion beyond the old city walls.[24] General Alexandre Buhler, a French military instructor at Dar al-Fonun, was commissioned to oversee the expansion of the capital. Inspired by the Marquis de Vauban's designs for Louis XIV, Buhler suggested a plan to redevelop the city and to construct new fortifications and bastions.[25]

This was almost simultaneous with the visit of Qajar statesmen to the Paris exhibition of 1867. Not only were they deeply impressed by the splendour of Haussmann's Paris, but they also started to compare Tehran's urban development with that of other capital cities such as Cairo and Istanbul. At the Fair, Iran's pavilion appeared inferior to that of the Ottomans and of Egypt, both in terms of design and the items displayed. Throughout the 1860s Naser al-Din Shah was inundated with reports, images, and petitions concerning the modernisation of Tehran by his advisors, in particular Iran's ambassador in Istanbul, Mirza Hossein Khan Moshir al-Dowleh,[26]

23 Mirza Taqi Khan Amir Kabir was the first prime minister of Naser al-Din Shah. He began the reform and gradual modernisation of Iran, including establishing the first polytechnic in Tehran. In 1852 the royal family planned to assassinate him as he had become too popular.
24 Habibi 1999, 133.
25 Sébastien Le Prestre de Vauban (1633–1707) was a military engineer of the French court. Zigzag fortifications in combination with one or two rows of concentric trenches are standard characteristics of his designs.
26 Mirza Hossien Khan was Naser al-Din Shah's prime minister from 1871 to 1881, and is known as one of the reformist figures of this period, after Amir Kabir. However, his period as prime minister saw a number of controversial decisions, including his agreement to the Reuter's customs concession of 1872.

1. Bazaar
2. Masjid-e Shah
3. Sabzeh Maidan
4. Maidan-e Arg and Artillery
5. Golestan Palace

6. Dar al-Fonūn

103: Schematic drawing created from Augustus Kriziz's
1855 'Map of the house of government of Tehran'.

later known as Sepahsalar, who had seen the urban developments taking place in Turkey under Fuad Pasha during the Tanzimat reforms.[27]

The desire for reform and plans for re-development were finally realised in 1868, by the construction of a new wall with bastions and a surrounding moat.[28] These walls allowed Tehran to expand to four-and-a-half

27 J. D. Gurney, 'The transformation of Tehran in the late nineteenth century,' in Adle 1992, 53–65.
28 J. Scarce, 'The role of architecture in the creation of Tehran in Adle' 1992, 83.

times its previous size, in an octagonal shape with twelve new gates.[29] The most significant additions to the urban fabric were the construction of two new squares. First, Tup-khaneh, which was built on what was formerly an abandoned site to the north of the Arg, and which was dedicated to the army and artillery.[30] Second, Maidan-e Mashq (the Parade Ground of Tehran), in a more distant location, north-east of the Arg. This was also dedicated to the army and was used as the parade ground for the Cossack Brigade.

As the intersection of the six main streets of Tehran, Tup-khaneh became the new focal point of the city. Several public buildings, such as the Imperial Bank of Persia and the Telegraph Office were constructed around it, which gave it an even greater significance.[31] An enclosed square, its design combined Safavid and European references. With a width of 110 meters and a length of 220 meters, it adopted the dominant proportions of the so-called 'Golden Mean' of the European Renaissance and Baroque periods, while its interior facades, decorated with false arches, were reminiscent of the Naqsh-e Jahan Square in Isfahan.[32] However, instead of the traditional elements of a Safavid square – a bazaar, a mosque, palace buildings, and a school – Tup-khaneh included public buildings with new functions that represented the arrival of social reforms. These eventually included the central Post Office building and the city hall on its northern side, the Bank-e Shahi on the east, the Telegraph Office on the south and the Police Headquarters on the western side.[33]

This round of urban expansion represents a new interpretation of Safavid urban design, one strongly influenced by European architecture of the seventeenth to nineteenth centuries.[34] The traditional significance of the bazaar as the commercial backbone of the city was overshadowed by the

29 Madanipour, Chichester 1998, 32.
30 Zoka 1970, 373–8.
31 Madanipour, Chichester 1998, 33.
32 Habibi, M., *The Intellectual Trends*, 23.
33 Farrokh Mohammadzadeh Mehr, *Maidan-e Tup-khaneh-e Tehran: Negahi be Seir-e Tadavom va Tahavol dar Fazahaye Shahri* (Tup-khaneh square, Tehran: a review of continuity and transformation in urban spaces), (Tehran, 2002), 98–132.
34 This is recorded in another map, produced by the teachers of Dar al-Fonun, led by 'Abd al-Ghaffar Najm al-Molk. He carried out surveys while the old city walls were being demolished from 1868 to 1888.

104a: Aerial photograph of Maidan-e Tup-khaneh in Tehran and
its surroundings during the reign of Naser al-Din Shah.

104b: Tehran's central Post Office in Maidan-e
Tup-khaneh during the early Pahlavi period.

addition of new streets such as Mariz-Khaneh , Cheragh-Gaz, and Naseri-yyeh. Inspired by nineteenth-century Parisian examples, these streets held commercial units in a linear arrangement connected to the surrounding neighbourhoods.[35] Each maidan retained its importance yet, unlike the Safavid examples, their function was limited to a specific purpose. Tup-khaneh housed the new civic buildings while Maidan-e Arg remained the governmental locus. Sabzeh Maidan, jāmi' and the bazaar gradually lost their importance as traditional public centres. As the only maidan located within the confines of the Arg, Maidan-e Arg was transformed into a garden – Bagh-e Golshan – in 1864 and became the first public park in Tehran. It contained a large octagonal pool surrounded by flower beds of Iranian and European plants and roads wide enough for coaches and car-riages.[36] Maidan-e Baharestan was surrounded by the Sepahsalar mosque and school, the Negarestan garden, and the private house of Sepahsalar, which in 1906 became the first national assembly building.[37] But Baha-restan and Maidan-e Mashq had little public significance in this period, and had to wait to become new urban focal points until after the political transformations of the late nineteenth and early twentieth centuries.

Nevertheless, from the mid-nineteenth century until the end of Naser al-Din Shah's reign in 1896, the effect of practical reform was constantly challenged as the economy grew weaker. This was the result of taking out loans, allocating concessions, and granting monopolies to Western gov-ernments and businessmen, such as the wide-range of exclusive rights, including the ownership of Iranian customs income, granted to Paul Julius Reuter, the founder of the Reuter's news agency. Meanwhile the owner-ship of the Iranian tobacco industry was given to an Englishman, Major Gerald F. Talbot, and the monopoly on archaeological excavations in Iran was given to France. All this put Iranian merchants and businessmen under great economic pressure. Meanwhile, the popularity of Western intellec-tual and political traditions was growing amongst the Iranian reformist elites, whose numbers in governmental positions were increasing by the

35 Habibi 1999, 134–9.
36 Bani Masoud 2010, 84; Zoka 1970, 29.
37 Bani Masoud 2010, 108–14.

1. Bazaar	6. Dar al-Fonūn	11. Nezamiyyeh Garden
2. Masjid-e Shah	7. Takiyyeh-e Dowlat	12. Sepahsalar Mosque
3. Sabzeh Maidane	8. Shams al-'Emara	13. Sepahsalar Residence('Emarat-e Baharestan)
4. Maidan-e Arg	9. Maidan-e Tūpkhaneh	14. Negarestan Garden's Frontal area
5. Golestan Palace	10. Maidan-e Mashq	15. Negarestan Garden

105: Schematic drawing of Tehran from an original
map by 'Abd al-Ghaffar Najm al-Molk.

1880s.[38] The general discontent amongst various levels of society resulted in a collective movement against the concessions granted to the British over the Iranian tobacco industry in 1891–2. The 'Tobacco Protest' has been called 'the first successful mass movement in modern Iranian history'[39] and resulted in the cancellation of the concession. It was regarded as a harbinger of future public movements, such as the Constitutional

38 Keddie 1999, 44–5.
39 Keddie 2012, 2.

Revolution movement[40] that began in 1905, and the revival of patriotism and demand for political reform that followed it.[41]

The next Qajar monarch, Mozaffar al-Din Shah (1896–1907), also took out loans from Russia and Britain, which resulted in even more monopolistic concessions. Among those concessions, Iran granted the Anglo-Australian mining engineer William Knox D'Arcy the right to explore the south of Iran for petroleum.[42] Mozaffar al-Din Shah did however extend some urban modernising developments, on a limited scale. Tehran, in particular, witnessed improvements in cleaning, street lighting, and the collection of refuse. But from this point until the end of Qajar dynasty, neither architecture in general, nor urban development in Tehran progressed, even though the political situation was transforming almost weekly. It was in this politically charged period that many of the architects who were to become influential almost two decades later first began studying Iranian and Western approaches to design. They included Hossein Lorzadeh, Nikolai Markov, and Karim Taherzadeh Behzad, whose design for the tomb of the poet Ferdowsi in Tus, near the city of Mashhad, can be considered as the culmination of what became the National Architecture style. So although there is a limited record of any significant construction in this era, until the premiership of Reza Khan, a brief account of this period will help in understanding the intense round of development that followed it.

By comparison to his father, Naser al-Din Shah, Mozaffar al-Din Shah

40 Keddie foresees the Constitutional Revolution as an aftermath of the Tobacco Revolt: 'The success undoubtedly gave courage to the conscious opponents of the government and of foreign encroachments, and led many to see for the first time that it was possible to defeat the government, even in a matter involving European interests. The movement involved a successful alliance between the Ulema, modernizing reformers, and the overlooked population of Iran, particularly the merchants – an alliance which was to reappear in later protests and to come to fruition in the Constitutional Revolution.' See Keddie 2012, 1.

41 Iranica: Amanat, 'Abbas, 'Constitutional Revolution i. Intellectual,' VI/2, 163–76, accessed online 10 September 2013. See also Ansari 2012, 41–3, where the Constitutional Revolution is considered as a project of the Enlightenment, with further roots in eighteenth-century intellectual traditions in Europe, and similar movements such as the Ottoman Constitution (1876) and the Urabi Revolt in Egypt (1881–2).

42 In 1908 oil was found in large quantities in the Middle East for the first time in Ahvaz, south-west Iran, under the D'Arcy concession.

was more open to political reform.[43] Demands for reform of the socio-
political environment were as strong, among the intelligentsia and the
reformist elites as were pleas to reform the economy.[44] These demands
were fulfilled after the protests of December 1905, when in parallel with
changes in economy, protesters demanded the establishment of a house
of justice ('edālat-kāneh), to which the shah agreed. The campaign for
reform continued throughout July and August of 1906, when the reform-
ist prime minister, 'Ayn al-Dowla, was dismissed, and a representative
assembly, or 'Majlis' was established.[45] This major political transition had
a small urban consequence when what had been the private house of Mirza
Hossein Khan Sepahsalar was transformed into the first location of Majlis.
This building, which is located near the large mosque and school of Sepah-
salar and in front of the small promenade of Negarestan (also known as
Maidan-e Baharestan) became the urban centre for a new type of govern-
mental system and was of great significance in upcoming events.

Supported by Russian forces, Mohammad 'Ali Shah succeeded Mozaf-
far al-Din Shah in January 1907. A few months later, Russian and British
forces signed a treaty dividing Iran into three zones: the Russian zone in
the north, the British in the south-east and a neutral zone in the middle.[46]
The Russians also supported Mohammad 'Ali Shah in setting up a coup
and abolished Majlis in 1908. Many nationalist leaders were executed,
many moved abroad and the rest, including the prominent politician and
diplomat Hassan Taqizadeh, took refuge in the British Embassy.[47] Protests
against foreign influence and the lack of government authority continued,
and led to the abdication of Mohammad 'Ali Shah and the succession of
his teenage son, Ahmad Shah, in 1909. Despite the restoration of Majlis in
1909, the country remained under the influence of the Russia and Britain,
and more importantly, still suffered from social and political divisions. The
crisis intensified during World War I, which not only led to the dissolution
of Majlis once more, but also brought Iran to the brink of dissolution. After

43 Keddie 1999, 50–51.
44 Iranica: Amanat, 'Abbas. 'Constitutional Revolution i. Intellectual,' VI/2,
163–176, accessed online 10 September 2013.
45 Keddie 1999, 55–7.
46 Michael Axworthy, *A History of Iran: Empire of the Mind* (London, 2007), 212.
47 Keddie 1999, 59.

the October Revolution of 1917, the Russians left Iran, and Britain became the most powerful foreign force in the country, along with German and to a lesser extent Ottoman forces.[48]

The Development of Nationalism in Iran

During the nineteenth century, the expansion of relations with the West resulted in a recognition of the socio-political problems and backwardness of Iran, and an increased desire amongst Iranians for social progress. Awareness of these issues, for the West, was set against the historical myth of Iranian decadence that had prejudiced Western understanding of Iran since Biblical times. But within Iran, this connection of ideas provided the intellectual framework for progress, and fuelled demands for reform and the advancement of nationalism, inspired by both the French Revolution of 1789 and earlier revolutions in Britain and North America.[49] One can see this in the text of the Iranian constitution, which is based on the English constitution and on the spirit of Iranian humanism in general.[50] These revolutionary influences entered Iranian thinking along with other intellectual developments of the industrial age, 'on the wave of scientific rationality and positivism', which was considered the main reason for progress.[51] As the historian Ali M. Ansari describes it, the reformist elite saw the cure in 'political reform, extending participation (more 'republican' than 'democratic'), the rule of law and crucially, the invocation of a patriotic, national ethos among the population'.[52] The essential part of the problem was considered political, and only to be solved through reforms that would replace the arbitrary power of the sovereign with the rule of law.[53] Meanwhile, the social aspects of reform were the main goal, so 'educating the public at

48 For the details of foreign influence and the challenges of Majlis from its establishment until the end of Qajar dynasty see Keddie 1999, 44–77.
49 Ansari 2012, 5 and 47–51.
50 ibid., 50–52.
51 ibid., 5.
52 ibid., 37.
53 Iranica: Amanat, 'Abbas, 'Constitutional Revolution i. Intellectual', VI/2, 163–176, accessed online 10 September 2013.

large and inculcating them with civic pride and patriotism was an essential part of the solution'.[54]

Within this framework, both history and myth found key roles in motivating the reformers, in activating nationalist sentiment, and ultimately in the use of architecture to help legitimise the future Pahlavi state. The development of European knowledge about 'Persia', which dated back to Classical Greek and Biblical texts, became an important element in this process. From the sixteenth century onwards, through the expansion of trade and diplomacy, the European imagination represented 'Persia' as a country mired in social and political decay.[55] However, during the nineteenth century, thanks to developments in historical and archaeological scholarship, the myth of Persian decadence was re-examined.[56] Linguistic and archaeological discoveries lent credence to Classical and Biblical narratives that presented the Aryan race as the common ancestors of Europeans and Iranians alike; and the ancient Achaemenid era of the fifth century BCE as a glorious period of global significance for the territory of Iran, with central attention paid to the character of its founder, Cyrus the Great.[57] All these elements greatly influenced the formation of Iranian national identity, and the historical consciousness of Iranians, which up to this point had been predominantly informed by origin-myths such as that portrayed in Ferdowsi's *Shahnameh*. Such myths now co-existed with scientific theories that had been in the process of development since the nineteenth century, and the first decades of the twentieth century thus became the time when these elements merged, and the politicising of knowledge of the past became the means of constructing a modern national identity, manifested in the establishment of the Pahlavi monarchy.[58]

By 1915, as a result of the outbreak of World War I, the failure of the Constitutional Movement and the migration of some of the young constitutionalists, the aim of social reform had found a strong nationalist aspect.[59] These issues were addressed in *Kaveh*, a seminal journal published by

54 Ansari 2012, 37.
55 ibid., 9–10.
56 ibid., 11.
57 ibid., 13–17.
58 Marashi 2008, 53–4.
59 ibid., 54–6.

Hasan Taqizadeh in Germany from 1916 to 1922 to promote national-ism amongst Iranians. A colleague of Taqizadeh's in Berlin, Hossein Kazemzadeh,[60] followed Taqizadeh's ideas in another journal, *Iranshahr*, from 1922 to 1926.[61] Nationalism had become a central issue during the War and was disseminated through the publication of *Kaveh*.[62] From this point onwards, projects of modernisation and reform shift from a late imperial model to a nationalist one.[63]

From its title to its content, the complementary roles of historical myths and of evidence-based historical knowledge are evident in *Kaveh*.[64] The political and ethical message of Iranian mythology played a crucial role in promoting patriotism and political mobilisation.[65] The post-war issues of *Kaveh* focused on the construction of civic nationalism, culminating in the January 1921 issue where Taqizadeh introduced a manifesto-like list of actions for progress.[66] Similar to the approach of its predecessors, this list covers both the top-down and the bottom-up aspects of reform, prioritis-ing political change and the promulgation of such ideas within society as a whole.[67] Indeed, the list emphasises the role of individuals and of public education (*ta'līm-e omumī*)[68] in social development.

The challenges of the period after the Constitutional Revolution were not only how to deal with domestic chaos and foreign interventions, but also how the process of modernisation should be continued.[69] This is evident in Taqizadeh's list, as he mentions elements of modernisation such as 'the cultivation (*abādī*) of the country in the European manner especially

60 Hossein Kazemzadeh was also known as Kazemzadeh Iranshahr.
61 Iranica: Jamshid Behnam, 'Irānšahr, Hosayn Kāzemzāda,' XIII/5, 537–9, accessed online 5 June 2017.
62 Marashi 2008, 50.
63 ibid., 52–3.
64 Kaveh was the name of the blacksmith hero in *Shahnameh*, who rebelled against the tyranny of King Zahhak, and helped the rightful king, Fereydun, to ascend to the throne.
65 Ansari 2012, 55–6.
66 Dibacheh-ye Sal-e Dovvom-e Kaveh (Introduction to Kaveh's second year) *Kaveh*, January 11 1921, 1–4.
67 Ansari 2012, 64.
68 *Kaveh*, January 11 1921, 4.
69 Homa Katouzian, *The Persians: Ancient, Mediaeval and Modern Iran* (New Haven and London, 2009), 194.

through the import of industry (*māshīn*)', along with general demands for 'the preservation and unity of the nation of Iran'.[70] Iranian nationalism was founded not merely in opposition to the influence of the West, but from the beginning was part of the process of modernisation, both in its theoretical background and in practical measures. The challenges this approach presented for architecture become evident in the following decades, when modern architecture found a separate domain of influence from National Architecture. The two hardly meet even later. Perhaps the creation of National Architecture had taken indirect inspiration from another point on the list (one intended to inspire individual reforms): 'The revival of ancient traditions and customs of the Iranian Nation'.[71]

By 1921, the inadequacy of the Qajar monarchy and the pressing need for strong government had become clear. British forces had control over the majority of Iranian armed forces, including the Cossack Brigade, and facilitated a *coup d'état* led by Colonel Reza Khan and Seyyed Zia al-Din Tabatabayi, a political activist and journalist.[72] On 16 February 1921, Reza Khan marched 2500 of his Cossack forces from their camp near Qazvin to the Parade Ground of Tehran, in the north of the city, and seized control of the capital. Seyyed Zia became prime minister (but was soon dismissed, in May 1921), while Reza Khan was raised to the position of minister of war. He greatly increased his power by consolidating with major landlords, leading religious authorities, and nationalist activists, and by successfully putting down numerous revolts across Iran. This led to his promotion to prime minister in 1923.[73] The Reformists, who were not particularly looking for the overthrow of the government, supported Reza Khan as he seemed to promise the fulfilment their objective of reuniting the country under a centralised power.[74] This would give the nationalist reformers who supported him an opportunity to push their agendas further. In 1925, Reza Khan gained the support of the religious authorities by visiting Najaf on a pilgrimage, and on the way back he adopted the surname of Pahlavi – a

70 *Kaveh*, January 11 1921, 2.
71 ibid.; an English translation is given in Ansari 2012, 62–3.
72 Homa Katouzian, op.cit., 198–9. For clarification on the role and the degree of British influence on the coup, see Keddie 1999, 79–80.
73 Keddie 1999, 82–4.
74 Ansari 2012, 50.

reflection of his nationalist ideas as it is a name of the Middle Persian language of pre-Islamic times. In October of the same year, Majlis deposed Ahmad Shah and the Qajar dynasty, and before the end of the year, a constituent assembly agreed to a changeover from the Qajar to the Pahlavi dynasty. In 1926, with the assistance of the nationalist reformers, Reza Khan was crowned as shah. Distancing himself from more conservative parties, Reza Khan came closer to the Revival Party (Hezb-e Tajaddod), the leaders of which were influential constitutionalists and received high-status positions once Reza Khan ascended to the throne.

Saramadan-e Honar: A Blueprint for National Architecture

The political events during the first two decades of the twentieth century did not result in noticeable architectural or urban developments, but the premiership of Reza Khan brought the political support necessary for the flourishing of a new approach to architectural design, one whose agenda was to promote Iranian historical heritage as part of nationalism. The simultaneous publication of *Saramadan-e Honar* (Prominent figures of the arts)[75] in Berlin by Karim Taherzadeh Behzad Tabrizi brought the nationalist ideas of Taqizadeh and Kazemzadeh to the field of arts and architecture. Taherzadeh Behzad was a young constitutionalist in Tabriz, who left Iran for Istanbul after the coup of 1908 and the abolition of Majlis. He received his degree in architecture in 1917 and moved to Berlin where he worked on the Iranian collection in the Kaiser Friedrich Museum. He was accepted to study for a PhD at the Technische Universität Berlin in 1926, but returned to Iran to work as an architect.[76] He was encouraged to produce his book by Kazemzadeh, who was publishing *Iranshahr* at the time. *Saramadan-e Honar* is the first document in an Iranian context that reflects on arts and architecture from a nationalist point of view.

In the introduction of *Saramadan-e Honar*, Taherzadeh Behzad mentions the significant role of the fine arts in representing the superiority as well as the state of affairs of a nation, and as a way to show the role of one

75 Behzad 1923.
76 Shafei 2005, 14–18.

particular nation in advancing global civilisation.[77] His book divides the history of the arts in Iran into three main section: the pre-Islamic, Islamic and contemporary eras. Inspired by the nationalist ideas of his companions in Berlin, Taherzadeh Behzad particularly emphasised the significance of the pre-Islamic era. Praising the architectural skills of this period, he identified the Arab conquest of Iran as the reason that there are almost no remains of fine art from this period. In his view, it then took centuries for Iranian arts to revive the spirit of pre-Islamic civilisation and techniques in a new Islamic form. Taherzadeh Behzad believed that it was pre-Islamic Iranian culture that greatly influenced the Muslim Arabs, not the other way around. He argued that the next great period in Iranian artistic history happened between the thirteenth and sixteenth centuries, when Iranian artists were introduced to Western artistic traditions that inflected their work. Taherzadeh criticises Iranians who imitated Western artists during this period and ultimately calls for the preservation of the original values of Iranian art,[78] adding that every nation that has developed their arts has also revitalised their national spirit (*rūh-e mellī*) and thus been led toward progress. He then returns to the contemporary period, stating that not only has the Iranian nation not made significant artistic advances since the sixteenth century, but that it has also greatly damaged its own artistic heritage.[79] Taherzadeh emphasised the idea that this heritage 'is a privilege for a nation, the members of which are concerned with the ideas of reforms and development, as well as the need for learning science, decency, scholarship and the arts.'[80] In this regard, he criticises the lack of interest among Iranian artists to research and learn from the past achievements of artists in their field, instead of imitating the works of others.[81]

Throughout the book, Taherzadeh repeatedly criticises the majority of Iranian artists for their conservatism (*mohāfezeh-kārī*), their subjugation of thought (*ezhārāt-e fekr*), and practise of imitation (*taqlīd*) instead of the type of creation (*ījād*) and innovation (*ekhterā'*) that would move towards

77 Behzad 1923, 1.
78 ibid., 2–3.
79 ibid., 3.
80 ibid.
81 ibid., 3–4.

a Renaissance or renewal (*tajaddod*) in the arts.[82] Focusing on the histori-
cal examples that for him represented such ideals, the book includes three
chapters where Taherzadeh praises the work of three painters. These are
Mani, the painter and prophet who lived in third-century Iran under Sas-
sanian rule; Kamal al-Din Behzad, the master-painter who lived in Herat
during the second half of the fifteenth century; and his contemporary, the
renowned Italian Renaissance artist Raphael (Raphael Sanzio da Urbino).
Admiring the revival of classical culture during the Renaissance that
resulted in the flourishing of the arts across Europe, Taherzadeh believes
that a simultaneous flourishing of the arts occurred in the work of Kamal
al-Din Behzad in Iran.[83] The main point of agreement between the pro-
tagonists of the book, especially in the case of Iranian artists Kamal al-Din
Behzad, and Hossein Kazemzadeh (to whom Taherzadeh dedicated the
book), is their revival of historic values; while Mani's importance was his
emphasis on the significance of the arts – mostly painting in this context –
in the dissemination of ideas.[84] Focusing on the case of painting, the main
body of the text in *Saramadan-e Honar* highlights how art can and should
revitalise ancient values as they help the development of the discipline
itself, and how this can help the dissemination of ideas and ideologies.
In parallel with this point, Taherzadeh also discusses the importance of
official support from the state or religious authorities,[85] as well as the inter-
est of the public as the audience[86] for development of the arts. He firmly
believes that the lack of public interest in the arts, and the consequent
humbleness of the public worldview, was the reason for the limited devel-
opment of arts in Iran.

Comparing this text with Taqizadeh's article in *Kaveh*, one can see the
adoption of the ideas of his intellectual circle in Berlin, if not the direct
influence of the article. The development of the arts for Taherzadeh is
possible through both bottom-up and top-down processes and depends on
an increase in public awareness and interest as well as official support.
The duty of artists and scholars is to facilitate and generate this interest

82 ibid., 38, 90.
83 ibid., 5.
84 ibid., 54–7.
85 ibid., 3–5.
86 ibid., 389.

through the production of knowledge.[87] Taherzadeh's approach also suggests looking back into past artistic experience, mainly of the pre-Islamic era, and preserving and reviving its values while encouraging further advancement. He does not criticise Western influence; on the contrary, he writes that not only is their own art appreciated globally, but the study and preservation of Iranian arts in Western collections is a positive opportunity. More importantly, as he compares the history of Iran to the life of a person, Taherzadeh equates the splendour of ancient Iran to the vitality of young age, while the last centuries represented old age. He mentions that a new era had started in Iran since the Constitutional Revolution of 1906 and describes this as a time of growth and transition to a new Iran.[88]

Although most of the text is concerned with arts in general, there is a small yet important section where Taherzadeh introduces his architectural drawings. This section has particular value when assessing future development in Iranian architecture. In this regard, echoing Luis Sullivan's famous quote: 'Form ever follows function'[89] and despite his own design preferences as an 'ornamentalist',[90] Taherzadeh calls for an accord between the function of a building and its plan (shālūdeh), and ultimately its overall form.[91] Next, as he deals with technicalities, he mentions the importance of architecture in creating physical and mental health, especially in the case of the architecture of educational centres where the next Iranian generation would grow up.[92] He does not directly refer to the Beaux-Arts system of design,[93] but examples of his work showcase the direct influence from this style. Their neoclassicist facades, ancient Iranian references, and classical elements are all examples of such influence. More importantly, earlier in this section, Taherzadeh has not only categorised building types according to their function but also represented his designs as examples, drafted as

87 ibid., 40.
88 ibid., 40–41.
89 Louis Sullivan, 'The Tall Office Building Artistically Considered', *Lippincott's Magazine* (March 1896), 408.
90 Harry F. Mallgrave and Christina Contandriopoulos, eds, *Architectural Theory. Vol. 2, An anthology from 1871–2005* (Singapore, 2008), 126.
91 Behzad 1923, 45–6.
92 ibid., 46–8.
93 The characteristics of Beaux-Arts architecture and their influence on National Architecture are discussed in Chapters Two and Three.

simple templates that can be used for future designs. This influence was to become even more evident nine years later in the design of the tomb of Ferdowsi – Taherzadeh's first architectural work in Iran.

From the Parade Ground to the National Garden (1925–34)

Reza Khan's early years in power are crucial in understanding not only his future political plans, but also how political developments influenced developments in architecture and the built environment.

At this time, Reza Khan's priorities were the same as those of the nationalist reformers who had paved the way for his succession: to secure the rule of law and launch reforms that could facilitate progress, regularise state revenue, strengthen the armed forces, and enforce centralisation by governmental control over the whole territory of Iran.

One of the first transformations of Tehran by Reza Khan was deliberately located in the plot of land from which he was effectively raised to power: Maidan-e Mashq (the Parade Ground of Tehran) where he had trained as a soldier and returned after the coup. When the French army came to Tehran to reinforce and refresh Iranian military forces, Fath 'Ali Shah Qajar allocated a piece of land to them in the north-west of Tehran. During the reign of Naser al-Din Shah it had been enclosed and became the parade ground of the Cossack Brigade, whose proximity to the capital was intended to help them protect the city and the government. In 1899 Mirza Mohammad Sepahsalar, the minister of war and later prime minister under Naser al-Din Shah, created the Cossack's headquarters as the first building in the site, enclosed within brick walls decorated with fake arches. During the last years of the Qajar dynasty, the site was unused – at least until February 1921, when Reza Khan moved his army from Qazvin to Tehran and staged his *coup d'état*. Reza Shah knew the Maidan-e Mashq, and ordered the destruction of the old gates of the Parade Ground in order to build a new memorial gate.[94] This gate, which includes a kettledrum room (*naqāreh-khāneh*) is decorated with painted tiles depicting Cossack

94 Mohammad Reza Shahrivar, 'Maidan-e Mashq va Emarat-e Shahrbani' (The Parade Ground and the building of the Police Headquarters), *Contemporary Architecture*, 15–16 (2003), 65.

soldiers and the victory of the coup.[95] It was constructed by Jafar Khan Kashi, one of the prominent master builders of the constitutional era.[96]

On 3 April 1928, the idea of constructing a public garden inside the Maidan-e Mashq was announced in the *Ettela'at* newspaper. Bagh-e Melli (National Garden), designed within the Parade Ground, opened to the public later in the same year.[97] Its design was elaborate, with geometrical patterns for green areas and flower-beds and countless electric lights, and it soon became a gathering place for the public, and the site of events such as the launch of the first hot-air balloon and the flight of the first aeroplane in Iran. (Further plans for the site included tennis and football courts, a zoo and a cinema, although these were never constructed.) Instead, some administrative buildings were erected in this area.[98] The first, almost simultaneously with the construction of Bagh-e Melli, was the construction of the central Post Office within the enclosure of the Parade Ground. Complaints about the malfunctions of the former post office building had appeared repeatedly in the press; now the south-west corner of the Parade Ground was set aside for the construction of a new building. *Ettela'at* newspaper announced this project on the same day that it reported the construction of the National Garden. By 1934, on the shah's order, many important government buildings and cultural centres had been built on this ground.

Of course, Bagh-e Melli was not the first public park,[99] or even the first private garden with public access in either the capital or the country as a whole, but is significant that its name references both public ownership and nationhood. Building a national park on the site where the new shah initiated his rise to power was perhaps seen as a suitable means of satisfying his nationalist supporters as well as the general public in the early years of his reign, when Reza Shah represented himself as the supporter of progressive ideas. An enclosed national park might certainly represent fundamental ideas of 'autonomy, unity, and identity'[100] in an urban context.

95 Bani Masoud 2010, 108.
96 See: Mofid 2005, 25–7.
97 Bani Masoud 2010, 107. See also Ettela'at, 3 April 1928, 2.
98 Mohammad Reza Shahrivar, 'The parade ground...', 66.
99 Maidan-e Arg could be an older example of public parks in Tehran.
100 Smith 2010, 9.

Die Stadt Teheran aus 400 m Flughöhe. In der Mitte der Militär-Paradeplatz

106a: Aerial photograph of Tehran and the Parade
Ground of Tehran in the early Pahlavi period.

106b: The main gate of Bagh-e Melli.

107: Bagh-e Melli (the former Parade Ground) as
it appeared in the early Pahlavi era.

It was also an uncontroversial yet explicit secular gesture, considering
the Islamic traditions of the time in Iran, where in traditional architecture,
green space was generally in the form of private courtyards, usually out of
the sight and out of reach by others. Bagh-e Melli did not last long (by the
late 1930s, Maidan-e Mashq had been transformed into the main govern-
mental and cultural centre) but nevertheless, the success of Reza Shah's
first unifying project can be seen in the fact that this area of the old Parade
Ground is still known as Bagh-e Melli.[101]

Other significant constructions during the first years of Reza Shah's
reign included a new royal complex, Kakh-e Marmar (Marble Palace),
located on the west end of Sepah Street. Sepah Street was at this time the
main arterial east-west road in Tehran, starting from Maidan-e Tup-khaneh
in the east with Arg on its south side and Bagh-e Melli on its north. Now a
larger royal compound was built in Sa'dabad, in the northern outskirts of
Tehran. At the time of completion in the mid-1930s, this relatively small

101 Comparing maps of Tehran from 1930 to 1944, the area of Bagh-e Melli was
completely transformed during this period into an administrative complex.
Meanwhile, south of Sepah Street, and close to the north-west corner of Arg, a large
area of abandoned land remained throughout Reza Shah's extensive developments.
Part of this area, which was known as Arazi-e Sangelaj (the lands of Sangelaj), was
allocated to the construction of the new Bagh-e Melli. This garden, which first
appears in Colonel Mohammadreza Ghaffari's 1944 *The Guide Map of Tehran and
its Environs*, was later known as Park-e Shahr (City park). To compare the maps, see
Reza Shirazian, Atlas-e Tehran-e Qadim (The Atlas of Old Tehran), (Tehran, 2015),
180–81, 192–93, 211 and , 217.

royal complex included eleven residential buildings for the royal family, several official and service buildings and more importantly, Marble Palace, used as the office and residence of Reza Shah himself.[102]

Marble Palace is the result of exceptional collective work by archi-tects, master builders, and artists.[103] It is a free-standing two-storey cubic building with a dome, and was designed by the Iranian-Armenian architect Leon Tadosian under the direct supervision of Reza Shah, and for a brief period before Tadosian by Heydar Siah.[104] The design of Marble Palace was inspired by the Sheikh Lotf Allah Mosque in Isfahan, and replicated its famous dome decorated with *haft rangi* (seven-colour) tiling, a much simpler technique than the *mo'araq* (mosaic tiling) also often used in Isfa-han.[105] The rim of the dome brings natural light to the core of the building, where the central stairway connects the central halls of the two levels. The decoration of the exterior was also inspired by Islamic architecture of the Safavid period, while the gate of the building, constructed by Jafar Khan Kashi,[106] has a combination of references, from Corinthian capitals to the statues of Achaemenid soldiers and panels of Islamic tile work. The interior of the palace is heavily decorated with intricate *moqarnas* (honey-comb) designs and large mural paintings, many of which were produced at the Academy of Fine Arts, under the supervision of Taherzadeh Behzad. In particular there are two major murals on the walls of the second-floor hall. One depicts the Alborz mountains in northern Iran and the famous Veresk Bridge, built by order of the shah in 1934–5; the other is a much-elaborated copy of the nineteenth-century French architect Pascal Coste's study of Persepolis.

This period saw an extensive round of urban development right across Iran,[107] which was to transform Tehran, as the capital, more than any other

102 Mofid 2005, 37–8; see also map, 64–5.
103 ibid., 36–7.
104 ibid., 35.
105 ibid., 40.
106 ibid. Perhaps this would be the only time that depictions of Persepolis other than those of Ernst Herzfeld were used during the reign of Reza Shah. Of course, at the time of the construction of the Marble Palace, Herzfeld's drawings were themselves in the process of creation.
107 Ali Madanipour, 'Urban Planning and Development in Tehran', *Cities*, vol. 26, 6 (2006), 434.

city. The long-anticipated and extensive modernising projects started under
Reza Shah required a modern city, not only to represent modernity itself
but also to be able to function under his other drastic social changes. This
round of urban changes was far more intensive than any that had come
before. Unlike the nineteenth-century developments, which only enlarged
the city without drastic interventions within its existing fabric, develop-
ments under Reza Shah dramatically changed the city itself and left its
future expansion unlimited. In other words it 'was an attempt to change the
morphology of the entire urban area'.[108] This was accomplished firstly by
the demolition of the old city walls, enabling Tehran to expand outwards
(possible due to the increased security and social order that came about
after the 1925 change of government.)[109] Secondly, interventions in the
urban fabric of Tehran included road-widening schemes[110] that juxtaposed
a modern grid- system of boulevards suitable for motorcars on the existing
organic street-pattern. Such a juxtaposition is in contrast to the principles
of urban planning seen in countries such as India or Morocco under British
and French colonial rule, where the traditional and the modern urban forms
were separated. In Tehran one can see 'a close and intimate amalgamation'
of the two categories,[111] reinforcing the home-grown desire for fundamen-
tal change and modernisation from within.

The main streets of the city were named after the new ruler: Shah Reza
Street – now called Enqelab (Revolution), and Pahlavi Street, now Vali-e
'Asr (Guardian of the age)[112] – both more than twenty kilometres long,
became the main streets of Tehran, intersecting at the heart of the city.
They formed the main east-west and north-south axes of the city, and many
significant buildings were built along them. Marble Palace, for example,
was located at the intersection of Sepah (the army) and Pahlavi streets, and
was directly connected to Tehran's railway station through Pahlavi Street.
Public building along Shah Reza Street included the University of Tehran,

108 Madanipour 1998, 37.
109 Ehlers, Eckart and Floor, Willem, "Urban Change in Iran, 1920–1941", *Iranian Studies* Vol 26, 3/4 (Summer-Autumn 1993), 266.
110 Madanipour, A., "Urban Planning and Development",434.
111 Eckart Ehlers and Willem Floor, 'Urban Change in Iran, 1920–1941,' Iranian Studies, vol. 26, 3/4 (Summer-Autumn 1993), 266.
112 This title refers to the last Imam of the twelve Imam Shi'ite tradition.

1. Golestan palace	6. Majlis Building
2. Maidan-e Sepah (Tūpkhane)	7. Bank-e Meli
3. Former Bagh-e Melli	8. Marmar Palace
4. Sepahsalar Mosque	9. Tehran Railway Station
5. Maidan-e Baharestan	

108: Schematic drawing created from Mohammadreza Ghaffari's
1944 'The Guide Map of Tehran and its Environs'.

which was one of the most important projects of Reza Shah.[113] These urban reforms resulted in many Qajar landmarks, such as the Golestan Palace, losing their significance; while other significant Qajar public buildings such as Tekiyyeh Dowlat (the royal theatre) were demolished altogether.[114] In fact, this project explicitly attempted to draw attention away from the urban legacies of the last monarchy and toward those that represented the new age and the new regime.

113 Madanipour 1998, 39–40.
114 ibid., 37.

109: The exterior of Tehran's railway station.

It is worth mentioning that the formal and visual characteristics that simultaneously became prominent in Iranian architecture in the early 1920s came from two opposing categories: modernist architecture and an historicist interpretation of the Beaux-Arts tradition. The latter mainly used pre-Islamic forms as its decorative references for the design of government buildings such as Marble Palace[115] and other cultural projects, and later became known as 'National Architecture' or 'National Style'. Meanwhile, modernist architecture came to be employed throughout Iran for new facilities with new functions – office buildings, factories, universities, train stations, and the entire transport infrastructure in general. Although examples of National Architecture are fewer than those of modernist architecture of this period, and National Architecture had not yet developed its official principles, its political value was more significant.

Later, by constructing administrative buildings on the Parade Ground, the new government succeeded in turning attention from Tup-khaneh as the central public square of Qajar Tehran to this politically significant piece of land, which was outside the old gates of Tehran until 1896. As

115 Marble Palace doesn't represent a clear example of National Architecture as its principles were not fully established at the time. Nevertheless, in terms of the political use of historical references and values, it should still be regarded as a pioneering project.

110: View of the Post Office from Sepah Street.

111: View of Bagh-e Melli, part of Tehran, and the Alborz
mountains from Sepah Street in the 1960s.

has been said, the first government office to be relocated here from its iconic building in Tup-khaneh was the central Post Office. Nikolai Markov (1883–1957), an officer who had served with Reza Shah in the Cossack Brigade, was responsible for the design of the new building. Markov had been born in Tbilisi and studied architecture and later oriental studies and Persian language in Saint Petersburg.[116] His architectural debut in Tehran was the construction of Alborz American College in 1925. He also designed and was the contractor on several other educational buildings, including the renovation of Dar al-Fonun, all of which demonstrate the influence of Beaux-Arts architecture as well as Markov's admiration of Iranian architecture of the Safavid era. Decorative elements of Achaemenid architecture appear in Markov's work for the first time on the façade of the new Post Office, which is decorated with columns depicting the two-headed bulls of Persepolis. The process of design and construction, which was directly overseen by Reza Shah,[117] extended until 1934.

The transformation of the Parade Ground to the National Garden represented the shah's policies in the early years of his reign. As his rule changed from a constitutional to an absolutist monarchy, this plot of land also transformed, into a capitol complex housing a combination of governmental and cultural buildings. Henceforth, National Architecture, which visually celebrated the memory of the Achaemenid and Sassanid eras by using their ornamental motifs and forms became the key architectural theme of this area.[118]

116 Bijan Shafei, Sohrab Soroushiani, and Daniel Victor, Nikolai Markov Architecture, (Tehran, 2003), 12–13.
117 ibid., 83–86; see also Ettela'at, 20 May 1928, 2.
118 The architectural characteristics of these buildings are discussed in the next chapter.

2

Politics and the Production of Architectural Knowledge

The Past as Heritage: The Society for National Heritage (Anjoman-e Asar-e Melli)

If we consider the process of modernisation in Iran as 'conflictual', we should remember that this conflict did not come about because of opposition to Western political influence. From the beginning, the process of modernisation included the adoption of Western thinking about Iran, and was influenced by the Western idea of 'Persia'. The establishment of the Society for National Heritage (SNH)[1] can be traced back to the reformist movements of the second half of the Qajar period, when Iran's sense of cultural inferiority and social depression was at its most acute, due to foreign political interference and the decline of domestic power. In parallel with the rise of modern nationalism, this period also witnessed the rise of archaeological research in Iran[2] following the long history of Western interest in 'Persia'. For European architects, especially in France, at the influential École Polytechnique and École des Beaux-Arts, the study of

1 'Anjoman-e Asar-e Melli' is also translated as 'The National Monuments Council of Iran', which is a more exact translation of the Persian title. However, in most texts related to the history of architecture, the name 'The Society for National Heritage' is used, and for the sake of easier research and tracing the Society's activities in other sources, I use the latter translation here.
2 Kamyar Abdi, 'Nationalism, Politics, and the Development of Archaeology in Iran,' *American Journal of Archaeology*, 105/1 (Jan., 2001), 51–76; http://www.jstor.org/stable/507326, accessed online 17 June 2013.

architectural works from across the world had been a priority since the early nineteenth century. Jean-Nicolas-Louis Durand highlighted this in his seminal publication of 1805, Précis des leçons d'architecture données à l'École royale polytechnique[3]:

> It is of utmost importance to architects, to civil and military engineers, to those students of the Ecole Polytechnique who are destined to become architects and engineers, to painters of history and landscape – in a word, to all those who have to construct or to represent buildings and monuments– to study and to become acquainted with all the most interesting productions of architecture in every country and in every age.[4]

This interest resulted in the arrival of several prominent architects and engineers to undertake archaeological research in Iran, including Xavier Pascal Coste[5] and later Marcel-Auguste Dieulafoy.[6] During the nineteenth century, the number of envoys, travellers and Orientalists arriving in Iran increased drastically, which resulted in an increased knowledge of and interest in ancient 'Persia' in France and Britain in particular.[7] A British group had commenced systematic investigations around Susa (the capital of the sixth-century BCE Achaemenid empire, and one of the most famous

3 Durand's book was based on his lectures at the École Polytechnique. It later became one of the seminal works of references at the École des Beaux Arts, and despite numerous criticisms remained as one of the most influential design treaties in the Beaux Arts architectural tradition until the 20th century.
4 Durand 1805, 203.
5 Xavier Pascal Coste (1787–1879), was an architect who was selected by the École des Beaux Arts as the best candidate to work with the French embassy in Iran. He collaborated with Jean-Baptiste Eugène Napoléon Flandin between 1839–41, and produced some of the most important studies of historic edifices in Iran.
6 Marcel-Auguste Dieulafoy (1844–1920), an engineer educated at the École Polytechnique, was encouraged by the medievalist Eugène-Emmanuel Viollet-le-Duc to continue archaeological investigations in Iran. Accompanied by his wife, Jane Henriette Magre Dieulafoy, he travelled to Iran during the 1880s and studied architectural sites across the country. See Iranica: Pierre Amiet, 'Dieulafoy, Marcel-Auguste,' VII/4, 399–401, accessed online 10 Apr. 2017.
7 Ali Mousavi, *Persepolis: Discovery and Afterlife of a World Wonder* (Berlin, 2012), 123.

archaeological sites in Iran[8]) in 1847, while the French government bought the right to excavate across the country in 1895 in exchange for one thousand Tomans. The agreement was revised in 1900, to grant the French a monopoly on all archaeological excavations other than within Islamic religious sites such as mosques or shrines. They could relocate any item to France while only having to pay for the weight of any gold and silver they took; and the Iranian government was also responsible for security and for providing facilities at excavation sites.[9] As with the Talbot tobacco concession (see page 11), this agreement provoked much opposition against the government's negligence over Iran's historical heritage and strengthened the association of historical heritage with the pursuit of national interests. Consequently, resisting the French monopoly became a priority for Iranian nationalists. Meanwhile the new, fact-based, archeologically derived understanding of Iran's past, along with previously widely accepted historical myths facilitated the construction of a national narrative.[10]

It was as a result of Reza Khan's coup of 1921 that this sense of nationalism was finally able to surface, and remain prominent. The transfer of power helped the nationalist reformers push their agenda, and provided the conditions for the abolition of the French monopoly. Only one year after the *coup d'état*, thanks to nationalist elites and politicians, the Society for National Heritage was established in Tehran and benefited from the growing interest in Iran's historical heritage, especially among nationalist politicians and Reza Khan, the soon-to-be shah of Iran. The Society, a non-governmental organisation, aimed to preserve, cultivate and disseminate Iranian cultural and historical heritage.[11] Its activities made it possible to

8 Iranica: Francine Tissot, 'Délégations Archéologiques Françaises,' VII/3, 238–242, accessed online 6 Aug. 2013.
9 For complete details of the agreement see: Ezzatollah Negahban, *A Review of Fifty Years of Archaeology in Iran* (Tehran, 2001).
10 Of course, this does not mean that Iranians had no knowledge of their history prior to these events. But it means that the appropriation of such knowledge became central to the construction of an Iranian national narrative. To a great extent it was the premier contribution of Western interest in the history of Persia.
11 As the new Shah's priorities were to enforce centralisation and maintain the territorial integrity of Iran, his reign was often compared with those ancient Iranian dynasties that reunited Iran under an inclusive sovereign power, i.e. the Achaemenid (550–330BCE), Sassanid (224–651CE) and Safavid (1501–1736).

keep Iranian relics in the country, and more importantly, the SNH's efforts gave national value to historical research and the history it represented. Reza Shah supported the Society throughout his reign. Indeed, his dynastic surname – Pahlavi – had been suggested by Ernst Herzfeld,[12] a prominent archaeologist and Orientalist employed by the Society. With the monarchy's own identity thus defined from within Iran's historical framework, and with the role being played by history in the construction of a national sense of belonging, you might say that acting as a patron of historical heritage was inevitable for the shah.

In Pahlavi historiography and in the published report of the Society's activities –*Karnameh Anjoman-e Asar-e Melli* (1976)[13]– Reza Shah is mentioned as the actual founder of the Society. However, through a closer examination of documents and the biographies of members of the SNH, it becomes clear that the Society was in the process of formation well before 1922, by a group of reformists who were active in political and cultural sectors.[14] Most of the founding members of the Society were also founding members of the Revival Party, including its masterminds, 'Abd ol-Hossein Teymourtash; Mohammad Ali Foroughi, who was Reza Shah's first prime minister and the director of the Society; the politician and scholar Seyyed Hasan Taqizadeh; and Arbab Keykhosrow Shahrokh, the Zoroastrian representative to the parliament who also had an influential role on the revival of Achaemenid and Sassanid styles of architecture during 1930s.[15] Hassan Pirnia (1871–1935) was another prominent member of the Society, who also served as prime minister after the Constitutional Revolution for several terms; and was on the executive committee of the Society. Apart from his political activities, Pirnia was also a prominent scholar and historian, and one of the pioneers of modern historiography in Iran.[16] During his collaboration with SNH, he published several books on ancient Iran, its mythology and history. A member of the

12 Ansari 2012, 82.
13 Bahr ol-Oloumi, 1976, 32.
14 For a complete account of the origins of the SNH, see Grigor 2009, 17–21 and Grigor 2005, 39–95.
15 Grigor 2009, 18.
16 See Iranica: 'Abbas Amanat, 'Historiography ix. Pahlavi period (1),' XII/4, 377–386, accessed online 24 July 2013.

Commission of Education from 1928, Pirnia's most important work was entitled *Ancient Iran*, parts of which remained as high school textbooks for the next two decades.[17]

A year before his coronation, Reza Shah received the presidency of the Society for National Heritage[18] and remained a great patron for the rest of his reign, supporting the Society both financially and ideologically. The shah's appreciation of Iran's past and its heritage were shaped through this collaboration. Members of the court were prevented from joining any political party after 1927, so some members of the Society for National Heritage had to withdraw from the Revival Party. However, in her *Building Iran,* Talinn Grigor mentions that in dealing with the shah's increasing dictatorship, former members of the Revival Party continued their more political activities unofficially and under the cultural disguise of the Society for National Heritage, with the result that 'They co-opted the aesthetic domain into the mainstream of Pahlavi ideology'.[19]

As well as abolishing the French monopoly on excavations, the Society aimed to strengthen cultural homogeneity through collective historical memory, and to enhance public interest in ancient culture and crafts. Other objectives of the Society were to create a database of artefacts of national heritage, establish a museum and library in Tehran, and construct mausoleums for selected historical figures.[20] The construction of memorial buildings to celebrate Iranian historical figures followed the secular objectives of the Revival Party, and benefitted from simultaneous modernising projects, such as the expansion of the national railway system and of inter-urban roads.[21] These expansions made visiting the sites easier for the public and therefore, enhanced the significance of the historical figures in society. Here, however, the architectural aspect of Conflictual Modernisation becomes evident, since the two categories of projects hardly show a sense of balance between those concerned with modernisation and those

17 Kamyar Abdi, 'Nationalism, Politics, and the Development of Archaeology in Iran,' *American Journal of Archaeology*, 105/1 (Jan 2001), 51–76; https://www.jstor.org/stable/507326, accessed online 4 March 2023.
18 Ezzatollah Negahban, op.cit., 42.
19 Grigor 2009, 17.
20 Bahr ol-Oloumi 1976, 14. See also Kamyar Abdi, op.cit., 56.
21 Grigor 2009, 31–5.

of nation-building. The modernist design of the railway stations and the historicist design of the mausoleums represent the existence of two parallel endeavours that shared common goals yet often contradicted each other's visual representation in the built environment. The challenges of arriving at a more balanced form of modernisation were yet to unfold, and the architectural styles of characteristic projects of this period differ greatly, according to the differences that separated their domain of use.

The abolition of the exclusive French right of excavation in Iran was the main goal of the Society.[22] Mohammad Ali Foroughi (also known as Zoka-al Molk, the first prime minister of Reza Shah, who later became prime minister to Mohammad Reza Shah) and 'Abd ol-Hossein Tey-mourtash were the most influential figures in the abolition of the monopoly. In February 1924, Foroughi started negotiations with the French government to end the 1900 Convention. In his letter to the French government, Foroughi states that the concession 'has been drafted contrary to the rules and principles of the country and completely against its interests.'[23] During three years of negotiations, the Iranian politicians tried to combat French influence over archaeological affairs by adding a third party to the debates: the German Orientalist Ernst Herzfeld. Herzfeld (1879–1948) had exten-sive experience of archaeological research in Iran since 1905, and was employed by SNH in 1923 to prepare a description of the current state of the ruins of Persepolis and to make a plan for their preservation. SNH also appointed him to make a list of archaeological ruins and architec-tural landmarks. Additionally, he had ambitions of his own to establish a German archaeological institute in Tehran. These were never realised, but Herzfeld's expertise and the support he received made him a key figure in tackling French influence and in the initiation of Iranian-sponsored archae-ological research, especially in Persepolis.

In 1925, the Society published *Fehrest-e Mokhtasari az Asar va Abni-yyeh Tarikhi-e Iran* (Brief Inventory of Iran's Historical Heritage and Edifices),[24] which 'ultimately became the very foundation for the invention

22 ibid., 21.
23 Archive of the French Ministry of Foreign Affairs, *Direction des Affaires Politiques et Commerciales Asie-Oceanie 1919–29, Perse 66, Fouilles Archéologiques*, E387–3, Paris, 11 Aug. 1900; (cited in Grigor 2009, 23.)
24 The complete text is cited in Ernst Herzfeld, 'Fehrest-e Mokhtasari az Asar va

of the notion of historical monuments in Iran'.[25] Herzfeld was the Society's first candidate for Head of the Department of Antiquities, responsible for managing the Muzeh-ye Iran-e Bastan (Museum of Ancient Iran), its library and relics. After three years of tactical moves and negotiations, the French government agreed to give up the 1900 Convention 'in exchange for the attribution of the French directorship of the Antiquities Museum' (later known as the Museum of Ancient Iran).[26] The establishment of the museum was one of the main projects of SNH. A few months later, in the summer of 1927, Foroughi travelled to Paris and finalised the changes to the treaty. In exchange for the French monopoly, Foroughi agreed to give the directorship of the museum and the library to a French national, and the French archaeologist André Godard was appointed to the post.

As the first non-Iranian specialist appointed by the Society, the arrival of Herzfeld in Iran is significant in many respects. Firstly, as has been said, it was a tactical move by the Society to diminish French authority over Iran's archaeological sites and facilitate the release of what by that time was recognised as its national heritage.[27] Secondly, it paved the way for the arrival of other specialists, who not only helped establish a new international image of Iran but were also part of the development of Iran's academic environment and the expansion of knowledge in fields related to archaeology, including architectural history. Many such specialists taught in the newly established University of Tehran, and their publications are still primary sources for the study of the history of art and architecture in Iran. Finally, and perhaps most significantly, the mainly nationalist ideology of the Society was introduced to and increasingly supported by this more research-based knowledge, gradually replacing the myths of the past. It was a significant step in the formulation of modern Iranian nationalism, and specifically reinforced its associations with pre-Islamic Iran, particularly with the Achaemenid era.

Although they all contributed vastly to the new understanding of national identity in Iran, each of these scholars conducted different kinds of

Abniyyeh Tarikhi-e Iran' (The brief Inventory of Iran's Historical Heritage and Edifices),' in Anjoman-e Asar-e Melli 1972, 11–28.
25 Grigor 2009, 27.
26 ibid., 23.
27 ibid.

research. In the meantime, archaeological histories became a great source of inspiration for architecture in Iran as well, both in terms of composing an architectural history of the country and in contemporary design. The most significant example of this is the emergence of the politically charged 'National Architecture', based on the replication of forms and ornaments from the architecture of pre-Islamic periods in Iran. This revival of historical elements became a way of expressing Iran's new national identity, and has been called 'the key to envisioning Iran's future'.[28] The contradiction is obvious – the country's future was interpreted, imagined, and constructed not as a reflection or a response to its present, but as a continuation of a distant past and a forgetting of its present. Of course, the harsh criticism of the immediate past – the Qajar era – and the determination to rebuild and represent a new nation-state that would appeal to the international community encouraged such a bridging between a distant past and the future.

An Awakening Lecture

Amongst the archaeological groups that arrived in Iran from the 1920s to 1940s, the works of three scholars had the most influence on architectural discipline. Apart from Herzfeld, who had started his collaboration with SNH and archaeological research on Persepolis, two other figures – André Godard and Arthur Upham Pope, both of whom who had backgrounds in art history and archaeology – became influential in the development and dissemination of National Architecture.

Although Arthur Pope and his wife Phyllis Ackerman[29] arrived later than Herzfeld and Godard in Iran, their collaboration with the Iranian government was to be the longest. Among the three, Pope was the only one who was able to continue his research and publications after the abdication of Reza Shah. His influential role in politicising archaeological relics and

28 Kishwar Rizvi, 'Art History and the Nation: Arthur Upham Pope and the Discourse on "Persian Art" in the Early Twentieth Century', *Muqarnas* 24/1 (2007), 45–65.
29 The significant role of Phyllis Ackerman in their collaboration has usually been underestimated and occasionally ignored, but as this book focuses on a specific lecture and one particular book, both by Arthur Pope, I use only his name here. For more information on the significance of her role, see Grigor 2004, 39–55.

giving a national dimension to the curation of a carefully selected past is incomparably more important than that of other scholars of his time.

In his own words, Pope arrived in 'Persia' as a 'pilgrim'; fascinated by Oriental art and especially Persian rugs:

> I came to Persia as a pilgrim. I had for over twenty years been passionately fond of some of the great Persian carpets which I knew in museums and from a few Western books, but [on the] back of any achievement of such superb creations there must be people, people with minds, hearts, imagination, poetry, genuine nobility. That Persia I wanted to see, and started on a long trip from San Francisco to Isfahan, a five-weeks' journey[30].... From the first high ground beyond we looked back over the shimmering heat and opaque dust cloud, exultant to be at last on the very margin of the Promised Land. ... I was, of course, enraptured. There, beyond, lay the Persia of my dreams and I would soon be there.[31]

Pope always had an Orientalist approach towards the art and architecture of the region he used to call 'Persia,' even after the Pahlavi court had stressed the use of the term 'Iran' in an international context, as the original name of the country and being the term by which it was historically known to its people. But Pope's insistence on using the word 'Persia' in his lectures, letters and future publications are good evidence of his attitude.

Pope graduated in philosophy from Brown University in 1906 and continued his studies in the subject at Cornell University and Harvard. Meanwhile, his childhood passion for Oriental carpets grew to become a business activity.[32] Moving to Berkeley to teach philosophy, he met with Phyllis Ackermann, Assistant Fellow in the Department of Philosophy and Aesthetics, so one of his students and later his partner. Pope would write that he 'depended on her critical judgment then and throughout their long life together.'[33] Later, they would teach a course together on

30 Arthur Upham Pope, 'First approach to Persia,' in Gluck 1996, 80.
31 ibid., 82.
32 Arthur Upham Pope, 'Arthur,' ibid., 44.
33 Rexford Stead, 'Phyllis,' in Gluck 1996, 61.

Asian Ornaments, particularly of Near Eastern societies, at New York City University,[34] where Ackerman focused on iconography and interpretation while Pope focused on aesthetics and history.[35] As a result of his relationship with the Iranian government, and after relocating his Asia Institute to Iran (see page 21), Pope was also responsible for the creation of international archaeological and art exhibitions, and came to be seen as the official curatorial representative of 'Persian Art'. In parallel with his original goal, of travelling round the country to photograph its monuments and archaeological sites, this gave a certain political appeal to his future work.

On his arrival in Tehran in the spring of 1925, Pope delivered a particularly influential lecture, which brought him to the notice of Iran's elite.[36] Mohammad Ali Foroughi, the President of the SNH and the future first prime minister of the Pahlavi monarchy, was in the audience, and asked Pope to deliver the lecture again, at the Ministry of Post and Telegraph, for members of the supreme court, senior members of Majlis and the chief of the army (Sardar-e Sepah), soon to be Reza Shah Pahlavi. The lecture, which was originally titled *Honar-e Iran dar Gozashteh va Ayandeh* (The Past and Future of Persian Art),[37] is an example of an art-historical approach that favours a carefully selected past and tries to construct a future according to this; the role of the present is only as the facilitator for this process. It was translated into Farsi by the educator Isa Sadiq[38] and immediately distributed throughout the country. Sadiq later described the influence of this lecture, and how Pope succeeded in encouraging statesmen to support Iranian arts and its artistic heritage:

34 At the same time, Pope also involved himself in the controversial business of art dealing, through which he stepped into the role of establishing art galleries and exhibitions, and influencing curatorial appointments in museums.
35 Grigor 2004, 44.
36 The lecture was first delivered on 22 April 1925. See Gluck 1996, 93.
37 The speech is also published in Arthur Upham Pope, *Persian Art and Culture* (New York, 1928).
38 Isa Sadiq (1894–1978) is best known for his influential role in and contribution to the improvement of the education system in Iran in the twentieth century. Along with a number of publications, translations and academic activities, he was the minister of education for six terms, a founder and a chancellor of Tehran University, and a director of Tehran Teachers' College.

His enthusiasm and eloquence made a profound impression on the audience. His words, pronounced from the depth of his heart, went deep into our hearts. His statements about the significance of our culture and its influence upon other cultures kindled fires within us like magic. We became proud of ourselves.[39]

Pope started his lecture with 'a thunder of praise of Persia and her great past and what it meant for its destined future.'[40] He chose to highlight the nationalist dynasties in the history of Iran and their powerful sovereigns; Darius of the Achaemenid, Ardeshir of the Sassanid and Shah 'Abbas of the Safavid dynasty. After naming some 'Persian' contributors to world civilisation, he turned to Persian art, describing Persian decorative arts as 'the country's greatest asset', which 'not only has brought wealth and prestige to the nation, but it has in all ages and places made friends for the country.'[41] Pope described the Achaemenid period (550–330 BCE) as 'the first great art period in the history of Iran'.[42] He praised Achaemenid art as a 'kingly art', which would be the most suitable to represent rulers (and indeed soon after in National Architecture, the visual influence of Achaemenid art dominated that of the Sassanian at least until the end of Pahlavi monarchy). Pope saw no significant moments in Iranian art history in the period of Greek and subsequently Parthian domination; skipping over more than five hundred years; for him the next significant period in Persian art belonged to the next unifying dynasty, the Sassanian (224–651 CE), when 'a glorious revival of national life, and works of art, the natural expression of the new spirit, were produced that still are unrivalled of their kind.'[43] Through such historical selectivity, Pope managed to convince his high-ranking audience that the identity of Persia was already established in specific segments of its history and is manifest in the arts of those times. Should a new government construct a national identity, it must be associated with the already-established idea of 'Persia'.

The lecture then passed over another nine hundred years of history,

39 Isa Sadiq, 'American Pioneers in Persian art,' in Gluck 1996, 2.
40 Arthur Upham Pope, 'First approach to Persia,' ibid., 85.
41 Arthur Upham Pope, *Persian Art and Culture*, 1.
42 ibid.
43 ibid., 4.

and continued with praise for the art of the third major unifying dynasty in Persia, the Safavid (1501–1736), and the contribution it made to the Islamic world and to neighbouring civilisations. Pope concluded by criticising the condition of art in Iran since the eighteenth century, thus bridging over the present to look towards another glorified future for Persian arts. He condemned the state of Persian arts during the Qajar era, presenting this as a consequence of the lack of prudence and authority of the Qajar kings, and denounced the interest in the replication of European art that was another characteristic of Persian art during Qajar rule. For Pope, the problems he saw in Persian art of the present were to be solved by looking back to its heritage and learning from the same past he celebrated in his lecture; even though this heritage had never had the chance to be appreciated and studied in Iran before. It seemed impossible to him to resolve this situation without the patronage of the new government – a government that already had reasons for looking back to a distant past to establish itself. '... though barely, living art in Persia is still alive, and we can hope that with intelligent effort and genuine resolution on the part of those who control the life and destiny of Persia, a new epoch of Persian art may be soon inaugurated.'[44]

Pope did not directly recommend the revival of historical arts in Iran in his lecture, but he did not see any other way towards the improvement of Persian art without revisiting and re-appreciating its past. He talked about the current void in progress and called for the retrieval of past glory, something that would only be possible through the support of the government. He ended his lecture by focusing on these points, to revive the success of the arts in the past.

> If by instruction and example these wrong theories that retard the revival and development of real artistic sense can be corrected, then with the government's energetic support of practical measures the future of Persian art is secure. ... The claim of art on the attention of busy Ministers and Administrators may at first seem slight. Art always speaks with a still small voice while practical necessities thunder at the door. Yet art is a vital necessity of life for the nation as well as the

44 ibid., 23.

individual ... At least we can say that without the vision of beauty, the fullest and happiest life is not possible. May the new renaissance of Persia that is now dawning usher in again a day of great artistic achievement in which Persia will once more delight mankind and bring honor to herself. Persians should not forget that 'God has planted beauty in our midst like a flag in the city.' They who serve under that banner will win new triumphs.[45]

The past Pope was interested in was not a continuous story of Persian art, but rather artistically and politically selected episodes which favoured the 'authenticity' and historic significance of pre-Islamic Iran. For Pope and his patrons, the 'true spirit' of the modern Iranian nation had roots in its pre-Islamic history.[46] This lecture had a profound effect on Reza Khan and the rest of the audience as they grasped the cultural necessity and the political value in restoring Persian art and its ancient values. Pope considered the reformist government responsible for the revival of Persian art, and it became a powerful patron of Persian art and archaeology.

Nevertheless, to a great extent, the way Pope's speech echoed through architectural discipline of the time, and especially the way that the new government used architecture to communicate its political goals, were mostly in opposition with Pope's professional studies of the past and visions for the future. Pope did not see the art and architecture of Persia as mere representational practices. For example, in describing the 'arabesque' designs in Persian decoration, Pope focused on their non-imitative characteristic: a translation of natural forms and shapes into the language of lines and colours, with its own life and aesthetic value:

If we can get a clear grasp of some of the few fundamental principles of Persian art, it will help greatly to understand and appreciate individual works of art of all its types and periods. ... Persian art is primarily decorative rather than representative, and unless we get this clearly in mind, there is no hope of ever fully appreciating the work of her best artists. Purely pictorial or representative art aims at giving

45 ibid., 29–30.
46 Grigor 2004, 40.

an exact replica of some object. ... Decorative art, on the other hand, aims primarily to produce an ensemble of lines and colors, of shapes and textures that are in themselves charming and beautiful, and which do not necessarily represent or even closely follow any real object. ... The decorative artist is one who knows how to conceive and execute living and expressive lines, a line that is so filled with energy and spirit that we ourselves are caught up in its movement and share a little of its grace and liveliness. ... Now copying is not the same as creating. The fire has cooled, and the life fades away.[47]

But Pope's observations on Persian art as decorative were not its main point of interest for others, especially in the architectural discipline of the years to come. The pre-Islamic history of Persia became an invaluable asset for the government. The architectural elements and the visual characteristics of decorative art from the Achaemenid and Sassanian eras became the inevitable representation of a new national identity. In the case of the architecture, the direct replication of such elements was practiced extensively under the banner of National Architecture, despite the fact that this approach hardly holds true to the characteristics that Pope ascribed to 'Persian' art and architecture, since copying and replicating the past was its most significant aspect. In fact, for the most part, National Architecture not only ignored the 'decorative' characteristic of 'Persian' art as Pope intended it, but also acted as a 'representative' art, as it attempted to imitate original references as closely as possible. Considering that National Architecture was a trend that started as a political gesture rather than a disciplined development of ideas, one should not expect to be able to grasp from it the fundamental characteristics of 'Persian' art, as it tried to draw connections with it. National Architecture was formulated fundamentally to convey a socio-political message to the general public, hence it benefitted more from imitating its historical references than in trying to create new concepts out of them. The closer the new design to the original, the stronger the connection between the selected past and the present.

The kind of architectural renaissance Pope had envisioned manifested itself in the design of the monumental buildings constructed by the Society

47 Arthur Upham Pope, *Persian Art and Culture*, 14–17.

and even more clearly in the design of the new administrative buildings constructed during the early decades of Pahlavi monarchy, which were programmed to represent the official definition of national identity as well as the presence of the new state in the public space. Pope had characterised Achaemenid art as a 'kingly art' and associated a political value with it; the architectural developments and transformation of the area of Bagh-e Melli as the locus of Pahlavi power exemplify this association. From this point, the historical replication of a particular past became the new architectural language with which to express nationalism. This use – or in the German philosopher Nietzsche's view, 'abuse'– of history as a tool and reference rather than history as knowledge,[48] is made explicit when architecture becomes the ideological agent for the state and is used to further its political intentions. Consequently, those architectural projects that addressed the notion of Iranian nationality, especially in the capital, aided the establishment of a historicist understanding of collective identity in architecture for years to come.

Although Pope's lecture is never studied and critiqued today in academic circles, it greatly influenced the development of architectural discourse of the time. Soon after, in August 1925, Ernst Herzfeld gave another influential speech in August 1925[49] for the Society, confirming many of the points made by Pope.[50] Pope succeeded in influencing Reza Shah and his reformist politicians and members of the Society, as well as, later, Mohammad Reza Shah and of course his queen, Shanbanu Farah Pahlavi, the latter not only as a sovereign but also as a student and later a patron of architecture. Farah Pahlavi recalled Pope's early works, particularly *A Survey of Persian Art: from prehistoric times to the present*[51] not only as a key refer-

48 Friedrich Wilhelm Nietzsche, *The Use and Abuse of History*, 2nd edn (London, 1998), 28–30.
49 Grigor 2005, 25. For a complete text of the conference see Melli 1972, 29–44.
50 Herzfeld's focus was on the existence of a sense of continuity in the art of Iran, which is especially evident after the arrival of the Aryans in this territory in the 9th century BCE. According to Herzfeld, it is because of this sense of continuity that the artistic heritage of Iran can be considered as a national heritage. The notion of continuity would later become one of the key aspects to shape the development of National Architecture, especially from the 1960s onwards. See Melli 1972, 34.
51 Arthur Upham Pope and Phyllis Ackerman, *A Survey of Persian Art: from prehistoric times to the present* (London and New York, 1938).

ence work but also as a platform to initiate a sense of admiration among students for the history of Persian art as a valuable heritage.[52]

> My acquaintance with Arthur Upham Pope began long before we met, going back to the time when I was studying architecture in Paris. In 1959, during my summer vacation in Tehran, I had an assigned project on Persian architecture. As a part of my research, I went to the library of the Iran-e Bastan Museum [the Museum of Ancient Iran], where I inevitably came into contact with the monumental *A Survey of Persian Art*, a work which every student of Iranian art and culture is bound to encounter early in his or her academic career. The several thousand pages of this masterpiece on seven thousand years of Persian art inspired me with a sense of awe, which has endured over the years.[53]

After marrying Mohammad Reza Shah Pahlavi, Farah Pahlavi's acquaintance and collaboration with Pope began. *A Survey of Persian Art* was reprinted in sixteen volumes under her patronage, and Pope's Asia Institute was relocated from the US to Shiraz. In the following years, Farah Pahlavi and the court of Iran remained powerful patrons of the Asia Institute, and supported Pope's efforts to introduce 'Persian' art and history to the world.

Ferdowsi's Mausoleum: The Construction of a National Project

Aiming to empower a sense of national affinity and pride, and thus to use fundamental aspects for architecture to revive the glorious past, the Society for National Heritage embarked on the construction of a number of memorial mausoleums for the most prominent cultural and historical figures across Iran. The construction of a mausoleum for Abolqasem Ferdowsi, the renowned poet of the 10th and 11th centuries, whose *Shahnameh* had ensured the survival of the Persian language after the Arab conquest and played a crucial role in strengthening nationalism in Iran, was their first and the most significant project. Simultaneously, articles

52 Farah Pahlavi, 'Foreword H.I.M Farah Pahlavi,' in Gluck 1996, xi.
53 ibid.

published in *Kaveh* had a crucial role in bringing Ferdowsi and his *Shah-nameh* into the centre of the discourse on Iranian nationalism.[54] Thus the construction of the mausoleum, from 1928 to 1934, and the millennial celebration of the birth of the poet across October and November 1934, were major events in the history of modern nationalism in Iran.

The idea of constructing a mausoleum for Ferdowsi was an important project for the Society for National Heritage, and a national project in every respect. Despite many technical and economic problems,[55] it succeeded in engaging the public, strengthening a sense of nationhood, and enhancing international cultural collaborations, especially during the millennial celebrations of Ferdowsi. The government involved the nation by covering the construction of the monument and the millennial commemoration in the national press, and held public events[56] during the ceremony. More importantly, most of the funds for the construction of the mausoleum were raised by public fundraising, donations of land, and by selling lottery tickets. As intended by the Society for National Heritage, this project became a collaboration between the nation and the state as it elevated awareness of the significance of Ferdowsi and his cultural legacy. This national collaboration is stated in the memorial plaque located on the building, which reads:

As the millennial birthday of Hakim Abolqasem Ferdowsi was approaching, the state [*dowlat*] and the nation [*mellat*] of Iran decided to construct a lofty monument in the resting place of his body in order to express their gratitude for the lasting masterpiece of that great narrator [*gūyandeh*].[57]

As early as 1922, the members of the Society discussed the idea of commemorating the legacy of Ferdowsi and unofficial fundraising started early. In March 1925 the Society officially asked for help from Majlis. Soon after Reza Shah's succession, Foroughi submitted a bill to Majlis

54 Marashi 2008, 124.
55 See Bahr ol-Olumi 1976, 25–27, 34.
56 These included showing a biographical film based on the life of Ferdowsi by Abolhoseyn Sepanta. See Marashi 2008, 124 and 132.
57 For the complete text of the memorial plaque, see Bahr ol-Olumi 1976, 32.

proposing the issue of a Ferdowsi postage stamp, the revenue from which was to be used solely for the construction of the memorial mausoleum. The bill was ratified on 21 January 1926 and in May 1926 the Nationalist politician Keykhosrow Shahrokh, one of the masterminds behind the project, travelled to Tus in eastern Iran to locate Ferdowsi's burying-place. He concluded that the burial place was on land belonging to Mirza Mohammad 'Ali Razavi Qaem Maqam al-Towliyyeh, who had been the deputy trustee of Imam Reza's shrine in Mashhad in 1922–3.[58] Qaem Maqam 'gifted' (hadiyyeh dādan)[59] 23,000 square meters of land to the shah for the construction of the mausoleum, in return for nothing but seventy-five grams of sugar candy[60] to sweeten the deal and legitimise it according to the Islamic laws of transaction.[61] Additionally, the children of the prominent

58 Islamic Research Foundation, Dayerat al-Ma'aref-e Āstān-e Qods-e Razavi (The encyclopaedia of Astan-e Qods-e Razavi), (Mashhad, 2012), 511–12.
59 Isa Sadiq, Yadegar-e Omr, 2nd edn, (Tehran, 1961), vol. 203. (Also cited in Bahr ol-Olumi 1976, 30.)
60 The Ministry of Culture and Islamic Guidance (Tehran, 2001), 374.
61 The details of the gifting of the plot by Qaem Maqam Razavi are so described in all publications on the subject except for one, where it is claimed that Qaem Maqam al-Towliyyeh 'was promised an equal-sized territory from the endowment property of the religious and charitable establishment of the Imam Reza Shrine, the Astan-e Qods-e Razavi.' Therefore, 'a private citizen's estate was turned into a national park, while ulama suffered the property losses.' See Grigor 2009, 56. It seems that this conclusion is based on a misreading of several telegrams regarding the construction of Ferdowsi's mausoleum, especially the first: Qaem Maqam's message to Reza Shah on 13 July 1927, where he agreed to give a section of his property for the construction of the mausoleum (see Tehran 2001, 369–70). Here, Qaem Maqam requested Reza Shah to order the return of two loans, which following the Shah's order he had given to the charitable trust of Astan-e Qods four years before, when he was deputy trustee of the institution, and Reza Shah was still the prime minister. Being a wealthy man and a devoted descendant of Imam Reza, Qaem Maqam helped Astan-e Qods continuously from 1895, when Nasser al-Din Shah Qajar appointed him as the financial secretary of the institution. See: Mohammad Ehtesham Kavianian, Shams al-Shomus ya Tarikh-e Astan Qods-e Razavi (The Sun of Suns or the History of Astan-e Qods-e Razavi) (Mashhad, 1976), 88–9, 160. See also see: Mirza Mohammad Baqer al-Razavi, Shajareh-ye Tayebeh dar Ansab-e Selseleh-ye Sadat-e Razavi (The pure family tree of the righteous descendants of Sadat Razavi), (Mashhad, 2005), 223–8. The loan mentioned in the telegram refers to Astan-e Qods's debt to its tenants and the salary of its employees for one year, all of which Qaem Maqam had paid. See Ehtesham Kavianian, op. cit., 102–03. The documented

بنام خداوند بخشاینده مهربان

هر آنکس که از مردگان دل نشست نباشد همان دوستی را درست

مده کار کردنیا کان یاد مبادا که پند من آیدت یاد

چونکی کند کس تو پاداش کن همان تا شود نیک نیکان کمن

در سالی که هزارمین سال ولادت حکیم ابوالقاسم فردوسی طوسی نزدیک میشد دولت و ملت ایران برآن شدند که پاس شاهکار جاودانی آن گوینده بزرگ بنای فردوسی بر آرامگاه پیکر خاکی او برپا بماند از آن میان چند تن از قدمتگذاران ایران بر این کار فرخنده مقدم گشتند و بنام حفظ آثار ملی انجمنی گرد آوردند و از پیچیده نه کوشش در راه انجام مقصود مبارک فرو گذار نکردند چنانکه بسیار از ایرانیان بلند همت بلکه سراسر باشندگان این کشور از کمک وثروت خود در این کار فرخنده یاری نمودند وزارت معارف که دو در حد توان خویش از مساعدت دریغ نمود تا آنگه این بنای رفیع و بلند به نظر خور افتاد گشایش یافت کنون پس از آن بی نهایت ترنام عضای انجمن در این تاریخ او ثبت میشود حسن مستوفی مستوفی الممالک

حسن پیرنیا مشیر الدوله محمد علی فروغی ذکاء الملک حسن اسفندیاری حاج محتشم السلطنه عبدالحسین تیمور تاش سردار معظم ابراهیم حکیمی حکیم الملک فروغ نظام میرزا نصرت الدوله نظام الدین حکمشاه الدوله سید نصر محمد علی فرخ علی اصغر حکمت حسین علاء امین امیر زنجانی کی حیدروخ شایخ

land owner and merchant Malek al-Tojjar 'gifted'[62] another 7,000 square meters from a neighbouring property.

On 21 July 1927 a second bill was ratified, allocating 20,000 tomans from the yearly government budget towards the construction of the monument, which began in 1928, with a fund of 60,000 tomans, under the supervision of Keykhosrow Shahrokh. The funds were of course not enough, and total costs had doubled at least by the time of the commemoration ceremony in 1934. According to Isa Sadiq, a member of SNH who recorded the process of fundraising and construction, the government donated another 10,000 tomans, and the rest of the funds were collected by selling lottery tickets, which generated 160,000 tomans. A total of 70,000 tomans from these funds was also spent on the project, while the rest was paid back to the public as lottery prizes.[63] In addition, in her *Building Iran*, Talinn Grigor mentions the existence of three further governmental loans,

correspondence between Qaem Maqam and the court show that the two issues were not related and were pursued separately. The correspondence also negates the claim of the ransacking of the plot by the Ministry of War, a claim based on a message from the commander of the west corps, Aman-ollah Jahanbani, to the shah on 22 December 1927. All the telegraphs from July up to this point show that both sides had happily agreed on the transaction and the minister of court expressed the court's extreme happiness at the situation (*nahāyat-e maserrat*) and thanked Qaem Maqam (*emtenān*). See The Ministry of Culture and Islamic Guidance (Tehran, 2001), 370–71. The last telegram from Qaem Maqam, which reads like a memo for the transmission of deeds in Iran, locates the plot and establishes the transaction of 75 grams of sugar candy (yek sir nabāt) to ratify the agreement according to Islamic laws of trade (ibid., 373–4). Also, considering Qaem Maqam's former position as the deputy trustee of Astan-e Qods and as a member of Sadat-e Razavi (descendants of Imam Reza), who had made numerous endowments and given loans to Astan-e Qods, it seems out of character to commit the illegal and haram act of including a third party's possessions in this deal. Later documents show Qaem Maqam never received any money from Astan-e Qods in return for his loans. See Mahdi Velayi, 'Sharh-e Hal-e Navab Towliyat 'Ozmaye Astan-e Qods' (The biography of the great deputy trustees of Astan-e Qods), Nameh-ye Astan-e Qods, 20 (March 1965), 102. See also Abolfazl Hassanabadi, Sadat-e Razavi dar Mashhad az aghaz ta payan-e Qajariyyeh (Sadat Razavi in Mashhad from the beginning until the end of Qajar era), (Mashhad, 2008), 135.

62 Isa Sadiq, op. cit., vol. 2, 203.
63 Bahr ol-Olumi 1976, 27–9.

which were kept a secret in order to emphasise the role of the public in making the project possible.[64]

Apart from financial issues, there were difficulties with regards to the exact location of the original tomb, due to contradictory information and a lack of primary sources.[65] Even Herzfeld, on his mission to produce the 'Brief inventory', had not been able to specify an exact location for the tomb.[66] The same sort of compromise over details is evident in dating Ferdowsi's birth for the sake of his millennial celebrations. Foroughi would describe this issue in his speech 'About Ferdowsi'.[67] Given on the 21 January 1934 at the Daneshsara-ye 'Ali (Teachers' Training Centre), he explained the problem of the lack of accurate historical information about Ferdowsi while maintaining that the *Shahnameh* reveals a great deal of information about the poet and his work. Regarding the date of the millennial celebration, Foroughi honestly admitted to the compromise made in specifying an exact birth date, on the grounds that this was balanced by the gain of celebrating the character and work of Ferdowsi.[68] Since the period of planning the memorial had brought the SNH close to the millennial for the accepted date of Ferdowsi's birth, Foroughi and the SNH decided to act according to international tradition, and organise a millennial celebration for the poet.[69] Foroughi also spoke about the indispensable role of

64 Grigor 2009, 61, 79.

65 ibid., 49–56.

66 ibid., 54. It is also curious that in Herzfeld's 'Fehrest-e Mokhtasari… (The Brief Inventory…,)', the list of edifices in Khorasan includes 'the location of the tomb of Ferdowsi' but omits the shrine of Imam Reza Shrine in Mashhad. Herzfeld only mentions 'the library and the treasury of Imam Reza, which hold exquisite examples of historic relics'. See Herzfeld, op. cit., 17.

67 Mohammad Ali Foroughi, 'Darbare-ye Ferdowsi' (About Ferdowsi) in Melli 1972, 181–207. In this publication, the lecture is dated as Sunday 1 Bahman 1313 SH, however in the later reprint of the lecture in *Majmu'eh Maqalat-e Mohammad Ali Foroughi*, known as Zoka al-Molk (The intelligence of the country), (Tehran, 2005), 309, 401, the date of the lecture is Sunday 1 Bahman 1312. Considering that the speech was given on a Sunday, it seems 1312 SH (or 1934) would be the correct year.

68 Comparing a memorial celebration with religious practices, Foroughi maintains that the main idea was to celebrate and appreciate Ferdowsi. See Mohammad Ali Foroughi, in Anjoman Asar-e Melli 1972, 181–207.

69 ibid., 207.

Ferdowsi in the cultural unification of the nation, indirectly reminding the audience of the reasons for the particular form of the mausoleum.

> In my opinion Ferdowsi is at the level of the most significant historical characters such as Cyrus, Darius, Ardeshir Babakan, and Zoroaster, and their counterparts. Why? You would say that Cyrus established the Iranian monarchy [*sāltanat*], Darius had formulated the politics of Iran, Ardeshir Babakan had revived the Iranian state, Zoroaster had established the ideology [*'aqīdeh*] and religion of Iran, of course all these are great men, [but] what has Ferdowsi done and why should he be considered at the level of these great characters? In a way Ferdowsi has revived the nation of Iran. ... the people who all have one memory [*yādegār*] of the past are one nation. ...the biggest element for establishing unity for a nation is their shared past history and their past glories. ... Ferdowsi has versified the book, and in fact has killed two birds with one stone, in that he has revived both the Persian language as well as the history of Iran. Had not Ferdowsi done this, we would not have a history of Iran today.[70]

Foroughi associated each necessary element for the creation of a nation-state with one of the historical figures he mentioned. Ferdowsi is the only one who represents the whole nation, since his work aimed to unify it from within, by constructing a shared memory of the past, and not through a political process.[71] This justified the construction of a Mausoleum[72] to celebrate his contribution. Also, as Isa Sadiq mentions in his memoir, this reasoning supported a similar argument that the shape of the monument should resemble the tomb of Cyrus the Great.[73]

However, this celebration of Ferdowsi was not limited to the building of

70 ibid., 197–9.
71 Foroughi also mentions how the form of the poem was essential for its survival, while assuming other forms of the history of Iran have been less publicly acknowledged and so eventually disappeared. ibid. 199–200.
72 In Neishabur, a small memorial stele was built near the tomb of Khayyam almost simultaneously, but never received the same attention as the tomb of Ferdowsi, nor did it remain as a part of the actual memorial to Khayyam. See Grigor 2009, 145–62.
73 Bahr ol-Olumi 1976, 30.

a mausoleum. On 4 October 1934, at the beginning of the Ferdowsi Congress in Tehran (part of the millennial celebrations), Foroughi introduced Ferdowsi in a new light. In his opening speech, he characterised the poet not only as a founder of the Iranian nation, but also as 'one of the fathers of humanity',[74] and therefore his commemoration was an international duty. Celebrating the character of Ferdowsi was an endeavour both on national and international levels. It helped to establish him as a key figure in the formulation of Iranian national identity and highlighted the contribution of Iran to global civilisation – which, in retrospect, secured international recognition of Iranian national identity.[75] In one way, 'in order for the Iranian national identity to be affirmed, the state felt the need to be recognised within the world system', and this need was expressed in these millennial celebrations.[76]

The details about the monument itself are sparse, and sometimes contradictory. The first design submitted to SNH in 1927 was a sketch by Herzfeld which was never realised, without any clear explanation why. This design represented a simplified version of a Persepolitan palace; a cubic room with a doorway inspired by the shape of the entrance in the palace of Tachara, and a small iwan (porch) decorated with two columns with symmetrical bull protomes in front of it. The sketch depicts the building located in a lush garden on the border of two pieces of land separated by a wall, where it seems to be working as the gateway from one property to the other.[77] There is another edifice which looks like a tomb tower in the background.[78] Comparing Herzfeld's design with Karim Taherzadeh

74 Kongereh-ye Hezareh-ye Ferdowsi, Hezareh-ye Ferdowsi: Shamel-e Sokhanranihayi az Jam'i az Fozala-ye Iran va Mostashreqin-e Donya dar Kongereh-ye Hezareh-ye Ferdowsi (Millennial celebration of Ferdowsi: including the speeches of some of the Iranian intellectuals and international orientalists in the millennial celebration of Ferdowsi), (Tehran, 1934), 39.
75 Marashi 2008, 129.
76 ibid., 129–130.
77 This could be a depiction of the two pieces of land donated for the project.
78 It is difficult to see how this tomb tower resembles Haruniyyeh, a fourteenth-century building located near the tomb of Ferdowsi. Haruniyyeh has a pointed dome, while the building depicted by Herzfeld in the background to his sketch seems to have a conical dome with a much taller base. Nevertheless, it seems strange for someone at Herzfeld's level to have designed such an irrelevant and disconnected

Behzad's first proposal suggests that Herzfeld's idea did not seem ostentatious enough for the celebration of such an influential character, while the correspondence between a Persepolitan palace and a monumental tomb for a poet seems rather unconvincing.

The final mausoleum was only realised between 1928 and 1934 after many twists and turns and several rounds of demolition and reconstruction. The SNH turned down Herzfeld's proposal and held a design competition between Herzfeld, Karim Taherzadeh Behzad (brother of the artist Huseyn Taherzadeh Behzad) and André Godard, who in 1928 had become the director of the Department of Antiquities at the Museum of Ancient Iran.[79] They selected Taherzadeh Behzad's design and announced the result in the *Ettela'at* newspaper on 26 August 1928.[80] However, Behzad's initial design predated Herzfeld's by at least two years. As a result of his close relationship with the inner circles of SNH, his design had first been published in *Iranshahr* magazine on 23 August 1925,[81] six months after the Society's petition to Majlis and four months before Majlis agreed to raise funds for the mausoleum. In his unpublished memoir, Taherzadeh mentioned the Society's reasons for holding a competition and how his successful final proposal was an altered version of his 1925 design.[82]

Taherzadeh proposed a grand building on three levels, surrounded by a vast garden. The first level was an octagonal platform two meters high, the second level was located in the centre of the platform and housed the old tomb, and the third was to be a monumental dome raised on Achaemenid-style columns and with a sculpture of Ferdowsi placed in its centre.[83] The process of construction began in September 1928 but soon stopped, as the quality of execution did not satisfy SNH, nor Hassan Taqizadeh, who was

combination of Achaemenid and medieval architecture in one complex. There are examples of buildings designed during the 1930s that resemble a combination of pre-Islamic and Islamic architecture in their facades, such as the Post Office built in 1928–1933 in Bagh-e Melli by Nikolai Markov, but these buildings display a much subtler and a more harmonious composition of elements.

79 Grigor 2009, 57.
80 *Ettela'at*, 26 August 1928, 2.
81 'Qabr-e Ferdowsi', *Iranshahr*, 3/10, (1925), 608–613.
82 Karim Taherzadeh Behzad, *Nehzat-e Honari-e Zaman-e Reza Shah Pahlavi*. This unpublished memoir of Taherzadeh Behzad is cited in Shafei 2005, 52–55.
83 ibid., 55.

202: Karim Taherzadeh Behzad, early sketch for the Mausoleum
of Ferdowsi as published in *Iranshahr* in 1925.

the governor of Khorasan, where Tus is located, at the time. Taherzadeh
was dismissed and replaced by André Godard, whose proposal was com-
missioned for construction.[84]

Godard's design was a completely different take on the monument. Its
pyramidal shape represented no Achaemenid references. It did not satisfy
the members of SNH, but it had the support of the court minister, 'Abd
ol-Hossein Teymourtash, once he had made some amendments to it.[85]
Once again, *Ettela'at* announced the acceptance of the new design, by
'the French architect,' on 1 May 1929. Meanwhile, Ferdowsi's sculpture
remained from the previous design, and was to be incorporated into the
new.[86] *Ettela'at* reported on progress on several occasions.[87] Construction
continued until a few months up to the celebration when Keykhosrow
Shahrokh, who was supervising progress for the government, was noti-
fied about problems in the roof of the pyramid and used this as a reason to

84 Shahrokh 1994, 76.
85 ibid., 77.
86 See Shafei 2015, 167; also Mofid 2005, 31.
87 The newspaper articles are cited in Shafei 2015, 167, 170, 173.

stop construction.[88] In 1932 Shahrokh asked Taherzadeh for a new and the final design for the tomb, and delivered the drawings to the Society.[89] This final design resembled the tomb of Cyrus the Great, with more elaborated Achaemenid decorations from Persepolis. Whether created by Taherzadeh, or as instructed by the Society, or even the work of a different architect altogether,[90] it came closest to the Society's understanding of the character of Ferdowsi, and resonates with Foroughi's lecture and the future report of the Society on the project. With this design, the tomb of the king who 'established the Iranian monarchy' and state, inspired the tomb of the poet who established the Iranian nation, through the construction of a shared narrative of origin; the two tombs could visually bridge over a vast historical gap and secure the two historical narratives in collective memory.

Now they had acceptable plans in hand, SNH faced a lack of funds. The idea of selling lottery tickets seemed to be the only way to raise money while engaging the public with the project. The selling of tickets was advertised in the papers in January 1933, at which time the members of the Society, especially Foroughi, started to promote the role of Ferdowsi in the construction of the Iranian nation, through actions such as his lecture at the teachers' training centre.[91] With certainty about the form of the monument, the ticket depicted the image of the building and the famous verses from Ferdowsi that later appeared on the marble plaque on the main façade of the building. Without consulting Taherzadeh, the Society employed Hossein Lorzadeh, a traditional master builder who was also involved in the construction of Marmar Palace in Tehran, as the contractor for the project, and the mausoleum was eventually finished just days before the millennial celebration.[92] In the opening ceremony, the Society's represent-

88 Shahrokh 1994, 79.
89 Shafei 2005, 60–61.
90 See Grigor 2009, 61–63.
91 See Bahr ol-Oloumi 1976, 27–28; also Shafei 2015, 172.
92 In an interview, Lorzadeh mentioned that he was appointed to demolish Godard's pyramidical building and the construction of the building 'in Achaemenid style' in 1311 SH (1932–1933); later he mentions that he has been working on the project for eighteen months. As the opening celebration was in September 1934, Lorzadeh must have started his contract in March-April 1933. In this text, he never mentions the name of Taherzadeh, but acknowledges that the order for constructing in the Achaemenid style had come from Shahrokh and few other statesmen who visited

203: Reza Shah Pahlavi giving his speech during the inaugural
ceremony at the newly constructed Mausoleum of Ferdowsi, 1934.

ative mentioned only the name of Lorzadeh as the Iranian constructor of
the project, Hossein Lorestani as the stonemason, and Taqi Dorudian as
the financial manager.[93]

On 13 October 1934, the apricot garden of Qaem Maqam al-Toliyyeh in
the outskirts of Mashhad was made ready to host the shah, with members
of the Society for National Heritage and their guests from across the globe.
Located in the centre of the garden was the elevated cubic design of the
mausoleum, adorned with inscriptions from *Shahnameh*, as well as Achae-
menid pilasters. Facing the audience, the shah gave his speech standing on

him on the site. He also mentions the disappointment of Foroughi in particular about
the pyramidical shape of the building. On the other hand, on 10 May 1933, *Ettela'at*
reported on the progress of the building according to 'M. Godard's' plans for the
building, and the arrival of stonemasons to make the sculptures of the great kings of
Iranian history. Taherzadeh mentioned on 1 June 1932 that he was asked by
Shahrokh to propose a new design, which was later constructed by Lorzadeh. See
Mofid 2005, 31–33; and Shafei 2015, 166–171.
93 Bahr ol-Oloumi 1976, 33.

the platform of the monument, seeming to suggest that all the agreeable myths of the past were embodied in this building and supporting him. He highlighted the necessity for the commemoration of such an historical figure as Ferdowsi, and while acknowledging that Ferdowsi had never been forgotten by the public, he mentioned that 'it was necessary to take some action and create an adorned structure that could visually show the gratitude of this nation'.[94] The shah then inaugurated the building now known as Ferdowsiyyeh, and entered the tomb chamber as a 'pilgrim', thus establishing the tradition of visiting Ferdowsiyyeh and other mausoleums that the Society would later build for other prominent historical figures.[95]

In terms of architecture, the Ferdowsiyyeh was a turning point. The Society started to employ architecture for cultural programmes and ultimately for the national unification in Iran. Architecture naturally became a means to realise these projects, but politicians and the shah himself acknowledged its role as a powerful reminder and narrator of the past. The construction of the monument made two points clear: first, that monumental interventions in the built environment were a practical means to publicly convey ideological and national messages. More importantly, these buildings could relocate the locus of attention from existing public centres, even if their sites were geographically peripheral. Secondly, since the national narrative of the Pahlavi monarchy was mainly based on the two elements of myth and history represented by *Shahnameh* and pre-Islamic history, especially of the Achaemenid era, the former must coordinate with the latter and therefore, Achaemenid architecture inspired the design of Ferdowsi's mausoleum.

94 *Ettela'at*, 13 October 1934; (English translation is cited in: Marashi 2008, 130.)
95 The term *ziyārat* was first used by Isa Sadiq for Reza Shah's entrance to the tomb. Grigor gives a comprehensive account on the use of the term and the establishment of the practice of pilgrimage (*ziyārat*) for the mausoleums built by the Society for National Heritage, inspired by the Shi'ite tradition. See Grigor 2009, 71.

204: The Mausoleum of Ferdowsi as it appears today.

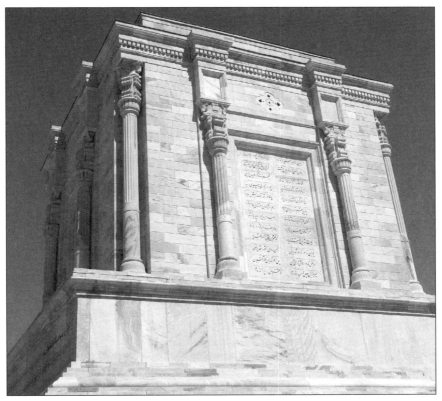

205: Decorative details on the Mausoleum of Ferdowsi: Achaemenid capitals.

Developments in History and Archaeology: Towards the Formation of a 'Representative' Architecture

The period of the construction of Ferdowsi's mausoleum was not only a time of trial and error for the architectural representation of national identity; it was also a period of historical and archaeological developments that ultimately supported the historicist approach to this issue. The transition from myths to history, while creating a fruitful balance to support nationalism in Iran, had been in the process of development since the nineteenth century,[96] and the beginning of the Pahlavi era could be considered as the start of a new era in Iranian historiography, as history became a more academic and scientific field. Previous attempts to write histories of Iran had been mainly limited to chronicles, biographies and local histories,[97] but the majority of historical translations during the early Pahlavi period 'were influential in the emergence of a historical consciousness attuned to the rising Iranian nationalism'.[98] The first attempts to write histories of Iran by Iranian intellectuals in this period followed the same form.

The study of modern Iranian historiography is impossible without considering Hassan Pirnia (Moshir al-Dowleh) as one of its protagonists. He was one of the most influential modern historians in Iran during the 1920s, a successful politician in both the Qajar and Pahlavi courts and a member of the Society for National Heritage. In the mid-1920s he launched a project to write the history of the country, using a comparative method that allowed him to follow more evidence-based references and not limit himself to the explanation of legends and myths.[99] His main goal was to produce an official narrative of national history, and one of his early works, *Iran-e Qadim* (The old Iran, 1929), was used as a school text.[100]

Pirnia's *Tarikh-e Iran-e Bastan* (The history of ancient Iran,1931–3) did not cover the complete history of Iran, yet it remained the main Iranian

96 See Ali Ansari, 'Myth, History, and the Narrative Displacement in Iranian Historiography', in Ali M. Ansari, ed., *Perceptions of Iran: History, Myth and Nationalism from Medieval Persia to the Islamic Republic* (New York, 2014), 5–24.
97 Iranica: 'Historiography,' XII/3, pp. 323–411, accessed online 24 July 2013.
98 'Abbas Amanat, 'The Study of History in Post-Revolutionary Iran: Nostalgia, Illusion, or Historical Awareness?', *Iranian Studies* 22/4 (1989), 3–18.
99 Iranica: Abbas Amanat, 'Historiography ix. Pahlavi Period (1)'.
100 ibid.

publication on the subject. It has been said that 'It aimed at an extensive and systematic treatment of Iran's pre-Islamic past based on all available sources.'[101] Pirnia was determined to produce a history of Iran based on scientific evidence that would support the nationalist narrative. Although the project was not completed, his work remains one of the most important examples of the use of historiography during the early Pahlavi period. The main characteristic of historical studies during this period is that their primary objective was to document Iran's national identity.[102] It is also worth noting that while 'the most visible change in the nationalist historiography under Reza Shah was [an] emphasis on the pre-Islamic, and particularly the Achaemenid, past'[103] and despite the popularity of the subject of Aryan racial superiority at the time in Europe and its echoes in the Iranian context, Pirnia never highlighted this matter in his works.

Focusing on the history of Iran from the Median civilisation (727–549 BCE) until the end of the Sassanian Empire, Pirnia based the division of Iranian history in the three volumes of his book on significant political events. He divided the history of Iran into four periods: the eighth century BCE to the seventh century CE; the rise of Islam until the collapse of the Timurid empire (in itself divided into pre- and post-Mongol eras); from the Safavid dynasty to the Constitutional Revolution; and finally, the Pahlavi Era.[104] This political periodisation is one of the main characteristics of his work, and influenced the work of other historians and art historians, including Arthur Pope in his *Persian Architecture*.[105] Pirnia's seminal work also reviews artistic and architectural developments in pre-Islamic Iran. His review of these fields contains a great appreciation of Achaemenid and Sassanian works while being condescending toward the period between

101 ibid.
102 ibid.
103 ibid.
104 Hasan Pirnia, *Tarikh-e Irān-e Bāstān: Ya Tarikh-e Mofasal-e Iran-e Qadim* (The history of ancient Iran: or the detailed history of old Iran) 6th edn, (Tehran, 1996), vol. 1, 163–7. Also see: Iranica: Abbas Amanat, 'Historiography ix. Pahlavi Period (1)'.
105 Although he mainly focuses on Islamic periods, Pope's historical narrative is divided by dynasty instead of the continuation of an artistic style.

them, when Iran was under the control of Seleucid and Parthian rulers. In this regard, he wrote:

> After the arrival of Alexander to the East until the arrival of [the] Sassanian, a void is evident in the history of architecture and stonemasonry in the East. Except for a few edifices, this period of five and a half centuries is almost empty of masterpieces of architecture or stonemasonry.[106]

As the main representative elements of nationalism in architecture, knowledge of the characteristics of Achaemenid and Sassanian architecture was being pursued at the same time by several archaeological teams, all of whom were collaborating with SNH. Among them, Herzfeld, Godard, and Pope were the most influential in transferring archaeological knowledge to the field of architecture. Their future publications continued the thread of thought initiated in the mid-1920s, and their works popularised this thinking within architectural circles in Iran more than either their first lectures or their direct collaborations with the government and the Society. In one of his early publications, *An Introduction to Persian Art Since the Seventh Century AD* (1930),[107] Pope mentioned the establishment of research institutes and an increasing interest in Persian art. Calling the time 'an age of discovery' and echoing Durand's encouragement to study art and architecture globally, he mentioned how recent discoveries in Asian and Persian art had broadened Western understanding.[108] Pope saw monumental characteristics in Persian art and architecture, and followed the common political periodisation for Persian art history, beginning with the reign of Cyrus the Great.[109]

As before, Pope emphasised the 'decorative rather than representative' aspect of Persian art and how 'It seeks its effects, not in the gratuitous reduplication of natural objects, but in the creation of significant entities composed out of various elements ... lines, contours, shapes, masses,

106 Hasan Pirnia, op. cit., vol. 3, 2699.
107 Pope 1930.
108 ibid., 1.
109 ibid., 5.

colors, movements'.[110] The section on 'Architecture and Architectural Ornament' echoes the Beaux-Arts tradition of architectural analysis that Durand had introduced as a guide for design.[111] Pope compartmentalised different segments of architecture into 'elements' and 'parts', including porches, vaults, walls and roofs, where he focused on dome structures and credited Persians with the construction of the dome structure on a square base known as *chāhār tāq* (four arches).[112] He then introduced some architectural types such as the mosque, madrasa, tomb towers, caravanserai and bazaars. He also highlighted both the decorative and instrumental role of columns from the Achaemenid era up to the Safavid era.[113]

Pope's approach to Persian art remains that of an Orientalist, calling 'Persia' 'them' and the West 'us'.[114] He was fascinated by forms and colours as the subtitle of his 1965 book, *Persian Architecture: The Triumph of Form and Color*[115] suggests, and searched for architectural fragments that could be represented and treated as objects of exhibition. His main goal in travelling all over Iran was to photograph archaeological sites for international exhibitions, and the illustrations in his book demonstrate how his vision and understanding of Persian architecture was focused on the study of fragments and separate architectural elements, rather than seeing buildings as a whole and in their context. Most of these photographs show either a decorative element, an ornamental pattern or a fragment of a building. There are very few photographs recording a complete building, or a special artistic quality or technical detail.

Whether to appeal to the political intentions of the time or not, Pope

110 To Pope, principles such as 'order in variety' and 'multiplicity in unity' are what make Persian art so powerful. ibid., 2.

111 In *Précis des Leçons d'Architecture*, Durand introduced one of the earliest formulations of the concepts of composition and type, giving a syntactical framework for design which is the product of a composition of architectural parts. These parts include: porches, vestibules, staircases, rooms and courtyards, and are in themselves a combination of elements: foundations, walls, floors, vaults, roofs, and detached supports. This last includes columns and plinths and refers to the Classical Orders of architecture.

112 Pope 1930, 28.

113 ibid., 47.

114 ibid., 33.

115 Pope 1965.

detects formal and visual 're-appearances' in the history of Persian archi-
tecture while acknowledging change and development. To him, despite the
frequent socio-political changes in Iranian history, these re-appearances
create a sense of continuity that is characteristic of Persian architecture.[116]
For example, he constantly suggests the revival of a past event or an his-
toric architectural object, even as the kind of recurrence he is interested
in is the return of architectural forms and fragments and not historical
edifices. His approach is very close to the eighteenth-century French clas-
sification of architectural types – as Pope found his examples in a ruined
state, this encouraged his study of them as fragments, suitable for future
re-composition. He later named several architectural fragments includ-
ing 'columns with bracket capitals' and 'the dome on four arches [*chāhār
tāq*],'[117] and traced their development and 're-occurrence' and transforma-
tion in history.[118]

However, the emphasis on re-occurring visual elements shows a depar-
ture from the definition of 'decorative art' with which Pope had associ-
ated Persian art in his famous lecture. Once the reappearance of elements
becomes the main characteristic of architecture, the need to create a devel-
oped version of the original is diminished to a great extent. The revival of
historic forms becomes central to the practice, to reinforce a sense of con-
tinuity. On the other hand, suggesting the historical revival of archetypes,
as Pope had done in his lecture in 1925, contradicts the twentieth-century
basis of modernity or modernist architecture. Considering the notion of
continuity as the primary characteristic of the most celebrated architectural
practice legitimises a return to the past, and resonates with Pope's call in
his lecture to revive the glorious state of Persian art in the modern era.
Henceforth, architectural elements mentioned as representative of Persian
architecture were to be incorporated in the design of new buildings.

116 ibid., 10.
117 ibid.
118 Although Pope's *Persian Architecture* of 1965 was published much later than
the period discussed here, some points in the book are developed and clarified
versions of the ideas Pope introduced in his lecture in 1925 and in his earlier
publication, *An Introduction to Persian Art*. The importance of *Persian Architecture*
in the discussion in this chapter is its focus on architecture rather than on the arts in
general.

A similar case is evident in André Godard's publication, Athār-é Īrān: Annales du Service Archéologique de l'Īrān.[119] As the director of Antiquities, he also formulated policies for archaeological excavations, and the preservation and restoration of Iranian antiquities. He published the eight volumes of his *Annales* in collaboration with his wife, Yedda Godard, in French between 1936 and 1949 while conducting archaeological excavations. The main focus of their studies was on architectural examples. Regardless of chronologies and historical periods, in each report, he focused on either one building type or a specific case. For example, volume four of the series, which is focused on the fire temples of Iran, examines the re-occurrence of the *chāhār tāq* in sites he had visited, including contemporary examples in Tehran. Here again, following the Beaux-Arts tradition, Godard surveyed the plans of these edifices and represented them as types, which could be used in future architectural compositions. The collection of these types also shows a juxtaposition of architectural cases, decorative arts, and objects.

Directly supported by the government, Godard's Athār-é Īrān became an informative source and an intersection between archaeology and architecture. Nevertheless, his greatest influence on the development of an historicist understanding of architecture was through his executive duties and involvement with architectural practice and education. The early works of Herzfeld and Pope in the form of lectures and publications had already made clear the value of historical heritage to the politics of nationalism and created a demand for the formulation of a national architectural language. This architectural language was later systematised through the academic contributions of Godard.[120]

Like Pope, in his *The Art of Iran* (1965)[121] Godard arranged his material in chronological order. The art of pre-Islamic Iran takes four out of the total five chapters of the book while the entire Islamic period is condensed into the last one. Throughout the book, he focused on the monumental

119 The book was first published as: André Godard, Yedda Godard, and Maxime Siroux, *Athār-é Īrān: Annales du Service Archéologique de l'Īrān* (Paris, 1936).
120 These aspects of Godard's contribution are discussed in Chapter Three.
121 André Godard, *The Art of Iran*, ed. Michael Rogers, and trans. Michael Heron, (London, 1965).

and therefore figurative aspects of architecture, to the extent that he even named the sections discussing architectural cases as 'monuments'.[122]

Unlike Godard and Pope, after the design of Ferdowsi's mausoleum Herzfeld did not engage himself further with architecture; never publishing anything focused on the discipline as Pope did, nor involving himself with architectural design and education like Godard. His research contributed greatly to the historical understanding of architecture in Iran; but he maintained the image of a professional archaeologist, and his writings on the history of Iran are based on archaeological evidence; especially his *Archaeological History of Iran* (1935).[123]

As the first archaeologist employed by SNH to excavate Achaemenid sites in Susa and Persepolis, Herzfeld had a great impact on the visualisation of Achaemenid architecture. He became the director of archaeological researches at Persepolis in 1923 and remained in the post until 1934, under various different sponsorships. The excavations at Persepolis were the most important archaeological task of the Department of Antiquities, and Reza Shah made several visits to the site, following the progress of excavations in person.[124]

In 1934 Herzfeld was replaced by his assistant Friedrich Krefter, and moved to London, where he started publishing his work. Krefter was a German architect who had joined the excavation group at Persepolis in 1928.[125] In the same year, he produced some of the most reliable drawings of Persepolis, visualising different buildings and architectural elements in the form of reconstructions, which in comparison with previous reconstruction made during the nineteenth century, show clear similarities to the design of the first examples of National Architecture in Tehran, such as the first building of the National Bank (Bank-e Melli). Krefter's drawings were

122 Ibid., 179.
123 Ernst E. Herzfeld, *Archaeological History of Iran* (London, 1935). This small book focuses on the pre-Islamic history of Iran in three chapters. It provides a great deal of information on Persian architecture, especially in the Sassanian era, yet is very little known in the field of Architecture.
124 For a detailed review of the archaeological excavations in Persepolis see Mousavi, op. cit.
125 Iranica: Hubertus von Gall, 'Herzfeld, Ernst iii. Herzfeld and Persepolis,' XII/3, 296–298; accessed online 15 June 2013.

first published in Herzfeld's *Iran in the Ancient East* in 1941, which proves they must have been produced during their collaboration. They represent a significant step forward from basic archaeological studies of Persepolis towards the depiction of its architectural qualities. Most of Herzfeld's earlier drawings of Persepolis were limited to the current state of the ruins, but at this point and perhaps with the architectural vision of Krefter, the pair attempted to imagine the palaces in a complete reconstruction. They produced drawings of the facades, indications of the spatial organisation of the palaces, and detailed drawings of the famous Persepolitan columns. Herzfeld had specifically identified the design of the columns as the most significant visual characteristic of Persepolitan and of Achaemenid architecture:

> The main characteristic of Persepolitan architecture is its columns.
> …The bases were always, [and] the capitals [were] normally of
> stone, even on wooden shafts, but the existence of wooden capitals is
> probable. …The artistic shape of the imposed-blocks of [the site of]
> Pasargadae is always a pair of animal protomes, either of fantastic
> animals resembling a lion, but with a crest and not quite the fantastic
> animal of Persepolis, or protomes of horses.[126]

From this point on, these drawings were used in the design of new administrative buildings and treated as an Iranian version of the Classical Orders for Western neoclassicism.[127] In the neoclassical approach, the architectural orders had a central role in introducing the social and customary aspects of design. As described earlier, through Durand's theories, this approach was not limited to the Greco-Roman orders. It allowed for the formulation and use of a wide variety of orders based on the antique

126 Ernst E. Herzfeld, *Iran in the Ancient East: archaeological studies presented in the Lowell Lectures at Boston* (London, 1941), 239.

127 Focusing on the decoration and proportions of columns, entablatures, and pedestals, the Classical Orders help us recognise certain architectural styles. They were initially formulated for Greek and Roman architecture and include the Doric, the Ionic, and the Corinthian orders, and greatly influenced eighteenth-century neoclassicism. For the study of the Classical Orders see Giacomo Barozzi da Vignola, *Canon of the Five Orders of Architecture*, trans. John Leeke (London 2012).

206: Drawing by Friedrich Krefter, 'Tripylon (Council Hall),
Apadana and Great Staircase: Isometric Plan', 1935.

207: Drawing by Friedrich Krefter, 'Reconstruction of the Gate of
All Lands and the Great Stairway to the Terrace Complex', 1934.

208: Drawing by Friedrich Krefter, 'Apadana: Four orders of columns', 1935.

architecture of other regions. In fact, the 'fruitfulness of Durand's methods lies partly in this potential for wider application, which was to resurface at the École des Beaux Arts',[128] and its influence remained until the early twentieth century. Once Persepolitan columns were surveyed and drafted, they were standardised and entered the inventory of architectural elements. They first became the signifiers of their original era, and were then added to the facades of the new government buildings as representative of Iranian national identity.

This is not to ignore the architectural examples constructed before the publication of these drawing and decorated with Persepolitan columns, such as Ferdowsi's mausoleum, the renovated northern façade of the Majlis building and the Adrian fire temple in Tehran. No matter how scattered, these cases show a degree of awareness and application of the Beaux-Arts tradition amongst architects, as well as an ideological inclination. The urgings of socio-political necessity and the awareness of architects such as Taherzadeh Behzad, who had already shown interest in the Beaux-Arts design tradition, predates the publication of these drawings. Nevertheless, the significance of these drawings stands out. A turning point occurs when not only a few architects incline towards a trend but when an architectural tradition becomes established, is theorised, and can be emulated across the country, representing a single political ideology.

But the standardisation of an architectural order is one thing, and its reinforcement within the bureaucratic system is another. Similarly, the construction of a few buildings either for the private sector or in the public eye is a different matter from the systematic construction of a series of government buildings bearing almost unified visual characteristics. The visual documentation of Persepolis happened simultaneously with the urban developments in and around Bagh-e Melli in Tehran, and the emergence of National Architecture which, especially in its first examples, are identical to Herzfeld's drawings and his imaginative re-creation of Persepolis.

The work of the archaeologist and architect André Godard, a graduate of the École des Beaux-Arts, supports this interpretation. Apart from his archaeological responsibilities, he was also an advisor to the municipality of Tehran, and his supervision of the design and construction of Tehran's

128 Antoine Picon, 'Introduction', in Durand 1805, 44.

209: The Bank-e Melli building on Ferdowsi Street, Tehran.

administrative buildings facilitated and encouraged this approach to design. Godard's role is especially well-documented in the case of the first branch of the Bank-e Melli, in the north-east corner of Bagh-e Melli.[129] In fact Godard and his team were involved with projects in the National Garden from the early stages, as consultants, until the final phase of 1937 that saw the design of Museum of Ancient Iran.

The capitol complex of Reza Shah started to take shape through the construction of the new Post Office building, the building of the National Bank, and the Police Headquarters (Kakh-e-Shahrbani). At least in the early stages, Herzfeld's columns were an inseparable element of this architecture, and its façades – as the most important site of architectural communication with the public – resemble his drawings of Persepolis. By 1933, many German architects and engineers were responsible for the construction of various projects across the country. One of them, H. Hemmrich, the architect of the first building of the Bank-e Melli, had his design assessed by a group of three architectural advisors, including André Godard. The

129 The document is reprinted in Kiani 2007, 446–450.

design of the bank elucidates the characteristics of National Architecture; the overall volume and composition are very similar to Herzfeld's drawings of the palaces of Persepolis. The additional decorative elements on the façade are Persepolitan columns, which become the most significant aspect of the design. As the project was developing, the consulting group requested its enhancement on several occasions.[130] As a result, apart from its entrance, the main façade, which represents Achaemenid architecture, bears additional Achaemenid and Zoroastrian references.

From the National Garden to Tehran's Capitol Complex (1934–41)

The new monarch had to distance his establishment from his Qajar predecessors, who were generally portrayed as the main reason for Iranian decadence. As the Iranian nation-state was taking shape, one of the elements that could unify all Iranian ethnic groups, tribes and religions was the reintroduction of their shared glorious past and a narrative of descent. The immediate architectural consequence was a shift from the Qajar fascination with European-style buildings and decorative motifs[131] and a revival of forms of pre-Islamic architecture. The revival of pre-Islamic architecture helped to legitimise the new government, to distinguish it from the former, and to empower a type of nationalism based on history and historical revivalism.[132] Being recently armed with a great deal of historical evidence and archaeological knowledge to back up this new approach to design, the new government tried religiously to revive and use pre-Islamic motifs and forms, from the Achaemenid and Sassanian eras, in politically charged projects. National Architecture started with governmental support within the new locus of Pahlavi power and reshaped the face of Tehran's first national Garden to make it the first Pahlavi capitol complex.

The conflict between a historically based national identity, and the speed of the process of modernisation, could not be better reflected than in

130 This is evident in the reports from the consulting group to various government bodies. For related documents, see Kiani 2007, 447.
131 Isenstadt 2008, 10.
132 Ali M. Ansari, 'Architecture Politics'. Debate with Niloofar Kakhi for the Architectural Association School of Architecture, 1 March 2013.

the way architecture was addressed in this capitol complex of the Pahlavi monarchy. Not only there is hardly any trace of modernist architecture here, but the historicist architectural trend that began in this place reveals nothing but the pure inspiration of pre-Islamic periods of history. This trend, commonly known as National Architecture or the National Style, transcended the enclosure of the old Parade Ground to become part of the understanding of national identity and a way to approach the question of the representation of national identity. Within this specific mode of architectural representation, the impact of archaeological studies on the understanding and appreciation of the past and their influence on architectural design is evident. National Architecture mainly focuses on facade design instead of spatial distribution and the organisation of an architectural plan. The following examples demonstrate how their political function is dependent on the message they communicate through their facades.

Soon after Bank-e Melli, the construction of the Police Headquarters in 1934 continued the process of transforming Bagh-e Meli into the locus of Pahlavi power. The building is on the east side of the street, which directly connects the main gate to the Qajar Cossack brigade headquarters. As the most prominent building of the complex, Ghelich Baghelian's design of the Police Headquarters is reminiscent of Persepolis in its main façade. The symmetrical building has four decorative columns at the central entrance and pilasters on the wings, which explicitly imitate the columns of Persepolis in detail as depicted by Herzfeld. The Zoroastrian symbol of Faravahar on the pediment extends over the main entrance, which encompasses several doorways similar to ones in the palace of Darius at Persepolis. The shape of the entrance stairs is another historicist imitation in this building. Although the orientation of the stairs is different, the proportions and decorative details look identical to the stairways of Persepolis, which are one of the most significant elements of the historic site. The main staircase is decorated with the reliefs of Achaemenid soldiers and is again very similar to the entrance stairs of the historical complex. There are some minor Islamic decorations in the facade, including the decorations of the second-floor window frames, but such decorations have a minimal presence in comparison with the Achaemenid and Zoroastrian references, and even those window frames are framed with repeating lotus flowers and friezes depicting winged lions and lotus flowers.

210: The main façade of the Police Headquarters, Tehran.

In both the National Bank building and the Police Headquarters, the other resemblance with Persepolitan architecture is in their masses and volumes. The symmetrical volumes with enlarged entrances in the centre, with colonnades and extensions to two sides of the building, are formal aesthetic aspects that National Architecture has borrowed from Herzfeld's drawings of the palaces of Persepolis. It is indeed the act of constructing history through archaeology and remembering it through architecture.

Just as historical references to the pre-Islamic Achaemenid era seemed like a means to religious emancipation and secularism, so did its architecture. The new physical appearance of these buildings allowed a sense of extroversion in comparison with the traditional architecture of the time in Iran. Apart from the climatic considerations, Islamic architecture is associated with a sense of introversion, represented by small entrances, courtyards and modest external façades, none of which appear in the design of the new government buildings. Such aspects were not considered until the end of Pahlavi monarchy when the emphasis on pre-Islamic histories of Iran was fading. The architect and scholar Mostafa Kiani, sees this as the selection of architectural characteristics of the distant past and the elimination of more immediate architectural traditions. This transformation starts with the volume of these buildings, and affects their plan and

211: The Ministry of Foreign Affairs, Tehran.

spatial organisation. Kiani highlights the emergence of linear plans and the significant role that is given to corridors and massive interior staircases, seeing this dramatic change as a consequence of the arrival of new functions that required more linear spatial organisation.[133]

In completing the development of the Parade Ground, other architects later adopted this same approach – for example Gabriel Guevrekian, in the design of the Ministry of Foreign Affairs, located north-west of the Police Headquarters. Guevrekian was a modernist architect who had studied in Vienna during the 1910s and was the chair of CIAM, the *Congrès Internationaux d'Architecture Moderne,* for four years from 1928 to 1932, and who had returned to Tehran in 1933. During his four-year stay in Tehran (1933–7), Guevrekian was the chief architect for the Tehran municipality and treasury, and was also commissioned to design several official buildings as well as private houses. But he could not stand the absurd pressure and demands of clients and the extreme rush of the government toward

133 Kiani 2007, 236.

modernisation.[134] His projects during the short period of his stay in Tehran are quite inconsistent with each other. Most could be considered as the first examples of modern architecture in Iran; while others, especially the Ministry of Foreign Affairs, which he designed within the enclosure of Bagh-e Melli, are historically loaded (even if, compared to other buildings here, it holds less historical and decorative references). In this building, Guevrekian used another historical monument of the Achaemenid era – Ka'beh-ye Zartosht (the Kaaba of Zoroaster) in Fars – as inspiration. It is strange that as one of the founding members of CIAM, who was enthusiastic about modern architecture, he designed this building with such an historical approach.

A comparison between Guevrekian's projects in Iran demonstrates the conflicts between modernity and the historicist approach of nationalism very clearly. The wholehearted modernist architect appears to have been almost forced to adopt an historicist approach to design, a trait that did not appear in his future projects. Nor did he design any other projects within Bagh-e Melli. Bagh-e Melli embodies design as a political apparatus, in which architecture proved itself to be trustworthy. The architect might not necessarily support the political ideology, but it was nonetheless employed to give physical and spatial form to the identity of the new government as it sought to establish a sense of continuity with specific chapters of history. Also, architectural practice is not something solely cultivated within professional and disciplinary debates. Its form is greatly influenced by the direction of political power, and cast by architecture.

The issue is not the historicist use of architectural elements as the representation of national identity, since that notion has an inevitable dependence on the past. The problem arises rather when the visual revival of the past becomes the only way to represent national identity. In architectural terms, a construction without such historical visual references is not considered as representative of national identity – one that arguably also deals with the characteristics of the current state of society – but in buildings that have such historical additions, the rest of building is not as significant either.

National Architecture gradually covered the face of Bagh-e Melli, while

134 Bavar 2009, 413.

Godard's influence also grew due to the commission to design the first official archaeological museum in Iran – the Museh-ye Iran-e Bastan, or 'Museum of Ancient Iran'. As the name suggests, there was no intention here of excavating or preserving relics of the Islamic period. Following the abolition of the French monopoly, the establishment of this museum was one of the main goals of SNH, in parallel with the shah's policies to concentrate on the pre-Islamic history of Iran. In 1929, the Ministry of Culture, which was responsible for the execution of the project, commissioned Godard, who had previously been employed by the government as the director of the Antiques Office to design the museum, in a style that was to represent Iranian architecture and be in harmony with the collection to be kept there.

Godard, who had extensive knowledge of architectural ruins of different periods in Iran, chose a very strategic source of inspiration, designing the façade with historical references from the Sassanian era. He maintained a rational and economical approach to the design of the structure and its plan of circulation, yet the two large patios and symmetrical layout are reminiscent of the central courtyard and spatial organisation of the Sassanian palace of Firuzabad, an ancient city from the Sassanian era in Fars. The architect and scholar Cyrus Bavar believes that the main goal was to build a monument in keeping with this historical background, rather than a functional museum.[135] The plan is simple, while the façade is decorated with red brick, similar to palaces in Firuzabad,[136] and the main entrance, which is the most noticeable part of this design, is a spacious iwan, opening with an arch stretched to the height of the façade.

This arch was inspired by Taq-e Kasra, the renowned triumphal arch of the Sassanian era located in the city of Ctesiphon, one of the regions that Iran lost after the Arab conquest.[137] Since Iran had lost many parts of her lands throughout history and her borders had changed several times (especially during the Qajar dynasty), one could suggest that commemorating a site no longer within the modern borders of the country leads to remembering the magnificence and power of ancient Iran beyond its modern borders,

135 ibid., 53.
136 ibid.
137 Kiani 2007, 58.

212: The Museum of Ancient Iran, Tehran.

and thus to generate feelings of patriotism and national identity as well as a sense of affinity and unity. It is as if these historical references on the façade of the museum are being used to recall the loss of valuable heritage and lands. Taq-e Kasra, the last monument of glorious pre-Islamic Iran (and one that Reza Shah never got the chance to visit), seemed to be the perfect reference to inspire the final addition to the site.

During this period of construction, many architects had the chance to build other historicist buildings within the enclosure of the park. However, Godard's design of the museum became a meaningful end to a national narrative, constructed to represent Iranian national identity. Although the process of design and construction witnessed many challenges, the opening of the museum in 1939 was a significant moment in SNH's activities, and for the government and the shah, who was interested in the representational values of the building.[138]

As one of the last buildings in Bagh-e Melli, the construction of the museum was completed in 1937. The new national library was designed as

138 Ullsen Archive Audio Collection, Fine Arts Library, Harvard University; CD 26 UIAuCD in GoA, Y/Of, interview with André Godard. (Cited in Grigor 2009, 181.)

an attachment to it, and it became the first national museum of Iran. Since it was named the Museum of Ancient Iran, relics of the Islamic period never found a proper place there until 1985, when the government of the Islamic Republic of Iran renovated a building in the complex as the Museum of the Islamic Era, and the entire complex was named the National Museum of Iran. The historical references used in the design of the museum, as well as the rest of the buildings in the enclosure of the former Bagh-e Melli, demonstrate ways in which architecture can be manipulated by political power to criticise recent history and to legitimise the contemporary by connecting it to a more glorious distant past.

3

Developments in Architectural Discipline (1941–79)

Founding the New Educational System

The reign of Reza Shah was a crucial period for the modernisation of the educational system in Iran. The educational reforms during the Qajar era[1] had been mostly limited to Tehran and to the private sector, but Reza Shah standardised and nationalised the educational system, and launched fundamental reforms to the curriculum. In higher education these changed the course of development for arts and architecture drastically. While modern Western artistic trends and theories had already entered some artistic circles, systematic transformation in these fields happened as a result of the new educational system.

Formulated mainly in the early years of Reza Shah's reign and promoted by institutions such as the Society for National Heritage, the new educational system encouraged the expansion of the official version of nationalism in Iran. It has been described as a 'modernizing project in terms of a return to a pristine modernity that was felt to exist within the deep reservoirs of Iranian tradition', and facilitated the establishment and administration of the paradigms of 'authentic national culture'.[2] It had several benefits. Firstly, in comparison with direct political force, a systematised

1 The reforms during the Qajar era started with the establishment of Dar al-Fonun in 1851 as the first modern higher education institution inspired by the Western educational system. See Behnam 1994, 100.
2 Marashi 2008, 88–9.

and centralised educational structure would have a long-term effect on the unification of society. Secondly, educational developments were expected to reduce the reliance on foreign specialists and would help remove their political influence. Thirdly, the establishment of a new nationwide educational system would diminish the dominance of traditional, mostly religious, education and the secularist ideology of the state would be better adopted in educated communities.[3]

As one of the fundamental modernising programs of the time, educational reform became the most effective means for the dissemination of national values – 'a force simultaneously capable of blunting supranational loyalties to Islam and blurring subnational ethnic and local loyalties.'[4] Schools began to promote 'patriotism (*maihān-parastī*), loyalty to the nation, national unity (vahdat-e melli) and national independence (*esteqlāl-e mellī*).'[5] Under the cloak of modernisation, nationalism was now publicised countrywide and penetrated all social levels, especially that of the younger generation. 'Ali Asghar Hekmat, the minister of education from 1933 to 1938, mentioned in his memoir that his mission was to unify Iran and make its society 'of a single cloth'.[6] Thus the establishment of a unified educational system became a priority for protagonists of socio-political reform in Iran, especially for the shah and Seyyed Zia Tabatabayi.[7] In a proclamation issued on 26 February 1921, less than a week after the coup and his own appointment as prime minister, Tabatabayi made a particular point of the importance of national education in the augmentation of patriotism.[8]

The unification of education had started with elementary schools in the

3 Menashri 1992, 94–102.
4 ibid., 94.
5 ibid.
6 Hekmat 1976, 130. (Translation cited in Marashi 2008, 88).
7 The fact that the key protagonists of educational reforms including Ali Asghar Hekmat and Isa Sadiq who were, at the same time, founding members of the Society for National Heritage denotes the close relationship between the two institutions and reveals the quality of knowledge appreciated at the time. While one was a non-governmental society, its activities could well have been fundamental to the reforms of the educational system, with the Ministry of Education supporting and promulgating the SNH's work.
8 Menashri 1992, 94.

mid-1920s. By 1937 all elementary school textbooks were designed to promote the Persian language and pre-Islamic history, to teach geography that portrayed Iran as a unified homeland (*vatan*) and to recognise Iranian art as a cultural heritage.[9] To this end, during the 1930s, the Ministry of Education had encouraged and financed those research projects initiated by the government whose aims were 'to stimulate identification with the pre-Islamic heritage, mainly poetry, archaeology and art.'[10] The focus on the field of history was a priority. The Commission of Education (Anjoman-e Ma'aref) in which members of the Society for National Heritage, such as Taqizadeh, 'Abbas Eghbal and Hassan Pirnia were involved, was responsible for this. One of the outcomes of the commission was *Iran-e Qadim* (1929), an abridged version of Pirnia's *Tarikh-e Iran-e Bastan* on the pre-Islamic history of Iran, which the National Assembly published as a history textbook for schools.[11] To historian and scholar Afshin Marashi, 'Textbooks were markers of modernity but also of nationalism', distributing knowledge in the national language across the country through state institutions, and therefore they were 'objects of national culture.'[12]

In the case of Iran, if we consider 'modernity' as being mainly about secularisation, standardisation, and (more importantly) industrialisation, rather than its fundamental philosophy, we might once again return to the question raised earlier regarding Gellner's definition of nationalism in industrial societies: if such pragmatic actions were the main objectives of modernising reforms, as Gellner has argued, it would automatically result in the establishment of the kind of 'cultural homogeneity' that nationalism required. In other words, this cultural homogeneity would emerge as a kind of nationalism, perhaps independently of the politicisation of the historical and cultural heritage:

> Mankind is irreversibly committed to industrial society, and therefore to a society whose productive system is based on cumulative science and technology. … We do not properly understand the range of options

9 ibid., 96.
10 ibid., 97.
11 Marashi 2008, 97–100.
12 ibid., 98.

available to industrial society, and perhaps we never shall; but we understand some of its essential concomitants. The kind of cultural homogeneity demanded by nationalism is one of them, and we had better make our peace with it. It is not the case ... that nationalism imposes homogeneity; it is rather that a homogeneity imposed by objective, inescapable imperative eventually appears on the surface in the form of nationalism.[13]

The question here is whether such nationalism would need such an intense dependence on the past that, in the case of architectural design, it would dominate the discipline, overshadowing creativity and creating an ongoing conflict with Modernism. If the focus was on modernity and even, in effect, on industrial development, nationalism and a sense of national identity emerging from this process might have other criteria to refer to, and might be represented on other terms – for example, those concerning contemporary shared experience, culture, or shared natural resources.

The need for nationalism, which was a return to the core aims of reform as far back as the mid-nineteenth century, became even more crucial in Iran after the Constitutional Revolution during the early 1900s. Iran traversed this path in reverse; nationalism did not come about as the consequence of industrialisation and modernisation, but the other way around: modernisation became another tool for the country to increase its independence and unity, and ultimately to maintain its territorial integrity. The priority for constitutionalists and reformists ever since 'Abbas Mirza's military reforms had been to regain independence for a country that was divided among foreign powers, rather than modernisation *per se*. Iran first needed to be acknowledged as an independent power, and as being capable of making decisions for itself, before it could step towards modernisation and development.[14] Perhaps the most 'modern' decision that the Iranian elites

13 Gellner 1983, 39.
14 It should be remembered here that the main reason given for the decadence of Iran during the nineteenth century was the inefficiency of the Qajar monarchs. The approach of the nationalist reformers to win public support was therefore to allocate power to the public first, in order to proceed towards development and modernisation.

made, therefore, was to depart from the traditional system of government and transition to a nation-state.

In this regard, for a new government that had promised to fulfil the goals of the constitutionalists, maintain territorial integrity, and consolidate the country, national unification was the more important priority, with modernisation necessary only as a tactic to promote it. The writing of histories and the construction of collective memories played a central role in the process of national reconciliation. No other platform would be of more practical use for the dissemination of these collective memories, celebrating an agreed-upon set of national values, than a comprehensive educational system targeted from a young age all levels of society. Architectural education was only a minor branch of this project, yet, from this point onwards, each building and each national monument was inevitably a product of this system and had the potential to promote this ideology to the public. Historicism thus acquired a far larger role in the architectural representation of national identity than other, more updated approaches, which might have followed more recent advances in the discipline.

Paradoxically, another measure adopted by the government in the promotion of nationalism through educational reform was to send students abroad for higher education. Of course, supporting students to study overseas would result in Iranian specialists returning home and would encourage independence from foreign influence. But as David Menashri explains, in his *Education and the Making of Modern Iran*, Reza Shah had another motive behind this approach, since 'Westernization was pivotal to the dispatch of students to Europe.' The Shah had made it clear that acquiring knowledge (*'elm*) and Western culture was the responsibility of those sent abroad at public expenses. In his view 'students should bring back from the West, among other things, a sense of patriotism and loyalty to the nation-state modelled on Europe.'[15] The state was quite particular in the selection of academic destinations for Iranian students, as the Shah saw acquiring 'moral education' as a priority. And of course, the result of 'moral education' was to be the stimulation of patriotism and loyalty to the nation and the Shah himself. In an address to students going abroad in 1929, he expressed his views thus:

15 Menashri 1992, 105–06.

Were it merely for scientific instruction it would not have been necessary to send you abroad. We could have engaged foreign instructors. … Our chief aim … is that you should receive a moral education, for we note that Western countries have acquired a high standing as a result of their thorough moral education.[16]

In another speech in 1930, the Shah again insisted that the minister of education should 'select the countries, which pay proper attention to moral education and send the students there'.[17] France therefore became the destination of choice for Iranian students, as the two countries already had long-established cultural relations. French was the foreign language most Iranian students knew and more importantly 'the Iranian educational system was modelled on the French one'.[18] Along with such practical reasons, France[19] was considered suitable on account of its patriotism, too; in his address to a group of students leaving Iran in 1928, the shah explained that it might be considered inconsistent of monarchical Iran to choose republican France as an educational destination, but that it was for students to learn the 'French sense of patriotism'.[20]

A strong relationship with French institutions remained a fundamental element in the Iranian educational system, and consequently in the establishment of the University of Tehran. Students in the fields of arts and architecture were sent to France from the beginning of this project.[21] This resulted in the development of architectural discipline in Iran being very much under the influence of the French Beaux-Arts system, and the École

16 See his speech to students travelling abroad in 1929,. (Translation cited in Menashri 1992, 105, from the original in Gondi Shapur, *Amuzesh*, 2:18).
17 Reza Shah's address to one hundred students who were about to leave for Europe, September 1930. (Translation cited in Donald Wilber, *Riza Shah Pahlavi: the resurrection and reconstruction of Iran* (Hicksville, 1975), 135.
18 Menashri 1992, 133.
19 In the following years, this gradually changed and more students travelled to England, Germany, and later, to the United States. However, 75.2 per cent of students studied in France. See Menashri 1992, 133.
20 *Ettela'at*, 9 October, 1928. (Cited in Menashri 1992, 106.)
21 A survey of 176 students who studied abroad between 1928–31, by the Institute for Social Research, shows that 19.9 per cent of students studied arts and social sciences. (Cited in Menashri 1992, 132.)

des Beaux-Arts inevitably became the main destination for Iranian students of arts and architecture. The Beaux-Arts system of education (described in more detail below), was imported not only as a disciplinary method but also (along with French neoclassicism) as an architectural style, to be used soon at the School of Fine Arts at the newly established University of Tehran. Neoclassical architecture, which in Iran had previously represented French and German nationalism, reinforced by the adoption of the French educational system, now became a means of conveying the sort of nationalism supported by the Iranian government and disseminated by that same newly established education system.

Of course, the shah and his government did not want to turn Iranian students into Westerners devoid of attachment to their nation; and from the beginning, the idea of dispatching students abroad and thus creating a professional class detached from the rest of their society was a matter of debate. The reformist prime minister, Mohammad Ali Foroughi, stressed the necessity of this course of action for the sake of social and economic development, and acknowledged that introversion and isolation would only lead to degeneration; however such a course must not 'prejudice Iran's unique culture or national identity'.[22] Regarding this concern, the shah gave his comments to journalist and author Rosita Forbes:

> I hope the young men we send to France and Italy will realise that
> civilization is different for every country. I don't want to turn the
> Persians into a bad copy of a European. That is not necessary for
> he has mighty traditions behind him. I mean to make out of my
> countrymen the best possible Persians. They need not be particularly
> Western or particularly Eastern. Each country has a mould of its own,
> which should be developed and improved until it turns out a citizen
> who is not a replica of anyone else, but an individual sure of himself
> and proud of his nationality. … The Persian character has got to be
> hardened. For too long my countrymen have relied on others. I want to
> teach them their own value, so that they may be independent in mind
> and action. … Persia must learn to do without foreigners. I hope that
> in five or six years it will be unnecessary to employ any but Persian

22 Hekmat 1976, 26–28. (Translation cited in Menashri 1992, 106.)

officials. ... Persia must learn to run her own affairs. Remember, she has inherited considerable experience, for she once ruled an empire.[23]

Even though the shah and the government were clear about the 'moral qualities' students should learn from the West, the reality was different. Sending students abroad only partially stimulated the sense of patriotism, while also bringing back critiques of the government and state. Many students were fascinated by the degree of freedom seen in European countries and became interested in democratic systems of government. Although they remained politically inactive in the first years after their return, they were active by the final years of Reza Shah's reign and became the nucleus of liberal movements during the rest of the Pahlavi monarchy, up to the Islamic Revolution of 1979. Other groups of students, interested in Marxism, became influential in early communist political groups. Although they mostly stayed abroad and many moved to Germany, they managed to form an Iranian Communist Party in 1929, publishing many journals; and from this point official opposition to and criticism of the monarchy began to itensify.[24]

The emergence of such criticisms of the state by educated activists became the most contentious issue in determining the success of sending students abroad. Although the possibility of 'bad influence' had always been a concern amongst politicians, the Shah had not expected this result. By 1933 there was talk of ending the project, and of founding a university in Tehran instead, and in fact the University of Tehran was officially inaugurated on 4 February 1935.[25] The government had to meet the growing need for professionals but, after the establishment of the University, it promoted studying in Tehran and the number of students sent abroad significantly

23 Rosita Forbes, *Conflict: Angora to Afghanistan* (London, 1931), 182–87. (Cited in Donald Wilber, op. cit., 135–6.)
24 Menashri 1992, 137–142.
25 ibid., 140–42. Other sources such as the Encyclopaedia Iranica and the website of the University of Tehran consider 1934 as the date of inauguration. The website of the University of Tehran also sees the roots of this institution in modern institutions such as Dar al-Fonun, in the Sassanid academy of Jondi Shapūr, and in the religious seminaries (howzeh). See: 'UT at a Glance,' University of Tehran, http://ut.ac.ir/en/page/757/ut-at-a-glance accessed online 12 July 2017.

decreased.[26] However, Prime Minister Mohammad Ali Foroughi believed Iran was not capable of continuing modernising reforms without strong international academic relationships, so the project of sending students abroad remained active, albeit on a smaller scale, and these graduates in return formed some of the most effective groups in the development of the country, especially in the academic, judicial, and administrative sectors, as well as in the field of architecture.[27]

The University of Tehran

In this environment of reform and the internal production of knowledge, the decision to establish a university in Tehran was very important. Initial examination of the possibility of establishing a small university, including schools of medicine, road engineering, and a teacher's training centre, began in 1931. Isa Sadiq, who was working on his doctoral dissertation on Iranian education at Columbia University, was responsible for this investigation.[28] While believing that conditions were not yet suitable, he nonetheless submitted his plan in a few months and drafted a law for establishing a university in the following year.[29] The process gained momentum from March 1934 when the new minister of education, Ali Asghar Hekmat, submitted the law for the establishment of a university to Majlis. The shah personally supported the project and decided on a location suitable for the future expansion of the campus. He visited the site frequently and ordered Andre Godard, the architect responsible, to work as quickly as possible.

According to the final decision of Majlis, six faculties – of theology, science, medicine, engineering, arts and political science, and law – were to be established. Except for the Faculty of Engineering, the rest of the schools already had separate dedicated academies in Tehran.[30] Whether it

26 Menashri 1992, 125.
27 ibid., 134–5.
28 ibid., 145.
29 The project was suspended for two more years until February 1934 when in a cabinet meeting, the new minister of education, Ali Asghar Hekmat, compared Tehran to other capital cities in the world and pointed out the absence of a university. Reza Shah issued a command for immediate action. See Hekmat 1976, 331–5.
30 Menashri 1992, 149.

was Pope's lecture of 1925, that had given such a significant role to the arts and made the government responsible for their safeguarding, or the choice of the statesmen in 1934, the fact that the University acquired a Faculty of Arts is important. The fact that the arts were considered so significant and were among the first selected disciplines – all of which would contribute directly to modernisation and cultural homogeneity – reveals how strategically important the role of the arts was seen as being. Agriculture, for example (which was the main source of income in Iran at the time) did not receive a faculty until 1949.

Although arts and architecture in Iran had other academic institutions before the opening of the Faculty of Fine Arts (Honarkadeh-ye Honarha-ye Ziba)[31] in 1940, the role of the Faculty in establishing the official understanding of what is known as 'Iranian architecture' is remarkable.[32] At the suggestion of Esma'il Merat, the minister of education, it was based on the model of the École des Beaux-Arts,[33] and had a different mission from previous independent institutions as the University of Tehran was established to promote and support state policies.

Its establishment is also significant in that it happened only a little before the global post-War dominance of modernist architecture, with all of its questioning of historicist and traditionalist approaches. The 'conflictual' relationship between modernist architecture and the historicist approach as the signifier of nationalism was later discussed mostly at the Faculty of Fine Arts, where investigation and debate also led to the development of a new phase in National Architecture. From this point on, National Architecture was not simply a few buildings to be found in Tehran, but a disciplinary discourse that sought to express aspects of Iranian national identity;

31 Iranica: Morteza Momayyez, 'Faculties of the University of Tehran ii. Faculty of Fine Arts', IX/2, 142–143, accessed online 18 March 2013.

32 See: Gholam Hossein Zargari Nezhad, Az Madrereyeh Sanaye' Mostazrafeh ta Daneshkadeh-ye Honarha-ye Ziba: Mururi Bar Zamineha-ye Sheklgiri va Tasis Daneshkadeh-ye Honarha-ye Ziba dar Daneshgah Tehran (From the school of fine arts to the faculty of fine arts: a contextual review of the formation and inauguration of the faculty of fine arts at the university of Tehran), *Honarhayeh Ziba* 30, 2007, 5–12.

33 Morteza Momayyez, 'Daneshkadeh-ye Honarha-ye Ziba dar nim qarn (The faculty of fine arts in half a century),' *Kelk* 11 & 12 (Jan-Feb 1991), 60.

with architects and teachers having the power to promote or question its principles and characteristics.

The years between the inauguration of the university in 1935 and the establishment of the Faculty of Fine Arts were turbulent and chaotic in Iran, with the beginning of the Second World War marking a period of particular instability. As Iran was still under the influence of British and Soviet forces, its declaration of neutrality did not remove the threat of war. The presence of German industrial specialists and the racist politics of Nazi Germany were seen by Britain and the Soviets as significant threats to their interests in the region. Regardless of the lack of interest in Nazi propaganda by the Iranian government, and Iran's declaration of neutrality, the Anglo-Soviet invasion of Iran began in August 1941 with the aim of forcing the Iranian government to support the Allied powers. The invasion targeted many cities and was a major threat to the territorial integrity of the country, as Iran was once again on the verge of a division between British and Soviet forces. To prevent this, the Allies forced Reza Shah, who had insisted on neutrality, to abdicate in favour of his son, Mohammad Reza Pahlavi. By sending Reza Shah into exile, the transportation network and other infrastructure facilities remained available to ensure the supply of goods and oil to the Soviets against the Axis powers. This situation continued until the end of the war, so although Iran was not technically at war, its resources were exploited and its lands were vastly engaged, while Reza Shah, who had been a forceful voice against foreign influence, was sent into exile and his son Mohammad Reza, who was under British and later American influence, came to the throne.

The post-war period was one of growth and construction in most of Europe, but was a period of stagnancy and slow recovery in Iran. The new king remained very weak during the early years of his reign. The academic environment, however, was developing, and the demand for universities in Tehran and other cities such as Tabriz, Shiraz, Mashhad, and Isfahan accelerated in the post-war period.[34] In such an environment, the early years of the Faculty of Fine Arts were very much dependent on the knowledge and skills of those foreign experts who had remained in Iran and on the first generation of Iranian students who had recently arrived

34 Behnam 1994, 102.

301: The Faculty of Fine Arts, University of Tehran.

from France. André Godard, who had become the most prominent figure in the development of archaeology and architecture, became the first director of the Faculty of Fine Arts. The Faculty, which in itself was formed by the conglomeration of existing art and architectural academies, started with three schools: architecture, painting, and sculpture.[35]

The Establishment of the Faculty of Fine Arts under Andre Godard (1940–53)

Honarkadeh, later renamed the Faculty of Fine Arts, was a conglomeration of Kamal al-Molk's[36] Academy of Fine Arts, including the Academy of Architecture (Madreseh-ye 'Ali-e Me'mari). Founded on 23 September

35 The Faculty of Fine Arts was founded by merging the Academy of Fine Arts, which had been established by the prominent Iranian painter Kamal-al Molk in 1911, with the Advanced School of Architecture (Madrasa-ye 'Ali-e Me'mari), which, through a two-year course based on the Beaux Arts system, was teaching architectural techniques.

36 Mohammad Ghaffari, also known as Kamal al-Molk (1884–1919) was a renowned painter during the Qajar era at the court of Naser al-Din Shah Qajar. He inaugurated

1938, the Academy of Architecture was a result of the recognition, by several French-educated artists and architects, of a lack of academic knowledge about Iranian architecture. The founders of the Academy were Mohsen Foroughi, the son of Mohammad Ali Foroughi; Roland Dubrulle, who with Mohsen Foroughi had also graduated from the École des Beaux-Arts; and Abolhasan Sediqi, a renowned sculptor. Hossein Taherzadeh Behzad – the older brother of the architect of Ferdowsi's mausoleum, Karim Taherzadeh Behzad – taught painting at this institution.[37] The Academy enrolled twenty students for a four-year degree in architecture. The curriculum's focus was on 'the architecture of Iran and encouraging the students' to study the subject.[38] In the summer of 1940, the supervision of the Academy of Architecture was transferred to the Ministry of Culture, and the Faculty of Fine Arts was inaugurated at a new location at the Marvi school near Maidan-e Baharestan in Tehran. André Godard became the head of the faculty. In November 1941 the faculty was relocated to the main campus of the University of Tehran, and housed in the basement of the faculty of engineering.[39]

The architects Maxim Siroux, Roland Dubrulle, and Mohsen Foroughi, who all joined Godard after 1940,[40] had previously collaborated with him either in archaeological research and in collaborations with SNH, or in the design of government projects such as the University's own campus. Amongst them, Foroughi remained the most influential in design courses. The Faculty of Fine Arts was modelled on the École des Beaux-Arts and its syllabus, and since Godard and other faculty members had graduated from that institution, they adopted its academic system and architectural approach without alteration,[41] simply translating its courses into Persian.[42]

The Beaux-Arts architectural tradition dominated French architecture

an academy of fine arts (Madreseh-ye Sanaye'a Mostazrefeh) in Tehran during in early 1910s.
37 Khajavi 1946, 31.
38 ibid., 31.
39 Gholam Reza Khajavi, 'Tarikhcheh-ye Daneshkadeh-ye Honarha-ye Ziba (The History of the Faculty of Fine Arts)', *Architecte* 3, (January 1947), 111.
40 Khajavi 1946, 31.
41 Bavar 2009, 204.
42 Marefat, 'The Protagonists', in Adle 1992, 106.

from the seventeenth century until the upheavals of 1968. Unlike modern-
ist architecture, with its focus on functionality, the mission of Beaux-Arts,
even in the early twentieth century, was still 'to work for the *rétablisse-
ment de la belle architecture*'.[43] In other words, the style of architecture
favoured by seventeenth-century pioneers such as François Blondel
(1618–86), which was intended to restore the type of classical Greek
and Roman architecture previously revived during the European Renais-
sance.[44] Beaux-Arts architecture evolved first at *the Académie Royale
d'Architecture* from 1671 to 1793, then after the French Revolution, at
the Académie des Beaux-Arts. The ultimate aim for students at the Aca-
démie was to win its most prestigious award, the Grand Prix de Rome,
which financed the study of architecture in Rome itself,[45] and guaranteed a
career as a distinguished architect with a better chance of winning signifi-
cant commissions. In both this competition and the rest of its courses, the
Académie valued the visual beauty of design above anything else; propor-
tion, the ornamentations of façades, and the beauties of a composition in
plan were the main priorities. Although based on the *Parti*, which was the
term used at the Académie to describe the primary programme or concept
of design, the aesthetics of composition and drawing were seen as being
much more important.

The Beaux-Arts approach to design became particularly influential after
the rise of neoclassicism in the late eighteenth century, when the romantic
celebration of the architecture of Greek and Rome was dominant, and led
to an increased interest and appreciation of classical architecture. There
was a close relationship between architecture and archaeology during this
period, which contributed to the expansion of knowledge of historical
architecture. This increased understanding of classical architecture was
classified and published by Jean-Nicolas-Louis Durand in his *Précis des
leçons d'architecture données à l'École Royale Polytechnique,* between

43 The English translation of the phrase might be given as 'the restoration and
recovery of beautiful architecture'. See Paul P. Cret, 'The Ecole des Beaux-Arts and
Architectural Education', *The Journal of the American Society of Architectural
Historians* 1/2, (1946), 7.
44 ibid.
45 Françoise Fromonot and Julie Rose, 'The Beaux-Arts: Model, Monster…
Phoenix', *Log* 13/14 (Fall 2008), 42.

1802 and 1805, where issues of architectural type and function were discussed in parallel. In this book, beauty of composition was presented as subservient to functionality of design, and an eclectic use of various elements was promoted in the design of new projects.

Although Durand was a critic of the romantic approach toward classical architecture promulgated at the Beaux-Arts, his book and more importantly his method of classification contributed to the production of local versions of Beaux-Arts architecture, especially in Asia.[46] The historicism of this style aligned with the historical reliance of nationalism at the time, and fostered the development of National Architecture in Iran. The main difference to the European version of the Beaux-Arts style was the replacement of the classical orders of Greece and Rome with 'Persian' references, examples of which were being excavated, categorised and lauded during this period in the works of Ernst Herzfeld in particular (see page 9). André Godard adopted this approach at the Faculty of Fine Arts, where he divided the five years of study required for the architectural diploma into three years of the *Premier cycle*, and two years in the *Deuxième cycle*. The three years of the *Premier cycle* were to learn practical skills such as drawing techniques, rendering, and shadow casting. At the same time, students had theory classes on material strength, concrete structure calculations, geometry and perspective, site surveying, and art history.

The main reference works on the history of architecture in Iran at this time were still Pope's *Persian Architecture*, and Godard's own journal *Athār-é Irān* and his *The Art of Iran*. In the Faculty's curriculum, Mohsen Moqaddam (1900–87), a prominent Iranian archaeologist who had collaborated with Godard at the Museum of Ancient Iran, taught the course on art history.[47] Moqaddam had studied art in Iran under the supervision of Kamal al-Molk, and moved to France to study archaeology at the Musée du Louvre under Georges Contenau.[48] When he returned to Iran in 1936, he

46 Of course, in Iran, as in many other adoptions of this educational system (China, for example), the focus was on the structure and design approach rather than the Greco-Roman visual references as the primary historical source of inspiration. In many countries, the dissemination of the Beaux-Arts system produced new architectural compositions and visual appearances.

47 Bavar 2009, 202–05.

48 The French archaeologist and Orientalist Georges Contenau (1877–1964)

continued his archaeological research as well as teaching archaeology and art history at the University of Tehran.[49] Moqaddam never published his ideas, but from his education and background in archaeology, one could estimate that his teaching method would focus on the description of architectural objects.[50]

Drawing skills were practised mainly through copying the Classical Orders in the first year, and through decorative compositions and sketching competitions in the second and third years of the *Premier cycle*. In drawing the Classical Orders, students learned proportion through the modular system of measurement used in their drawings. According to Cyrus Bavar, who studied in this system, any student who failed this part of the syllabus had to assist in the survey of Persepolis or of a mosque during the summer semester, and then present the resulting drawings. In this way, more information was collected on edifices about which not enough was known, and on the architecture of Iran in general.[51] (It is a pity that these drawings are still not systematically archived today.)

This practice of drawing historical buildings, especially in the case of Persepolis (the most celebrated archaeological and architectural site in Iran), produced an appreciation of architectural heritage amongst students;[52] similar to that evinced in Pope's *Persian Architecture* and his early lectures. The student of architecture was first a 'pilgrim' to these sites, and would then study their design and building techniques. This was an approach that resulted in many valuable examples of lesser political or historical significance being ignored, but these drawing exercises did succeed in giving Iranian examples the same validity as the Greco-Roman orders employed in the study of neoclassicism at the Beaux-Arts. However, the value associated with past architecture in both cases remained to a great

researched Oriental antiquities extensively and conducted several studies in Iran. He was director of the French Archaeological Mission in Iran from the late 1940s to late 1950s.

49 'Ostad Mohsen Moqaddam,' University of Tehran, http://museums.ut.ac.ir/mm/page-20.htm, accessed online 4 July 2014.

50 Moqaddam had a great passion for collecting relics and bought Iranian antiques from Europe to add to his collection in Tehran, which he later donated with his house to the University.

51 Bavar 2009, 208.

52 Cyrus Bavar, interview with the author, 7 and 9 Aug., 2013.

extent on the visual surface; and meant that the process of studying the past began with the evaluation of its external aspects (that is, proportion, decoration, and formal characteristics) as its primary objective, translating such a visual investigation into the realm of architectural design. The resulting 'de-composition' of historical examples and their 're-composition' in the design of new projects was the main inheritance that the School of Architecture in Tehran took from the École des Beaux-Arts. In an article on his experiences as a student at the Beaux-Arts after the First World War, the architect Jean Paul Carlhian (1922–2012) described the importance given to drawing and compositional exercises in the Beaux-Arts syllabus:

> The importance of such a step and of the administration's insistence that it be mastered first cannot be overestimated. While a superficial appraisal of its merits might condemn it as useless or, even worse, an inducement towards copying, its basic value, and one essential to the student's whole future attitude towards historical matters, rested upon the fact that by forcing him to actually make use of past historical elements as basic components of his own composition, it developed in the student not only a familiarity with, but an attitude towards history which was going to stay with him for life. Historical elements, far from being merely illustrations in a book, or a slide projected on a screen, became his own to use, manipulate, distort or rearrange. Should he or she one day decide to discard them deliberately, it would be *en connaissance de cause* and not through sheer ignorance.[53]

In this regard, drawings similar to Krefter and Hertzfeld's drawings of the columns of Persepolis and Godard's classification of examples of *chāhār tāq* construction, which were published in *The Art of Iran*, were not only produced as part of archaeological knowledge, but also entered into architectural discipline as 'elements' and 'types' that could be used in new compositions.

One might consider this simply as the legacy of Beaux-Art architecture, but the impact of such historicism was much deeper in the socio-political

53 Jean Paul Carlhian, 'The École des Beaux-Arts: Modes and Manners', *JAE* 33/2 (1979), 8.

context of Iran. Nationalism was still the main item on the agenda at the time in Iran, and was dependent on the celebration of a shared glorious past, where this architectural approach found a pivotal role. After all, choosing France as the primary destination for students abroad had been part of the policy to elevate a sense of patriotism. Educators such as Mirfendereski and Bavar have repeatedly drawn attention to the fact that had Iranian students chosen to go to Germany instead, modernist architecture might have been adopted more easily in Iran because of the influence of Bauhaus, and perhaps the definition of National Architecture might have been different.[54] A few years before the establishment of the Faculty of Fine Arts, some of the teachers of the School designed examples of National Architecture for the National Garden and thus set the primary models for students.

Therefore, one could argue that the adoption of the Beaux-Arts system was a key moment connecting surviving historical fragments to the architectural representation of national identity. To summarise, this attitude towards history and design stemmed from the nationalist ideology cultivated after the Constitutional Revolution of 1906–11. Emphasising a shared past became a significant step in the reconciliation of Iranians, and was reinforced by newly discovered archaeological evidence. Particular periods of history were celebrated and ultimately fostered the sense of Iranian national identity, following the attitudes of the time and interpreted through selected epochs. Figures in the field of archaeology and historiography, such as Hassan Pirnia, Mohsen Moqaddam, and especially André Godard, played a significant role in transmitting these historical values to the academic environment. From this point on, architecture in Iran found a kind of secondary support that enabled and valued historicism in a new light; with Beaux-Arts architecture, both as an architectural style and as an educational system, systematising this design approach. As an architectural style, Beaux Arts was known for incorporating historic elements in the design of governmental buildings, under the banner of National Architecture. As an educational system, it reinforced the dominance of historicism as the accepted approach within academia, promoted a sense of historical continuity, and remained an opposing force against modernist architecture.

54 Cyrus Bavar, interview with the author, 7 and 9 Aug. 2013.

It also inherited the same conflicts within the architectural realm that both nationalism and modernising reforms bore during this period.

The Modern: The Faculty of Fine Arts under Mohsen Foroughi (1953–62)

The early years of the School of Architecture were mainly spent on formulating its system of education. The school was established during the Second World War, when the country went through a turbulent phase after the Anglo-Soviet invasion of 1941 and the abdication of Reza Shah. The post-war period in Iran was a period of stagnation, althought the Faculty of Fine Arts remained active, even if with fewer students. Manouchehr Soleymanipur, who graduated from the School of Architecture in 1953, describes the Faculty during this period as employing only three teachers for architecture and two for painting, while each course had no more than four or five students.[55]

In the early 1950s, the nationalisation of the oil industry and the increase in the oil price improved the economy. Consequently, from 1953 onwards, Mohammad Reza Shah's power increased, leading to him becoming an absolutist monarch until the revolution of 1979. Meanwhile, the increase in oil revenues resulted in another round of modernisation in Iran, and the socio-political atmosphere of these years was reflected in architecture and academia. In 1953 André Godard retired from his post in the Faculty of Fine Arts and Mohsen Foroughi became the next director of the Faculty. Like Godard, he was a graduate of the École des Beaux-Arts in Paris and had a great appreciation of and interest in the art and architectural heritage of Iran, as well as being a collector of mainly pre-Islamic Persian art.[56] His main difference from Godard was his interest in modernist architecture, which is evident in his works, especially in several branches of the National Bank that he designed in Tehran, Shiraz, and Isfahan. Such an

55 1 'Sargozasht-e amuzesh-e me'mari-e Iran: Az zaban-e faregh ol-tahsilan-e reshteh-ye me'mari' (The story of architectural education in Iran: according to the graduates of the course of architecture), Abadi 3 (1991), 61–68.
56 Iranica: Mina Marefat, Richard N. Frye, 'Foroughi, Mohsen,' X/2, 113–116 accessed online 5 July 2014.

appreciation of modern architecture was appropriate for the socio-political environment of the time, as a new round of architectural projects had started in Iran.

Foroughi was a member of the Society of Iranian Professional Architects (Anjoman-e Arshitektha-ye Irani-ye Diplomeh) – a group of modernist architects in Tehran that had been established in 1946.[57] The members of this group saw modernist architecture not only as a new trend in design but more importantly, as a new way of developing the built environment in accord with modern life. Like their historicist colleagues, they valued the ancient architecture of the Achaemenid, Sassanian, and Safavid eras, and recognised that there had been stagnation and a lack of progress in the architecture of Iran after the Safavid and especially during the Qajar eras. In contrast with the historicists, however, they were not keen to promote architectural design that was dependant on the revival of visual aspects of historical architecture.[58] The architect and architectural historian Mina Marefat has described how the establishment of the Anjoman was a response to the chaotic nature of urban reform during the early decades of the Pahlavi dynasty, and how the members of the group aimed to 'promote public and official awareness of the need for urban planning, modern approaches to sanitation, and technical improvement.'[59] Although the Society of Iranian Professional Architects was not very active for the first decades after its establishment, it did pioneer the publication of the first professional architectural journal in Iran, *The Architecte*, to push forward its agenda.[60] Appearing from August 1946 to July 1948, *The Architecte* only lasted for six issues, and as the first issue made clear, would deal only in the discipline of the subject, not with politics:

Our aim to publish this journal is to discuss the techniques of architecture, urban design and the related subjects. We want to inform our dear readers about the latest developments of the related

57 ibid. See also Manuchehr Khorsand, 'The Society of Iranian Professional Architects,' *Architecte* 1, (July-August 1946), 3.
58 ibid.
59 Mina Marefat, 'Building to Power: Architecture of Tehran 1921–1941' (PhD diss., Massachusetts Institute of Technology, 1988), 145.
60 ibid., 145–7.

techniques. … the main goal of this society is to renew (*tajdīd*) the industrial successes of Iran and to rectify its problems. … It is a purely technical and tasteful publication and cannot have and does not want to have the smallest connection with the world of politics.[61]

In retrospect, this shows how modern architectural practices of the time were considered outside the ideological spectrum of the discipline (a position supported by the government) and the extent to which the politically inclined architecture of the time conflicted with this approach. The majority of the members of the Anjoman were leftist and communist activists, including Nour al-Din Kianouri,[62] an architecture graduate from the University of Tehran and the Unversity of Achen, and a prominent member of the Tudeh, or Communist, party of Iran. Like most of the articles in the journal, his contributions were concerned with social housing, industrial development, and socially functional buildings, including hospitals. The historicist approach of the state-sponsored National Architecture had no support amongst the members of the Anjoman. Although National Architecture was not as widely practised as modern architecture, it had greater political significance for the state. The other important goal of the journal was to present the work of contemporary architects in Iran, thus showing how its primary interest was in the present, not the past.[63] Even more significantly, in other articles of the journal, the principle of historicism is criticised, with modernist architects explicitly condemning revivalism and the reliance of contemporary practice on the symbolic use of historical architectural elements. Vartan Hovanesian, a notable architect of the time and one of the active contributors to the journal, in his seminal

61 Iraj Moshiri, 'Hadaf-e Ma' (Our aim), *Architecte* 1, (July-August 1946), 1–2.
62 Kianouri fled to East Germany after the coup of 1953 and the dissolution of the Tudeh party. There he adopted the pseudonym Dr Silvio Macetti and most of his publications on architecture can be found under this name. For further information on Kianouri's contribution to architectural activities in Iran see Hamed Khosravi, 'CIAM Goes East: the inception of Tehran's typical housing unit,' *Urban Planning*, 4/3 (2019), 154–166. For further information on his political activities in Iran see Nour al-Din Kianouri, *Khaterat e Nour al-Din Kianouri* (Memoires of Nour al-Din Kianouri) (Tehran 1992).
63 For examples of such articles, see *The Architect* issues. 1–4 or alternatively Mokhtar Taleghani 2002, 110–13.

article, *'Masael-e Marbut be Me'mari dar Iran' (The Issues regarding architecture in Iran)*, published in the first issue of the journal, explained this concern:

> In many countries too, the idea of reviving the past methods [*oslūb-e qadīm*] is replaced by the new rational methods that can fulfil the expectations of this century. …Our young architects who finished their studies in Europe and returned to their country found themselves greatly responsible to benefit their country with the fruits of what they have learnt during these years. Common sense [*'aql-e salīm*] cried: stop! Are you willing to turn Tehran into a zoo of chaos! What is the use of all these statues of lions and cows, etc.?[64]

As one of the members of this architectural society, as well as being head of the Faculty of Fine Arts and a member of the Society for National Heritage, Mohsen Foroughi was in a paradoxical position and this paradox is reflected in academic development during his directorship. On the one hand, he was a member of a group that propagated architectural modernism and in particular questioned historical revivalism; on the other, he was a member of the Society for National Heritage, which celebrated the past and was the most active society promoting historical revivalism in architecture. Lastly, as the head of the Faculty, his approach to art and architecture influenced the direction of the School.

The best examples of these contradictions in Foroughi's work are the series of branches he designed for the National Bank in Tehran, Shiraz, and Isfahan, as well as the Senate Building in Tehran, which was a collaboration with Heydar Ghiai and Andrea Bullock. These projects could be seen as modernist buildings, although all have implicit and explicit hints of historicism. Comparing the works of Foroughi with those of Godard and Siroux who designed the Museum of Ancient Iran and its library, demonstrate their different approach towards design. In the case of the Museum of Ancient Iran and the National Library, for example, Godard and Siroux not only relied on archaic references as representative of Iranian architecture and nationalism but also seemed to aim towards re-creating the original

64 Vartan Hovanesian, 'Masael-e marbut be me'mari dar Iran,' ibid., 5–8.

302: Bank-e Melli, near the Bazaar in Tehran.

303: A branch of the Bank-e Melli in Shiraz.

building once again.[65] But in Foroughi's works, the volumes represent a new take on international style, while being decorated with historical patterns around their entrances. Similarly, the Senate building is a modern building, but with elements of historicism in its appearance, including an elevated light façade covering a prism volume with a half-oval plan, while the interior of the main hall shows a hanging ceiling inspired by Sheikh Lotf Allah Mosque in Isfahan; and the sculptural columns of the main façade, designed by Andrea Bullock, represent the mythical hanging chain from the front of the palace of the sixth-century Sassanian king Khosrow Anushiravan the Just.[66]

Despite the interest at the time in modernism, what connects these examples and indeed projects from the mid-1930s to those of the 1950s is this thread of historicism, as a way to sew a building to its socio-political context and to represent national identity. What makes Foroughi's case even more intriguing is the fact that unlike Godard, he was promoting modern architecture at the same time as he was celebrating historical ornamentation. Although educated under the Beaux-Arts system, Foroughi's inclination towards modern architecture reveals the influence of an extensive historical architectural knowledge. His political position, as a member of both Majlis and the Senate and later as minister of culture and science, gave him a deeper understanding of Iranian society, which was itself still dealing with the conflict of modernity within a traditional Iranian context. Foroughi was fascinated by Iranian history, but these conflicts could also have been observed in society at the time, and must be the primary reason for his 'conflictual' modern architecture.[67] In fact, the paradoxical character of his works gracefully represents the 'conflictual' characteristics of modernisation in Iran. In his work, Foroughi seems to have surrendered to this conflict more willingly than did his predecessors. His interest in modernist architecture differentiates his approach from Godard and Siroux, as instead of positioning his work on one side

65 They went even further in terms of material, choosing bricks as a traditional building material in Iran and adopting historical patterns for the brickwork.
66 Ghobadian 2013, 272–3.
67 Mohsen Foroughi was one of the main collectors of Iranian antiques. His collection of Sassanian seals, which was later donated to the Museum of Ancient Iran, also represents his personal fascination with the ancient history of Iran.

or the other of the conflict, he acknowledged and combined both sides in his work.

Similar conflicts are evident in academic developments of the School of Architecture after Foroughi was appointed director of the faculty in 1953. From this point, modern architecture was taught through the Beaux-Arts system of education[68] and without any significant change in the teaching structure. Modern architecture was treated simply as another visual and technical reference, to conform to the Beaux-Arts objectives of design (such as composition and the aesthetics of the plan as well as visual values), rather than in accord with such modern objectives as functionality or the absence of ornamentation. The School's theoretical courses show little change during this time,[69] even though a new group of mostly modernist architects replaced the previous academic staff at this date (except for Foroughi who maintained his atelier). However, in particular projects, especially in collaborations with SNH, all these teaching staff show a degree of historicism in their works. The School now had four ateliers led by Foroughi,[70] Yevgeny Aftandilian, Heydar Ghiai, and Houshang Seyhoun who became the next director of the Faculty after Foroughi.

Students could choose their atelier every year according to their personal preferences.[71] Although the approach of ateliers differed in many ways, the overall inclination of the School was towards modern architecture. Cyrus Bavar, in his memoir of the time, remembers that in the first year, drawing classes and composition practices continued much as they had been from the time of Godard, and focused mainly on the study of the Classical Orders. After that, during the years of the *Premier cycle* and *Deuxième cycle*, modern architecture was taught in design courses, but there was no course on the theories of modern architecture.[72] The only references for the students here were the works of some modernist architects in Tehran as well as a few publications, such as issues of *L'architecture d'Aujord'houi* in the university's library. This method was not successful

68 Bavar 2009, 211.
69 ibid.
70 Parviz Moayyed Ahd and 'Abd ol-'Aziz Farmanfarmaian were also involved in teaching in his atelier.
71 Bavar 2009, 212.
72 Cyrus Bavar, interview with the author, 7 and 9 Aug., 2013.

in providing a proper knowledge of modernism for students, even though it equipped them with design skills to produce works that would correspond visually to a modern aesthetic.[73] Of course, during the 1950s, there were still no textbooks on the theories of modern architecture translated into Persian. Therefore students would learn the principles of the 'new architecture'[74] mainly through the study of its formal appearance, which they then tried to imitate in their studios.

The other aspect of the Beaux-Arts system that remained influential during this time and limited the growth of modern architecture was the importance the school gave to the aesthetic aspects of the composition of plans and to presentation skills. The design of a well-composed plan, from which the elevation and the sections would emerge, remained a crucial point in each student project. When these projects were judged at the end of each year, those with more beautifully composed plans, that were better presented, would receive better grades.[75] The value of an architectural plan resided in the aesthetics of its composition instead of its functionality; so one could argue that the main characteristics of modern architecture were compromised by the dominance of the Beaux-Arts system during Foroughi's directorship.

Perhaps, if the main emphasis of architectural education had been on the functionality of projects, or the way they responded to the brief and the conditions of a changing society, the adoption of modern architecture would have been less criticised later in the 1960s and would have been accepted more easily both by architects and users in Iran. In this case, it

73 For this reason and the fact that modernity in its social sense was not adopted amongst most people, Bavar (see Bavar 2009) argues that modernity *per se* never arrived in Iran, and sees such practices as the 'new architecture' as an architectural trend not much integrated within all levels of society, nor representative of the state of modernity in Iran. As the country lacked a suitable cultural background to support the reforms and the process of modernisation that had started in the early 1920s, these only touched a minority of people, with the majority remaining unfamiliar with such ideas. For Bavar, the case of architecture is no different, as he believes that modern architecture arrived in the school earlier than its theories. Perhaps the fact that Bavar himself was the first person to translate a book on the history of modern architecture in Iran, after his return from Italy, is the best evidence of this claim.
74 Bavar 2009, 471–88.
75 Cyrus Bavar, interview with the author, 7 and 9 Aug. 2013.

would not be the appearance of the modern that was taught at the School of Architecture, but a much deeper, all-too familiar lesson, of dealing with the questions and requirements of each project. We will see in the following chapters that one of the main criticisms of modern architecture in Iran was its inability to represent and respect all aspects of Iranian culture. This would lead to drastic reforms in both academia and in design trends, but if the emphasis had been on responding to the demands of each project rather than merely producing a new – and perhaps in some cases strange – visual appearance, the criticisms would not have had such validity and effect.

The Vernacular: The Faculty of Fine Arts under Houshang Seyhoun (1962–8)

The educational system remained unchanged under Foroughi and under Houshang Seyhoun after him until 1968, but Houshang Seyhoun did manage some notable developments within the existing structure.[76] Seyhoun was himself a graduate from the School of Architecture and later of the École des Beaux-Arts. He had entered the school of Architecture in the first year of its official establishment at the University of Tehran, and received his Diploma in 1944.[77] He was a successful student who seems to have ably absorbed the doctrines of the school, and especially the approaches of Godard and Siroux. This is evident in Seyhoun's collaborations with the Society for National Heritage, especially his first proposal in the competition for a mausoleum for the eleventh-century polymath Avicenna.[78] It was after his success in this competition that Godard suggested Seyhoun move to Paris, to continue his training at the École des Beaux-Arts. After four years of study under Othello Zavaroni, Seyhoun received his *Doctorat d'Etat d'Art* in 1949, returned to Iran, and immediately started teaching at the School of Architecture. In 1962, he became

76 Morteza Momayyez, 'Daneshkadeh-ye Honarha-ye Ziba dar nim qarn (The faculty of fine arts in half a century),' *Kelk* 11 &12 (Jan-Feb 1991), 64.
77 Bani Masoud 2010, 274–5. See also Mohammad Gharipour, 'Goftegū ba Houshang Seyhoun (An interview with Houshang Seyhoun)', Abadi 48 (Autumn 2005), 130–33.
78 Seyhoun was still a student at the School of Architecture when his proposal was successful in the competition.

304: The Mausoleum of Avicenna in Hamedan.

305a: The Mausoleum of
Khayyam at Nishabur.

305b: Interior of the Mausoleum
of Khayyam at Nishabur.

the director of the Faculty of Fine Arts and initiated three new schools, of Urbanism, Music, and Theatre. He was known as 'the architect of monumental buildings'[79] and was involved in the architectural activities of the SNH and later became a member of the Society.[80] His most influential modification of the curriculum of the School of Architecture was to make course trips around Iran compulsory for his students. These trips aimed to introduce students to both significant historical buildings and to rural areas of Iran.[81] As a result, students saw at first hand examples of architecture that they had previously learnt about only through the archaeological lens of figures such as Godard and Pope.

Seyhoun was also a gifted painter, and produced a collection of sketches from these trips. As well as his interest in details, these sketches demonstrate a completely different reading of architecture when compared with the works of Godard and Pope, which had focused only on monumental buildings (Pope's 'kingly art'). Rural architecture seemed irrelevant to many prominent architects of the early 1960s, but during this period, rural and civic communities had come to be increasingly at the centre of attention as a consequence of Mohammad Reza Shah's 'White Revolution'[82] of 1963. Without any commentary, Seyhoun's sketches depict a realistic, up-to-date view of Iran, while examining the vernacular and customary[83] architecture of different regions and landscapes across the whole country.

Seyhoun published his sketches in 1974 in France. Instead of trying

79 Houshang Seyhoun, 'Khat dar khiyal: Zendegi va asar e Seyhoun' (A line in the imagination: the life and works of Seyhoun), interview with Amin Zargham, BBC Persian 2011, http://www.bbc.co.uk/persian/tvandradio/2011/05/110506_tamasha_seyhoun.shtml, accessed online 10 July 2012.
80 Grigor 2009, 135.
81 Bani Masoud 2010, 274. See also Houshang Seyhoun, interview with Amin Zargham, op. cit.
82 The 'White Revolution' was a period of rapid and forceful modernisation launched by Mohammad Reza Shah in 1963. It was partly concerned with land reform and the abolition of feudalism across the country, which resulted in increased attention being given to rural areas, their costumes, and culture.
83 Drawing on Hobsbawm, the term 'customs' (and consequently, 'customary') has been used here to stress and remind the reader of the differentiation Hobsbawm makes between something that has organically become a norm amongst a group of people and has developed throughout time, and those traditions that have been invented at a certain point for a particular representative purpose. See: Eric J.

to depict the past, his *Regards sur l'Iran*[84] shows the present practice of architecture across various communities in Iran outside the bigger cities, and concerns itself with the contemporary state of this architecture. It illustrates architectural examples that are in use by the public and that don't have the monumental aspect of the architectural examples published before. One could conclude from this collection of sketches that the goal of the trips was not to visit the monuments, nor was it limited to the study of one historical period, i.e. pre-Islamic Iran. The aim of the trips was to learn from and celebrate everyday life and traditional architecture, and to explore how this architecture dealt with its context. The trips and the book dissolve the historiographical boundaries between the pre-Islamic and Islamic periods by focusing on the present state of architecture in the most remote corners of Iran, and provided a new source of inspiration for architectural design.

At this point, many prominent architects acknowledged the importance of historical continuity in architecture and were concerned with incorporating traditional aspects of Iranian culture into new architectural projects, but Seyhoun's approach towards learning from the past shows an advance in thinking. As the architect whose designs for SNH were the least iconographical, he pushed the understanding of Persian architecture and the architectural representation of Iranian nationalism away from the representation of icons and toward metaphorical and less imitative representation of concepts. Despite social developments in Iran and the growth of knowledge about Western architecture, Seyhoun did not see Iranian society as being nearly ready to adopt foreign architectural trends, nor were its architects truly familiar with the historical and theoretical basis of Western architecture.[85] To Seyhoun, therefore, the direct emulation of Western architecture in Iran was the biggest threat to the discipline.[86] He called instead for the expansion in the knowledge of architecture in Iran,

Hobsbawm, 'Introduction: inventing tradition,' in Eric J. Hobsbawm and Terence Ranger, eds, *The Invention of Tradition* (Cambridge, 1983).
84 Houshang Seyhoun, *Regards sur l'Iran*, (Paris, 1974).
85 Houshang Seyhoun,'Mosahebeh-i ba Aqa-ye Mohandes Seyhoun (An interview with engineer Seyhoun), *Bank Sakhtemani* 1, (March 1961), 10–13. (Cited in Bani Masoud 2010, 275.)
86 Bani Masoud 2010, 275.

and a proper consideration of its geographical conditions.[87] He saw the impact of the rapid import of modern architecture to Iran as a shock to its architectural traditions, and believed that there was an influential role for 'ordinary people' as clients and users of architecture in the setting-up of trends.[88]

The most significant subject during this period in academic architectural debate became the value to be given to vernacular architecture – to which someone like Seyhoun, who had experience of regional architecture, could redirect academic attention. Whether it was as a consequence of his compulsory course trips, or the cultural aftermath of the White Revolution, this is the period when a deeper level of knowledge of traditional architecture in Iran entered the academic environment. To a great extent, it dissolved the boundaries between the pre-Islamic and Islamic periods in architecture through a closer examination of their technical and functional similarities. Although in most cases these vernacular examples came themselves to be treated as historical monuments, during the mid-1960s, the reading of architecture in Iran seemed to take another turn. It was not only the 'kingly art' praised by Pope in the 1920s; its vernacular and 'traditional' references became significant sources of inspiration. Architectural elements such as windcatchers (*bādgīr*), icehouses (*yakhchāl*) and the *chāhār tāq* (dome on four arches), were studied and celebrated as significant architectural innovations. Their formal appearance was re-used by prominent architects more frequently than, for example, Persepolis in future projects and they became signifiers of Iranian national and cultural identity. Perhaps as the source of these first steps, *Regards sur l'Iran* should be seen in a different light: not only as a collection of drawings by a talented painter, but also as study-records by an architect, and as a way of seeing and reading 'traditional' architecture by a teacher; which could have been even more influential if texts and captions had been included. Although the book was

87 Houshang Seyhoun, 'Gharbzadehgi dar me'mari-e Iran (Westoxification in Iranian architecture)', *Kayhan Hafteh,* 57 (November 1962), 144–51. (Cited in Bani Masoud 2010, 276.)

88 Farokh Ghaffari, 'Mosahebeh-yi ba mohandes Seyhoun darbareh-ye me'mari-e Iran, ba tak kalameh-yi darbareh-ye zelzeleh-ye akhir (An interview with engineer Seyhoun about architecture in Iran, with a mention of the recent earthquake)', *Arash* 5, 1962, 42.

published almost a decade later, it still shows how vernacular architecture was regarded at the time by the School of Architecture, and while teaching architectural lessons on dealing with various contextual problems, it also became an inventory of new inspirations and new forms.

Despite changes during the directorship of Seyhoun, many students felt the curriculum still did not provide them with sufficient knowledge of vernacular architecture in Iran. These same reservations were also felt about historical and monumental architecture. As much as appreciation of the historical heritage was central to their studies, actual knowledge around the subject was scarce. And students who had visited historic sites had been faced with the fact that most of the ruins were in a critically fragile condition. These concerns became the reason for many to seek further education on subjects such as conservation and historical studies.[89] Some, like Mohammad Karim Pirnia (K. Pirnia), sought to expand their knowledge by returning to the traditional practice and pedagogy of architecture. Others decided to travel to Europe and the United States to learn more in the fields of design and conservation. This generation, who were influenced by the new architectural movements in the West during the 1960s, became the next influential academics and protagonists of architectural design, and most importantly of architectural conservation, as it increasingly became a popular subject. For this reason, Italy became the main academic destination of choice for Iranian students and in a few years, graduates from Rome, Florence and Venice returned to Iran.

This generation became influential after the academic reforms at the University of Tehran in 1963 when the American university system replaced the French. Following this reform, the faculties were divided into various schools and groups with a unit-based system replacing the year-based system. The University introduced the position of Assistant Professor , and the undergraduate course increased to four years, with two-year courses beginning at graduate level.[90] Academic years were divided into semesters, while each term consisted of both compulsory and elective course units. As part of this reform, a board of trustees was also established, but unlike the American system, where the members of such boards

89 Cyrus Bavar, interview with the author, 7 and 9 Aug. 2013.
90 Behnam 1994, 102–04.

are often from the private sector, most members here were representatives of the government. These reforms happened in other universities in Iran as well.[91] Such comprehensive changes resulted in the dissolution of the system of ateliers at the Faculty of Fine Arts. Instead five new schools were formed: Visual Arts, Dramatic Arts and Music, Architecture, and Urban Design.[92] Students were given the chance to learn from various teachers, although they lost the opportunity for close interaction with other students at different levels.

The Authentic: The Faculty of Fine Arts under Mohammad Amin Mirfendereski (1968–79)

During these academic reforms, Fazl-Allah Reza, the new president of the university, replaced many of the academic staff with younger teachers, especially in managerial posts.[93] He assigned Mohammad Amin Mirfendereski to be the next director of the Faculty of Fine Arts, who facilitated theoretical studies and further academic changes. Mirfendereski had graduated from the School of Architecture in Tehran, received his PhD in architecture and urbanism from the university of Florence and started teaching at the School of Architecture in 1964. Mirfendereski was one of the students who had questioned the academic system, and upon his return to Tehran, was one of the most active educators. Nader Ardalan, who was a teacher at the School during this period, describes how 'the dominant cultural force in Iranian schools of architecture and engineering shifted from French domination to an Anglo-American bias with some Italian influence.'[94]

These academic reforms transformed the definition of Iranian architecture once more. The transition from 'kingly' to vernacular, which began during the directorship of Houshang Seyhoun, solidified during this period.

91 Iranica: Morteza Momayyez, op.cit.
92 Bavar 2009, 216.
93 Iranica: Morteza Momayyez, op.cit.
94 However, he saw the abolition of the interactive environment of the Beaux-Arts system as one of the failures of the new system. Iranica: Nader Ardalan, 'Architecture viii. Pahlavi, After World War II, II/4, 351–5, accessed online 17 Oct. 2013.

Simultaneously, Islamic and pre-Islamic architectural heritage came to be seen as equally significant and valuable, and were placed under the banner of traditional architecture – even though this gradually revealed a gap between academic and official understanding of national identity as represented through architecture. What remained unchanged throughout this period was a general fascination with the architectural heritage of Iran, which continued as a sort of historicism in architectural design. Nevertheless, in comparison with pre-1968, this period, up until the revolution of 1979, witnessed significant growth in architectural knowledge.

Although Mirfendereski shared the same fascination with the past as previous educators at the Faculty, his approach and agenda were different. Instead of merely focusing on visual aspects of the past and compositional techniques, Mirfendereski and his colleagues were more interested in the rational relationship between architecture and its social context.[95] Since the Iranian context seemed to be not completely a modern one, Mirfendereski defended the necessity of relying on the past in order to connect new designs to their traditional context.[96] He also emphasised the relationship between art and architecture and literature and philosophy,[97] which increased interest in architectural theory, escalated the number of translated books on architecture, and promulgated future interdisciplinary studies. Mirfendereski also worked to establish a platform for architectural discussion and criticism that was a new addition to the academic environment, and connected the contemporary state of architecture in Iran to international discourse. This provided a suitable platform for inviting foreign architects and scholars to the School of Architecture, and several international congresses were organised. These events shaped theoretical reform during Mirfendereski's time. In his own words, 'Architecture was to be transformed from pictures and images into philosophy and thinking.'[98]

At this point, the University added several theoretical and practical classes to the five-year curriculum for studying architecture and urban

95 Bavar 2009, 219.
96 Parvaneh Naraghi and Cyrus Bavar, 'The Design of the Grand Museum of Khorasan,' interview with the author, 5 Aug. 2013.
97 Alireza Ghehari, 'Man va Mirfendereski,' in Iran's Architecture Prideworthies Foundation: http://www.ammi.it, accessed 19 July 2013.
98 Bavar 2009, 135.

design. Classes were now offered on the history of art, the history of modern architecture, and the history of modern urbanism, all of which focused on Western histories and theories. Although there were still no classes on the history of Iranian architecture,[99] a course was offered on Architectural and Urban Conservation. This was the only platform for introducing the examination of historic architecture through a new lens, of identifying historical examples and ascribing value to them with the aim of preserving them. Modernism maintained its strategic place; this time, however, the study of modern architecture was focused on rationality and its relationship with social conditions.[100] Cyrus Bavar's translation of Leonardo Benevolo's *Storia dell'architectura moderna* (1960) was the first and for a long time the only book translated on the subject. Like Mirfendereski and many others, Bavar studied at the university of Florence, and his choice of this work for translation shows the new academic inclinations of the School of Architecture. The visual aspects of modern architecture were emphasised less, and allowed Iranian vernacular architecture to become part of the discussion and to retain its impact and its remarkable role in representing Iranian society.

The next director of the faculty, Mehdi Kowsar, who also was a graduate from Italy, and followed the same academic system.[101] In this period, too, there were strong connections with foreign scholars and architects. Perhaps if taken further, these could have transformed the external view of Persian architecture, from the Orientalist viewpoint that merely celebrated its archaic values to a more pragmatic approach that looked for evolution and development. The fascination with the past did not disappear, but was transferred to the field of conservation. Looking at some of the most celebrated architectural designs produced at this time, both by graduates from the School of Architecture as well as by the many foreign architects who designed significant buildings in Iran, they still retain a great degree of historicism. The architectural representation of national identity in Iran

99 For a general account of the problems of art history in Iran see Nazanin Shahidi, 'Tarikh-e honar va vaz'e-e konuni-e an dar Iran az manzar-e ahl-e nazar (Art history and its current state in Iran from the view point of its commentators)', *Golestan-e Honar* 1, (Spring 2005) 8–35.
100 Bavar 2009, 130–35.
101 Bavar 2009, 220.

had developed and changed since the 1920s, but it retained historicism as its main principle.

This long-term historicism was transformed by a simultaneous social tendency, which gave an oppositional and critical dimension to the appropriation of the past in the architectural representation of national identity and the present. The use of the past was one answer to the issue of nationalism, but it gained even more resonance through an emphasis on the notion of 'authenticity', introduced initially by critics of the government. Here, the value of the Islamic past gradually found a greater significance, which led to the expansion and re-appropriation of mystic and Islamic theories in the intellectual arena, especially in philosophy, as well as in the arts and architecture. This theoretical transformation in architecture should be seen in the broader social context of the period between the early 1960s and the late 1970s.[102] The 'discourse of 'authentic culture', as it has been called, gained prominence in response to a combination of Third-Worldism and the counter-culture movement predominant in the West.' Disenchanted intellectuals first adopted this approach in opposition to the establishment, and by the late 1960s it became an undeniable force against the Iranian regime.[103]

In the early stages of these social changes, at a time of extensive censorship and suppression in Iran, intellectuals used indirect means of criticising the establishment. It led them to draw parallels between the problems of the Third World and Iran, and enabled them to criticise the West and imperialism as the main supporters of the Pahlavi regime. The necessity of establishing an authentic culture was reinforced through the coincidental uprisings of 1968 in the West and established the view in Iran that 'the West could no longer present a solution to their problems.'[104] This was the first step in looking for an authentic 'Eastern culture'[105] by intellectuals. By the early 1970s, the government had also adopted the discourse of 'authentic culture' and consequently, it became important for the government to be able to establish its interpretation of authenticity too. This is evident in

102 Bani Masoud 2010, 240–52. See also Nabavi 2003.
103 Nabavi 2003, 105.
104 Nabavi 2003, 92–94.
105 Nabavi 2003, 94.

the instructions of the cultural programme of the 5th Development Plan (1973–8):

Now that developed societies, entangled in cultural and moral crises, have begun to seek solutions ... we can endeavour to reinforce and consolidate the cultural and moral foundations of [our] society and to [re-familiarize ourselves] (*bāzshenasī*) and strengthen our national identity [as it is] manifested in our national culture.[106]

The government launched various events, festivals and celebrations as well as establishing museums and foundations to promote the kind of authentic culture that conformed to its ideology. All these of course followed previous objectives, especially the programme of nation-building seen in the early years of the Pahlavi monarchy. The focus was on notions such as 'return to roots', and the rediscovery of past cultural heritage. In this respect, the difference between the approach of the government and that of the intellectuals opposed to it resided in their relationship with the West. As the Pahlavi government had strong links with Western powers, its aim was to create a perfect balance between Western-style industrial civilisation and to 'maintain its traditions and national heritage to give a sense of identity to the nation'.[107] Anti-West intellectuals criticised this approach as no more than another way of viewing the East through the Orientalist lens of the West. They inclined toward mystical and religious culture, as it offered a traditional alternative approach, different from the Western and the regime's idea of an 'authentic culture'.[108]

Whether state-sponsored, or leftist, the field of architecture became the platform for the manifestation of both sides of the 'authenticity' debate. Criticism of the modern was shared ground, while the issue of Westernisation or *Westoxsification* as a social malady, and consequently, the inclination of the Left towards mysticism and religion, marked the the critical point where the two trends diverged. However, both sides showed a great deal

106 Changiz Pahlavan, 'Barnamehrizi-ye farhangi dar Iran' (Cultural planning in Iran), *Farhang va Zendegi* 15 (1974): 55. (Cited in Nabavi 2003, 97.)
107 Changiz Pahlavan, op. cit., 55.
108 Nabavi 2003, 105.

of attention to architecture as a communicative and effective discipline. There were various platforms where the state either employed architecture as a communicative tool, in the same fashion as it was used in previous years, or sponsored architectural development and transformations, both through publications and international congresses that sought to establish 'The Interaction of Tradition and Technology'.[109] At the same time, within academic circles, the new teaching environment at the Faculty of Fine Arts after the reforms of 1968 allowed for extensive communication among different disciplines, especially with the departments of Philosophy and Literature, which were the locus of both critics and pro-regime figures. The result of such collaborations provided the platform for the further production of architectural knowledge, and a deeper exploration of the architecture of the past in Iran and of the notion of identity.

The Development of Architectural Histories and Theories

The expansion of architectural knowledge and the academic reforms resulted in the emergence of different readings of architecture in Iran and consequently, the architectural representation of Iranian national identity. Historical knowledge of Iranian architecture, which had begun with the description of famous ancient buildings in travelogues, developed through archaeological studies from the late nineteenth century onwards. After the establishment of the Faculty of Fine Arts, this field was developed more independently by the architects themselves; and from the 1960s a number of significant works were published on the subject. The increase of attention given to architecture other than monuments and examples of the 'kingly art' resulted in a reading of architecture that was much closer to everyday life and public practice. An example such as *Regards sur l'Iran*, without recognising itself as an historical or theoretical book, dem-onstrates the difference between Seyhoun's academic approach, and that found in the state-sponsored publications of the time under the title of 'Persian Architecture,'[110] such as Arthur Pope's *Persian Architecture* and Andre Godard's *The Art of Iran*.

109 See Bakhtiar 1970.
110 It is worth remembering that the word 'Persian' has not still been replaced with

Nevertheless, the majority of publications on the subject suffered from the lack of an inclusive approach towards history, portraying – if not highlighting – a discontinuity between pre-Islamic and Islamic architecture and the 'hierarchical categorisation of objects,' according either to their monetary value or to political preferences. This resulted in what has been called the 'monumentalism in historiography,' instead of investigating the broad range of vernacular architecture and its social aspects.[111] Despite the profound ideological difference before and after the revolution of 1979, the propagation of national and cultural identities in Iran remained persistently historicist. Whether it was focused on pre-Islamic history during the reign of Reza Shah Pahlavi (1926–41), or on a more eclectic collection of both pre-Islamic and Islamic references during Mohammad Reza Shah's reign (1941–79), or on Islamic elements after the revolution of 1979, the construction of national identity in Iran has always depended on various interpretations and representations of the past. In this larger picture, however, there exist important nuances and varying interpretations during each period.

Persian Architecture at a Glance: **Mohammad Taqi Mostafavi (1967–71)**

One of the first books published by an Iranian scholar of this time that aimed to give an overview of the history of architecture in Iran was *Persian Architecture at a Glance* (1967), by Mohammad Taqi Mostafavi.[112] Although he came from an archaeological rather than architectural background, Mostafavi's publications on architecture, on several official occasions, are the best representation of the official narrative of architectural heritage.

the word 'Iranian' in many similar publications. Despite the official demand of the government to refer to the country as 'Iran', as its original name, scholars such as Pope, in his *Persian Architecture, The Triumph of Form and Color* (which was published in this period), and Mohammad Taqi Mostafavi (see below) continued to use the terms 'Persia' and 'Persian' in their publications.
111 Mohammad Gharipour, 'Introduction: shifting the historiography of Persian architecture', in Mohammad Gharipour, ed., *The Historiography of Persian Architecture* (London, 2016), 1–13.
112 Mostafavi 1967.

Together with some semi-official publications, such as Pope and Godard's work, and more academic and independent publications, these examples present a spectrum of approaches in architectural historiography.

Persian Architecture at a Glance was published for Mohammad Reza Shah's coronation in 1967. Mostafavi was an active member of the SNH and was involved in many archaeological expeditions, meeting Herzfeld during the latter's excavations at Persepolis. In *Persian Architecture at a Glance*, Mostafavi follows the historiographical tradition of Hassan Pirnia, the writer of *Tarikh-e Iran-e Bastan,* especially in terms of the division of historical periods. Assuming a pivotal role for Achaemenid architecture, Mostafavi introduces pre-Achaemenid and Achaemenid architecture as the first and second significant periods in Iranian architecture. Similar to Godard's approach in *The Art of Iran*, he then omits the five hundred years of the Seleucid and Parthian eras, arguing that the remains of Seleucid buildings and temples 'do not show any specifically Persian characteristics appearing at that time'[113] and moves on to the architecture of Sassanian period.

Mostafavi put the rest of the history of architecture in Iran under the title of 'Islamic Architecture' and finally dedicated the last chapter of his book to 'The Architecture of the Last Hundred Years'. Being active in the field of archaeology, Mostavafi's general approach towards the subject is similar to that of the archaeologists who had worked on the sites he describes, and in several cases directly represents their archaeological reading of these buildings.[114] The characteristics that Mostafavi associates with Persian architecture are limited to components significant in the architecture of each period but that reoccur in different periods. For example, elevating the volume of buildings on a raised foundation and the use of *chāhār tāq* and iwan as the most prominent forms of the spatial configuration of architecture in Iran. Focusing on these elements of Sassanian architecture, which were influential in the formation of Islamic architecture, Mostafavi identifies a sort of continuum throughout the history of architecture in Iran,

113 ibid., 39.
114 For example, the section on the pre-Achaemenid period and the architecture of the Medes was directly based on the outcome of Roman Ghrishman's research and excavations in tsouth-west Iran, especially at the site of Chogha Zambil.

and follows the development and transformation of these forms.[115] He also shares another point of conformity with Godard and Pope in describing how Persian architecture represents an ability to combine the old with foreign elements to produce something new, valuable, and original. Mostafavi quotes the archaeologist Roman Ghrishman, on this point with regard to Iranian, especially Achaemenid, architecture:

> Professor Ghrishman believes that Pasargadae affords a glimpse of the vast horizon of Persian art, the beginnings of which are still unknown to us. This art, which combines winged Assyrian bulls, statues placed on the side of halls, Hittite in the colourful Babylonian manner and borrowings from Egyptian styles, remains in essence a representative example of the national culture of Iran, which was quite progressive for the time. Whatever was brought from the outside was changed and mixed with other elements to produce a new art. This art [was] especially sensitive to colours and shades of light and dark, showed itself in alternative use of black and white stones. It was also most successful, and surprisingly advanced in portrayal of the human profile and such things as draped clothing. All this, whether borne of innovations or borrowed from other nations, was moulded into a distinctly Persian style.[116]

Mostafavi tried to connect this abbreviated history to the present time and to include projects supported by the SNH as being among the best examples of Persian architecture and the ones that were most successful in following their predecessors. Having connected SNH projects to other celebrated moments in the history of architecture in Iran, Mostafavi suggested that the architecture of his own day should follow the same approach. In other words, one could conclude from the book that since Persia has always been a mosaic land, and has had close connections with both East and West, Persian architecture was successful in bringing in various forms, symbols, and styles, and recreating from them a new and original product. If the contemporary is considered as part of the same

115 Mostafavi 1967, 50–55.
116 ibid., 26.

continuum, its successful architecture should be able to follow the same tradition.

It is important to mention here that the final pages of the book act as a sort of treatise, giving directions towards future architectural developments. It allows for, and in fact calls for, learning from the architecture of the past. It also appreciates the type of historicism embodied in the design of mausoleums and other buildings by SNH; however, Mostafavi cleverly distinguishes between these and constructions of the first decades of the twentieth century. He sees a kind of advancement in appropriating historical elements in these buildings, whereas those of Reza Shah's period merely copied a few decorative motifs.

> With the exception of the Archaeological Museum [the Museum of Ancient Iran], …foreign engineers and Iranian engineers unacquainted with the history of Iranian architecture have failed to utilise the principles of traditional Iranian architecture in the construction of large governmental buildings. In spite of a lack of attention and apathy, patriotism and respect for the traditional have caused a revival of Iranian decorative techniques in some royal buildings. If we consider the Shahvand Palace in Sa'dabad, the Marble Palace in Tehran, the impressive Officers' Club, the National Bank Building, the Palace of Justice, City Hall [the Police Headquarters] and the Records' Office, we can see the degree of the builders' discrimination and their taste in selecting Iranian techniques and decorative motifs for better or for worse. …Now that the level of taste, education and artistic discrimination have surely risen, neither the elite nor the public at large favor the works of architects who ignore Iranian architecture. Large buildings which are simply imitations of non-Iranian architecture are constantly criticized. …Fortunately, the number of well-qualified architects who prize Iranian national architecture is increasing. Their use of Iranian elements and techniques can be noted in the National Bank Buildings with their hand[s]ome tile work, the tomb of Reza Shah, the tomb of Ferdowsi, Hafez, Saadi, Abu Ali Sina, Omar Khayyam, Baba Taher, Sa'eb, and Nader Shah, the Iranian Pavilion at the recent Brussels World Fair, and above all, the Iranian Pavilion at Expo 67 in Montreal. It is certain that with the passing of time the art

of architecture in Iran will achieve the position it deserves in the eyes
of world history and civilization.[117]

Such differentiation could only be possible through a closer study of
past architecture and an increase in archaeological knowledge as well as
a more advanced approach towards architecture. Since Mohsen Foroughi
and Houshang Seyhoun consulted on the book, these final paragraphs also
show part of their concerns. Perhaps the fact that Mostafavi distinguishes
two phases in National Architecture is another consequence of this col-
laboration. He differentiates between the first phase of National Architec-
ture around the Parade Ground of Tehran and the buildings later put up
mainly as memorials by a new generation of architects such as Seyhoun
and Foroughi themselves. The influence of Seyhoun in this publication
is also evident in the introduction, where Mostafavi mentions vernacular
architecture as another valuable source of knowledge and inspiration from
the past. Finally, as had Pope, Mostafavi sees the future of architecture in
modern Iran in looking back at these examples. He may only have sug-
gested learning from historical examples here, without being historicist
in the sense that one should in one way or another re-use or revive such
'architectural elements', yet the examples he considered successful in
modern times display the quality of historicism to a significant extent.

The important historical buildings of Iran have naturally gained the
praise of art lovers and connoisseurs, but even in the unknown villages
and mud huts of this land there are architectural elements of much
significance and precision which cannot fail but be of interest to those
familiar with the intricacies of architecture. …It is to be hoped that in
accordance with the progress made during these felicitous times and
through the improvements in knowledge and culture of modern Iran,
sons of this land will deem it their duty to know the works of their
ancestors and to base their future efforts on these works and thus to
succeed today by understanding and appreciating the past.[118]

117 ibid., 94–96.
118 ibid., 13.

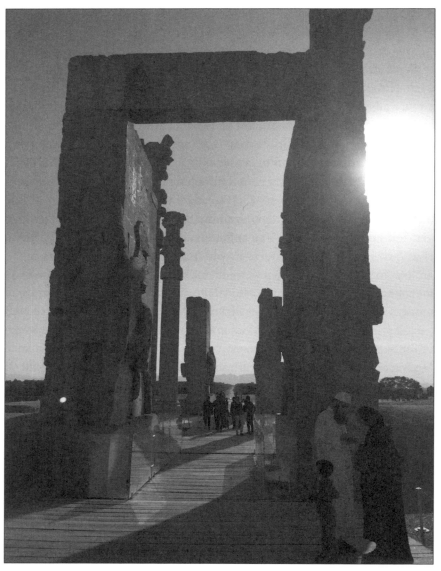

306: Entrance gate at Persepolis.

In 1971, as a memorial edition for the 2500th anniversary of the establishment of the Persian empire by Cyrus the Great, Mostafavi published *Estemrar-e Honar-e Memari dar Iran* (The continuity of the art of architecture in Iran).[119] In contrast with his previous publication, which emphasised the significance of Sassanian architecture in the creation of a sense of continuity, this volume focused only on the case of iwan as a key element of continuity in Iranian architecture, which in contrast to *chāhār tāq*, can be traced back to the earlier Achaemenid era. The *chāhār tāq*, which before this was considered the genius of pre-Islamic architecture, only appears in a few sentences of the book, and is treated as secondary at best. If until now, iwan and *chāhār tāq* together had been considered the key Iranian contributions to Islamic architecture, this book repositions the Achaemenid contribution. This could be because the main focus of the 2500th anniversary celebrations was to present Mohammad Reza Shah as the rightful successor of Cyrus the Great, the founder of the Achaemenid empire. In other words, *chāhār tāq*, which had been considered as the genius of Parthian and Sassanian architecture, lost their national significance in architectural histories of the second half of twentieth century. In return, and at least in the more politically inclined version of architectural histories, Achaemenid architecture received more attention.

'The Stylistics of Architecture in Iran': Mohammad Karim Pirnia (1968)

In a parallel attempt and outside the academic environment, Mohammad Karim Pirnia carried out similar research, publishing this in a book that became more influential than almost any other as soon as it was published. K. Pirnia was a student enrolled at the School of Architecture during the first years of its establishment in 1940. He had been born and raised in the historical city of Yazd in central Iran, which because of its arid climate has developed a famous and highly adapted architecture. Even before starting his academic education, K. Pirnia had been fascinated by the architecture of Yazd and repeatedly mentioned that his appreciation for architecture began in this city. He kept

119 Mohammad Taqi Mostafavi, *Estemrar-e Honar-e Memari dar Iran* (The continuity of the art of architecture in Iran), (Tehran 1971).

a nostalgic fondness for it throughout his academic career.[120] After entering the School of Architecture, K. Pirnia showed a promising talent, built on his extensive knowledge of architecture in Yazd. As well as his design skills, he gained the attention of his teachers, Godard and Siroux, by incorporating vernacular elements or a verse from a poem into his work.[121] However he was not interested in Beaux-Arts architecture, which was still dominant in the School. According to his memoir, Pirnia felt that there was not enough attention paid to 'national art'. It seemed to him that the Faculty had prioritised following the Beaux-Arts over the lessons one could learn from the historical art and architecture of Iran itself. Disenchanted, he left the School of Architecture before graduation and followed his own interest, which was to learn from traditional architects and to study architecture outside modern institutions. He introduced a profound knowledge of vernacular architecture in Iran, and helped to cover gaps in the field of architecture at the time. To him, his role was that of 'a depository and a messenger,' who would transmit the knowledge he had learnt in this way to academia.[122]

K. Pirnia returned to the University of Tehran in 1965, after working for the Department of Antiquities and the Ministry of Culture and Arts, where he was responsible for several restoration projects and started to teach courses on restoration. He remained one of the most influential figures in architectural history despite his limited connections with the School of Architecture, especially in the early years. He rarely finished drafts of his books, with most of his works being collected and published by his students after his death.[123] But he attended almost every conference held in Iran and published a large number of journal articles. His first article was published in the proceedings of the Fifth International Congress of Iranian Art and Archaeology in 1968, held in Tehran, Isfahan, and Shiraz.[124] Of

120 Ghalamsiyah 2002, 26.

121 ibid., 27.

122 Mohammad Karim Pirnia, 'Pirnia as zaban-e Pirnia' (Pirnia from Pirnia's words), in Ghalamsiyah 2002, 31.

123 These are still some of the most important textbooks for students of architecture in Iran.

124 The International Congresses were the legacy of Arthur Upham Pope, who initiated the series in the 1920s. The 1968 congress was the fifth, and the first to be held in Iran.

course, architectural history was still almost exclusively dominated by archaeology, as having more followers and patrons, so it seemed natural that the congress should include K. Pirnia's paper. It is also worth mentioning that this article was the only one out of 109, all of which covered archaeological subjects, on Iranian architecture, and the first not to use the accepted periods of architectural history.[125]

The title of this article was 'The Stylistics of Architecture in Iran'. K. Pirnia identified six styles in Iranian architecture.[126] He suggested that the names of each style should represent their place of origin, instead of the dynasty ruling the country. Thus, his six main styles were Parsi, Parthi, Khorasani, Razi, Azari and Isfahani. In each case, formal characteristics were discussed as a list and in several general examples. For the first time, he argued for a reading the history of architecture that was not confined within a political framework, but was approached from a visual, functional, and technical point of view. For example, in the case of the Persian style (Parsi) that covers the Achaemenid period, Pirnia gave a list of eleven general physical characteristics that would be common to most of the buildings of the period; while also seeing it as a continuation of previous styles. These characteristics include: constructing the main building on a raised foundation; having a maximum distance between columns; flat roofs; polished and intricate stone-cutting; construction of internal walls with adobe and covering them with tiles and paint; access to utility spaces that are out of sight; exterior spaces between buildings that include water fountains and flowerbeds; shadings over windows and entrances; well-finished floorings; and decoration and reliefs on stairs and doorways.

He discussed this Parsi style in particular detail. His analysis consists of characteristics related to construction methods and material selection, yet he hardly touches upon spatial qualities, urban configurations, symbolism of decoration or specific forms, and the way each of these styles would perhaps address social, religious, and individual life. Although K. Pirnia tried to distance himself from archaeological historiography, his view is still closer to archaeology than it is to architecture. This is evident in the

125 See: M.Y. Kiani and A. Tajvidi, The Memorial of the Vth International Congress of Iranian Art and Archaeology, vol.1 (Tehran, 1968).
126 Pirnia 1968, 36–50.

first paragraphs of the article, where he describes architecture as 'the art of systematically composing parts and fragments.'[127] The main critique of his methodology would not revolve around the fact that his periodisation is based on visual transformation, or the fact that he only focuses on physical appearance. The main critique is that he only introduces six styles for more than three thousand years of history in a climatically diverse land with fluid political and cultural borders. These aspects are hardly addressed in his article, which consequently is a very generalised account of architecture that reads as a continuous narrative. Such a strong sense of historical continuity remained the strongest defence for the revival of past forms in new designs to make the latter representative of Iranian identity.

Apart from its historiographical importance, this particular article had a strategic significance. The International congresses of Iranian art and archaeology were specific events, initiated by Arthur Pope and sponsored by the Pahlavi government not only to generate knowledge but also to promote the historical heritage of Iran globally.[128] The educational reforms initiated by Reza Shah provided the academic basis to host such events in Iran. Several governmental institutions supported them, while Mohammad Reza Shah and Shahbanu Farah were patrons. K. Pirnia finished his article in a manner very similar to the way Pope ended his presentation in 1925. Acknowledging the reforms and developments under the reign of the Pahlavi monarchs, he mentions the time as being suitable for the inauguration of a new style that could carry the name of Pahlavi into the future.[129] With many statesmen and the shah in his audience, he described maintaining and contributing to the historical heritage of Iran as a responsibility of the government, and thus managed to strengthen the ties between politics and architecture once again.

At last, now that the era of developments has started by the decree

127 Despite his critical view of Beaux-Arts architecture, this approach still shows the influence of the educational system at the School of Architecture on his understanding of architecture. See Pirnia 1968, 37.
128 Kishwar Rizvi, 'Art History and the Nation: Arthur Upham Pope and the Discourse on "Persian Art" in the Early Twentieth Century', *Muqarnas* 24 no.1 (2007), 45–65.
129 Pirnia 1968, 49.

of Shahanshah Aryamehr, I hope through the efforts of young and talented architects, a new style appears that is worthy of the prestigious name of Pahlavi.[130]

The Sense of Unity: Nader Ardalan and Laleh Bakhtiar (1973)

The other seminal publication to come out of the academic reforms of 1968 was *The Sense of Unity: The Sufi Tradition in Persian Architecture* (1973) by Nader Ardalan and Laleh Bakhtiar, with an introduction by Seyyed Hossein Nasr.[131] As a highly referenced theoretical book, it is a product of interdisciplinary collaborations in an academic environment, and addresses the main topics of the time – authenticity and traditional architecture. *The Sense of Unity* brought the architecture of the Islamic era to great attention and gave it a disciplinary value equal if not more than that of pre-Islamic architecture. The book was first published in English in 1973 by the University of Chicago Press on the occasion of the 2500th anniversary of the foundation of the Persian empire, the same event for which Mostafavi's *The Continuity of the Art of Architecture in Iran* was also published. In contrast with Mostafavi's publication, which followed the theme of the celebrations and emphasised Achaemenid architecture, *The Sense of Unity* is a study of architecture in Iran through the lens of the Sufi tradition, which gives it both historical and ideological limits and consequently a deeper, less descriptive insight into the subject.

The idea of writing *The Sense of Unity* came to the authors from Seyyed Hossein Nasr, a prominent Islamic philosopher who had arrived at the University of Tehran[132] and soon became director of the Faculty of Letters.[133] To groups in search of their own notions of authenticity and tradition, Nasr seemed to be a moderate, and he remained an influential thinker in arts and architecture. His fascination with Islamic thought had deep roots in his upbringing and education in the United States. Nasr used his position to change the structure and philosophical approach of the time

130 ibid.
131 Ardalan 1973.
132 Bani Masoud 2010, 247–8.
133 He later became the president of Aryamehr University and the head of Shahbanu, Farah Pahlavi's private office.

at the University (which, like other faculties, was directly under French intellectual influence), and replaced it with a focus on Islamic philosophy and on his own area of expertise: perennial philosophy and the Sufi tradition. He initiated the teaching of Islamic philosophy from the Islamic perspective, based on its history, and encouraged his students to study other philosophies and intellectual traditions from their own point of view. He maintained that one couldn't hope to understand and appreciate one's own intellectual tradition from the viewpoint of another, just as one could not see oneself through the eyes of another person.[134]

Nasr had an influential role in the publication of two books on the subject of the art and culture of Iran. He co-authored *Persia, Bridge of Turquoise* (1975)[135] with Mitchell Crites and provided the philosophical framework for *The Sense of Unity* in its introduction. The idea of writing a book on the philosophy of Iranian architecture was suggested to Nasr by the University of Chicago while he was a professor in Tehran. At this time Laleh Bakhtiar, who had studied Law, Design, Literature and Art History and who later became an Islamic author and psychologist, was his student.[136] Nasr suggested the writing of such a book to Bakhtiar and her husband Ardalan, based on the Sufi tradition and its effects and 'levels of realizations' in architecture.[137] The book aims to trace and interpret the manifestations of Sufism in architecture and is the result of a close collaboration between experts on Islam and mystical philosophy with an architect. This collaboration and the absence of an archaeological approach give the book a distinctive character when compared to previous publications. It overlooks chronological order, with each element being studied outside its historical lineage or context, and looks directly at the relationship between the Sufi tradition and architecture. Arguably, the book is more about how

134 'About Seyyed Hossein Nasr,' Nasr Foundation, http://www.nasrfoundation.org/ bios.html, accessed online 18 April 2014.
135 Seyyed Hossein Nast, Mitchel Crites and Roloff Beny, *Persia, Bridge of Turquoise* (London, 1975).
136 Since my focus is on the architectural contribution of the book, my discussion of it focusses on Ardalan's role as the only architect of the group. Nevertheless, Bakhtiar's multiple specialties and her significant contribution should not be underestimated.
137 Bani Masoud 2010, 269.

the architecture in Iran could be seen through the lens of Sufism than how Sufism has changed and revolutionised architecture in Iran, since it mostly has a retrospective, explanatory, and comparative approach to the latter.

Although the idea and the philosophical framework of the book did not come from Ardalan, the architectural material and its symbolic interpretation in this framework would only have been possible for an architect who had previous field research in Iran, who knew about the fundamental principles of the discipline, and who chose the key elements discussed in the book. Ardalan had moved from San Francisco to Masjed Soleyman in the south-east of Iran in 1964 as the 'architect in the field' for the National Iranian Oil Company. Soon after his arrival, 'the splendour of Persian art and architecture captured his imagination.'[138] It was during this stay that he met the archaeologist Roman Ghrishman, who was working on several sites in the region such as Chogha Zanbil (1250 BCE). As he visited these ruins and observed the process of excavation, Ardalan started to appreciate the value of historical architecture.[139]

Once Ardalan had moved to Tehran and started teaching at the School of Architecture, he became aware of a vacuum in architectural knowledge in Iran. Although Pope's *Persian Architecture* was still a core text, it suffered to a great degree from Orientalism and a descriptive approach towards architecture. 'In response to this need, documentation on authentically Iranian cultural values and belief systems began to proliferate, revealing the metaphorical nature of Persian expression in the visual, aural and literary arts,' Ardalan said.[140] It was in such a theoretical vacuum, and simultaneously with an increase in political and academic interest in authenticity, that books such as *The Sense of Unity* were conceived.[141]

The book starts with Nasr's extensive introduction, which not only

138 'About Nader Ardalan,' Ardalan Associates, http://ardalanassociates.com/about/about-nader-ardalan/2/2014 accessed online 16 April 2014.

139 ibid.

140 Iranica: Ardalan, 'Architecture viii. Pahlavi, After World War II'.

141 Ardalan himself identifies three publications of the time that aimed to fill this theoretical vacuum: his book, *The Sense of Unity: The Sufi Tradition in Persian Architecture*; Mahmud Tavassoli's *Architecture in the Hot Arid Zone,* (Tehran, 1974); and Seyyed Hossein Nast, Mitchel Crites and Roloff Beny's *Persia, Bridge of Turquoise* (London, 1975).

defines its philosophical framework but also explains the necessity of acquainting the reader with the Sufi spiritual tradition. Nasr sees the relevance of re-adopting a traditional world-view as a consequence of the failure of modernity to equip humankind with an understanding of higher transcendental truth. He then defines tradition as a vibrant notion with a transcendental origin in which religion becomes its key aspect and consequently affects its manifestation in arts.

> To speak of tradition is to speak of immutable principles of heavenly origin and of their application to different moments of time and space. It is also to speak of [the] continuity of certain doctrines and of the sacred forms, which are the means whereby these doctrines are conveyed to men and whereby the teachings of the tradition are actualized within men. ...Tradition, as here defined, is not costume or habit; nor is it the transient style of a passing age. Tradition, of which the most essential element is religion in its universal sense, continues as long as the civilisation which it has brought into being and the people for whom it is the guiding principle survive. ...Where tradition governs, namely in the traditional societies ... every facet of life ... is related to the tradition's spiritual principles. In fact, the arts are among the most important and direct manifestations of the principles of the tradition, for men live in forms and, in order to be drawn toward the transcendent, they must be surrounded by forms that echo transcendent archetypes.[142]

In teaching architecture, Nasr differentiated between the 'traditional' and the academic methods. Focusing on Islamic tradition, he argues that traditional methods are more relevant to their society since they have a closer relationship with their context, whereas modern academic systems tend to have a detached, elitist approach. For Nasr, Bakhtiar, and Ardalan, this method of teaching is the key factor that connects architectural design to traditional society and therefore provides its full accordance with other aspects of life. Hence it provides the sense of unity that is the main characteristic of Islamic society.

142 Ardalan 1973, xi, xii.

From the traditional point of view, man and the cosmos are themselves works of 'sacred art'. In their ontological reality, man, the cosmos, and sacred architecture are utterly dependent upon the Divine, while from the point of view of knowledge it might be said that traditionally, cosmology, anthropology, and the 'philosophy of art' are all so many applications of metaphysical principles to various domains. ...The unitary point of view of tradition embraces not only architecture in its totality but all of the elements that together create an architectural form, such as space, shape, light, color, and matter. Because the unitary point of view so emphasised in Islam leaves nothing outside its scope and refuses to recognise a legitimate domain of the purely secular or profane in contrast with the sacred, all Islamic architecture, whatever its use, is seen in its traditional setting in the same light as the strictly 'sacred' architecture such as that of the mosques.[143]

This point regarding modes of education and the Islamic world-view became more popular after the Revolution of 1979. It was during the post-Revolution period that the book was translated into Persian for the first time, and became one of the key works of reference in architectural discipline. It also backed up the ideological transformation in architectural education and legitimised the continuation of this tradition as the architectural manifestation of the new 'Islamic society'. Of the three chapters of the book ('The Morphology of Concepts', 'The Concept of Traditional Forms' and 'Levels of Realization'), the first two describe the symbolic relationship between transcendental notions in Sufism and architectural concepts and elements. The third chapter takes the analogy to the urban level and looks at the synthesis of order and unity in various forms of urban expansion. Finally, it puts forward the city of Isfahan as an example of 'man's ability to breathe life into and transform his built environment to create a sense of place.[144]

The second chapter, which looks at elements in Islamic architecture, identifies eight cases that are particularly evident in the architecture of Iran: the garden, socle, iwan, gateway, room, minaret, dome and *chāhār-tāq*. It

143 ibid., xii.
144 ibid., 96.

is obvious from the text that they were selected because they are the 'out-standing generic forms [which] constitute the fundamental building blocks of traditional architecture'.[145] Yet one could question why the authors did not see the value in other architectural elements that have a functional rather than visual importance, for example, the windcatcher, *ābanbār* (water reservoir), *yakhchāl* (ice house) or qanat (an underground water management system). Without being visually prominent, they could argu-ably also represent aspects of 'Iranian tradition' since they are designed to serve the particular needs of Iranian society. The function of the last three are directly related to the storage and distribution of water, fairly and in the best possible condition. The element of water, as explained in the book, has a 'traditional' significance; additionally, its methods of distribution have deep roots in Islamic culture. This point makes the book's selection seem somewhat subjective and perhaps as following previous architectural debates and publications. Many of these elements, such as socle, porch, dome and *chāhār tāq* had also been discussed by authors such as Godard and Pope in their works, albeit not as an invention of the Islamic era, but a continuation of a pre-Islamic architectural tradition.

The Sense of Unity is a thorough comparative study of various archi-tectural elements that ties even those not necessarily specific to Iran or its Islamic period to the mystical Sufi tradition. This point has been the cause of most of the criticism of the book. Bani Masoud sees the authors as 'entangled' in Nasr's philosophical framework and therefore trying to extract aspects of this philosophy from every architectural element. Other critiques, such as Lisa Golombek's, see as its main problem the lack of architectural documentation and comparison with other Islamic examples from the rest of the Middle East. Nevertheless, she maintains that it is 'the beginning of a dialogue. Its chief virtues are two-fold – that it introduces the Western scholar to how the Sufi viewed his architecture and, secondly, to introduce a series of ideas which spring from this tradition and which, for this reason, are more appropriate to the study of Persian architecture than Western methodology.'[146]

145 ibid., 75.
146 Lisa Golombek, 'Book Review: The Sense of Unity: The Sufi Tradition in Persian Architecture, by Nader Ardalan; Laleh Bakhtiar', *Iranian Studies*, 8/1&2 (1975), 97.

The International Approach to a Nationalist Question: The Architectural Congresses of 1970 and 1974

The new academic environment facilitated the publication of books such as *The Sense of Unity* as a way to investigate the notion of authenticity and represent the significance of a mystic tradition in architecture. After the reforms, the focus in design was not on creating the most beautiful composition in plan any more, while historical and especially vernacular architecture came to be seen as a resource for the production of visual authenticity and for representing national identity. The process of architectural design now included proper reflection on the conditions of a society that was considered to be traditional.[147]

In a broader view, the notion of a traditional or authentic society was not an issue limited to the critics and thinkers of academia. The government itself was in search of an interpretation and definition of authenticity. The initiation of the International Congress of Architecture in 1970 represented the government's willingness to collaborate with academia on this issue.

The First International Congress was one of the significant (and rare) moments when the problems of contemporary architecture in Iran and the aftermath of Conflictual Modernisation were projected externally and addressed in collaboration by a number of international experts. The Ministry of Housing and Development, in collaboration with the Ministry of Fine Arts, the Faculty of Fine Arts of the University of Tehran, and the Iranian Association of Architects initiated and sponsored the event; and a number of prominent Iranian officials and architects, such as Seyhoun, Mirfendereski, Kowsar, Ardalan, and other teachers of the School of Architecture were involved in holding the congress, while Mohsen Foroughi, who was a senator at the time, was elected president of the conference.[148]

147 It is important to consider the difference between the notion of tradition here, and Hobsbawm's definition of the term in *The Invention of Tradition*, where tradition is considered as a constructed entity. Here, tradition means the customs and the existing design and building techniques that have evolved in Iran throughout history.
148 Due to his extensive architectural background, combined with the social knowledge that he gained in his government positions, Foroughi was a significant contributor to this event. In fact, his presence was more evident than that of Mirfendereski or of his successor, Mahdi Kowsar, as director of the faculty and an active protagonist in architectural education at the time. The theme of the conference

The Congress was held in Isfahan, and in its title focussed on the central question of architecture in Iran at the time: 'The Interaction of Tradition and Technology'. This title alone suggests a change of lexicon and intimates how the main contradictions and conflicts around this interaction were being formulated. In essence, the aim of the Congress was to address the conflicts that had followed modernisation in Iran and to investigate how modernisation challenged the simultaneous historicist project of nationalism.[149] The title of the conference suggests a very subtle yet significant transformation in these ideas: the vernacular, national, and in one word Iranian aspects of architecture are to be understood through 'tradition', while modernisation is limited to the employment of technology. The conference was thus not looking for a way to merge or connect the two ideas, or even to debate the validity of either notion at that time in Iran, but had succumbed to the idea of associating contextual considerations (that is, national or other collective values) with 'tradition,' and diminishing modernity to 'technology'.

This issue was one of the criticisms of modernity raised globally in the late 1960s, and of the cultural challenges that emerged in countries outside the immediate context of modernism. The title of the Congress becomes therefore a proclamation of such conflicts, even as the conference itself aimed to reconnect 'traditions', as an evolving aspect of Iranian identity and an inheritance from the past, with the present. And since the aim of the Congress was to create an international 'think-tank' on this issue, the committee invited eighteen architects from fourteen countries, including George Candilis, Buckminster Fuller, Luis Kahn, Paul Rudolph, Philip Will, and Oswald Ungers.[150] Some of the guests, such as Ludivicio Quaroni, were former teachers of the new generation of educators at the

also resonated with Foroughi's design concerns as reflected in his architectural practice, especially in his designs for branches of the Bank-e Melli.

149 In many respects, it is possible to see the projects of modernisation and nationalism that began earlier under Reza Shah as contradictory approaches towards the same goals: to maintain territorial integrity and to develop the country. The two projects complemented each other despite internal contradictions that would remain for years to come. As both projects were formulated with a top-down, elitist framework, they remained in conflict with contemporary conditions of society as well.

150 Kuros Amouzegar, 'Preface', in Bakhtiar 1970, ix.

Faculty.[151] As with previous archaeological congresses, Shahbanu Farah Pahlavi supported the four-day event with her presence and even entered into discussion with some of the participants, such as Georges Candilis.

In his opening speech, Mohsen Foroughi began by describing the past success of Iranian architecture, up until the beginning of the Qajar monarchy at the end of the eighteenth century, when the country went through a period of economic and social decline. Pointing out that the period of decline was over, and that socio-economic growth had made possible the 'hope to catch up with time', even as 'the relation between traditional architecture and the contemporary one has been interrupted', Foroughi posed the question of the Congress: 'to what extent do we have to rely on our past, in both its form and spirit?'[152] As a modernist architect himself, torn between designing something totally new or drawing inspirations from the past, Foroughi posed the question again later, asking: 'To what extent should we endeavour to reclaim the form and spirit of the architecture of our past and at what point should we adopt present-day innovations and inventions?'[153] Foroughi did not mean to neglect the past, nor to diminish its physical and visual presence in architectural design, but he was looking for a kind of ideal balance that would include the significance of historical architecture and make the transition smoother, as with the artistic transition from the Sassanian to the Islamic era.[154]

Arguably Foroughi was looking to find a similar sort of balance between existing architecture and new contemporary technological advances. His task, however, appeared very difficult. What was regarded as of value in architecture and in the traditional belonged to at least a century before, while historical knowledge was still in the process of development through

151 Mohsen Foroughi had also invited three influential Modernist architects
– Walter Gropius, Mies van der Rohe, and Richard Neutra. They accepted the invitation but all three were dead before the Congress began. Their deaths prevented a greater level of discussion for the Congress and on modernist architecture in general. See Mohsen Foroughi, 'H. E. Mr. Mohsen Foroughi's Address' in Bakhtiar 1970, 10.
152 ibid.
153 ibid., 65.
154 For example, the transition from the Sassanid use of *chāhār tāq* in their fire-temples to their use in Islamic mosques and perhaps the later adoption of the form of guiding towers for minarets seemed smooth and appropriate.

recent excavations and was subject to failure. To use the philosopher Paul Ricoeur's terms here, there was no original 'testimony'[155] to describe or defend those architectural experiences, and what had been produced recently – for example, Adralan's or Mostafavi's works – were the interpretation of earlier histories, written by archaeologists; a sort of hermeneutic circle such as Ricoeur describes in linguistics and historiography. Without defending Pirnia's methodology and certainly not his conclusions regarding the 'characteristics of Iranian architecture', it must be recognised that the only research which truly focused on traditional architectural modes of production, through the lens of an architect looking at the living architectural traditions of the time, was his work. It remains unexplained why he did not attend this conference or similar events, as he might have offered valuable insights into the notion of tradition.

During the four-day conference delegates also discussed the impact on education of notions of tradition and technology.[156] However, although the Congress began with a visit to Persepolis,[157] it was hardly part of direct discussions. Generally speaking, the notion of the past seemed abstract and without clear historical preferences; the focus here was more towards Islamic heritage, with the first paper presented being Ardalan's summary of his *The Sense of Unity*.

The published proceedings of the Congress start by defining the notion of 'tradition', followed by a brief description of the issue 'of the adaptation of modern techniques to traditional forms of architecture' by Nasser Badie, the deputy minister of housing and secretary-general of the Congress.[158] Badie suggested that past architectural forms and their traditional use were inseparable factors in addressing the notion of authenticity and an indivisible part of Iranian identity.

Although interpretations of tradition can vary, in their foreword Bakhtiar

155 Paul Ricoeur, *Memory, history, forgetting*, Kathleen Blamey, trans. (Chicago, 2004), 161–6.

156 The morning sessions consisted of presentations with a general discussion afterwards. The discussions in English and French, focusing on the sub-theme of the day, continued in three working groups in the afternoons.

157 On the first day, delegates visited Shiraz and Persepolis and travelled to Isfahan where they stayed for the following days.

158 Nasser Badie, 'Preface' in Bakhtiar 1970, xii.

and Farhad, the editors of the published proceedings, quote Luis Kahn and suggest that tradition 'can be said to be the result of an inspiration which has lasting value as long as the original inspiration can be felt.'[159] In other words, as long as the source of inspiration is still effective, tradition moves on and 'creates something eternal and timeless'[160] which retains a sense of historical continuity. But such eternal values, as Candilis would say in the same volume, 'comes from consideration of the qualitative and unmeasurable aspects of art to build 'something of quality'.[161] Therefore, by the appropriation of 'immaterial' values, something of quality could be built. One can observe a sense of continuity as long as these values persist as traditions. This was the quality that architecture was evaluated by at the time. It is at this point that Bakhtiar and Farhad bring in Ardalan's argument regarding the conditions of the 'traditional society' in Iran and its architecture.[162] They describe how 'traditional society acts within a spiritual framework that seeks perfect harmony in both its quantitative and its qualitative aspects.' The products of such a society, including its art and architecture 'are inspired by total world-views that generate and direct man's creative energies while integrating the whole of society into totality' and in this way enhance a sense of continuity. The understanding of such intellectual foundations was therefore seen as important for the appreciation of Iranian architecture.[163]

Here, the most significant aspect of the notion of tradition was the sense of continuity, which was the main characteristic of the architecture of Iran, mentioned in earlier works by Godard and Pope, and in the later works of Pirnia and Ardalan. It seems that the notion of tradition was addressed in the hope that it could prevent the disruption detected in the architecture of Iran at the beginning of the twentieth century. The congress clarified that

159 ibid., xiii.
160 ibid., xiii.
161 ibid., xiv.
162 Considering Ardalan's approach towards the notion of tradition stems from Nasr's idea of the Islamic mystic tradition in Iran, one can assume that his speech was mainly concerned with Islamic society as the 'successive culture' of the last fourteen centuries in Iran. It seems that the 'not-naming' of any specific tradition at the beginning of the Report had both political and theoretical reasons.
163 Bakhtiar 1970, xiv.

as long as traditional values were valid in Iran, the suitable appropriation of new technologies would only facilitate its extension. The editors of the volume made this clear by stating that tradition and technology are 'one and the same thing' as 'cultural traditions contain a technology and modern technology may someday be contained within a future tradition.'[164] The editors' quotation from an Iranian architect, Ali Sardar Afkhami explained this further:

The most valuable and profitable lesson which we can receive from tradition, in the field of architecture, … is to establish the fact that it comprises an obligatory and inseparable part of technology, however primitive, without which architectural tradition hardly exists. … one must comprehend how past generations have reacted with the means at their disposal to the problems of their times. How did our ancestors attain such a degree of perfection by solutions so simple and efficient? Perhaps it was because of their total harmony with the condition of their time.[165]

George Candilis's noteworthy comments during the first afternoon session, which were referred to several times throughout the event, give further explanation as to how the issue of interaction should be addressed, not only as a specific problem in Iran but also as a relevant question in most contexts. On one hand, he emphasises respecting historical heritage and identity in every country. But he took it for granted that historical replication was not the answer as such examples would certainly not be 'genuine', would lack the authenticity of the original, and would 'diminish the value of the past'.[166] On the other hand, he did not completely defend forgetting the past and condemned the unquestioning approval of modern architecture, as it too is part of a certain past and has its own history.[167]

Candilis's also cautioned against interpreting modern architecture as

164 ibid., xiii.
165 ibid., xv.
166 ibid., 66.
167 His approach seems to have stemmed from his Team X membership as well as the pervasive criticisms of modernism at the time in terms of its complete detachment from the past.

representative of contemporaneity and retaining it in the architectural vocabulary not as an architectural movement or style with an historical beginning and end, but as the constant representative of the present and the future. He saw the affordability and simplicity of modern architecture as a threat, which could prevent future architectural development and diminish architecture to 'building' by mistake. In his view, architecture's main preoccupation should be 'to truly define, to clarify and to give value, to that which the notion of an architectural language merits,' instead of confining architecture to a few labels and trends.[168]

Candilis continued by explaining his earlier conversation with Shahbanu Farah, regarding how contemporary architecture should respond to its heritage and how one could design a building that is suitable for an historic city such as Isfahan. He also asked how one might to incorporate contemporary demands and contemporary architectural possibilities in ways that complement historical fabric instead of downplaying it. While his answer is open to interpretation, it is remarkable since it is not limited to any trend of its time.

> One must build something of quality. The site demands a quality more
> noble than elsewhere. … 'But what it is, this quality?' … Quality
> is nothing else but a true architecture. If it is genuinely a work of
> architecture, it embodies and expresses in itself the quality required. It
> is no longer a question of style, or proportion or many other different
> little questions which we ask everyday. … It is a question of the
> complexity of synthesis, of all the problems, in regards to the past, to
> the site, in accordance with the mentality and identity of the people
> of the present period and above all, to our own responsibility. We
> must respect our own responsibility. It is here that the means lie to
> developing in this country genuine architecture which expresses the
> identity of the country and its tradition. Can you truly be assured that
> you can feel your responsibility, you architects of Iran?[169]

Candilis's account liberates architectural design from historical replication.

168 Bakhtiar 1970, 66–7.
169 ibid., 67–8.

Here, the value of the past is not undermined, but the aesthetic and func-
tional decisions of the design are granted solely to contemporary taste.
Here, the success of a project depends on the extent to which the architect
can respond to the contemporary condition of society. Their most impor-
tant responsibility is towards the present, with an appreciation of the past,
not a mere fascination with it. Candilis avoided using the term 'tradition',
and the reason for this can be found in his speech on the fourth day of the
Congress, when he described how he did not see any sort of imitation and
repetition of the past as suitable behaviour for their time. Candilis believed
that their time was the moment for being creative and leading towards the
future.

He thought architecture of their time must create 'archetypes' instead of
'prototypes', stressing the importance of being influential and guiding the
discipline rather than reproduction and imititation.[170] This differentiation
led Candilis to oppose any repetition and replication in architecture that
stemmed from a fascination with the past. Since architecture is to produce
archetypes, the acceptable view of historical architecture must be arche-
typical as well.

Candilis's account leaves no place for 'tradition' in architecture to be
defined in terms of visual or formal replications of past examples. Tradi-
tions should rather be reflected in every aspect of life comprehensively,
with the Islamic tradition in Iran being an example of this happening. Can-
dilis declares that 'one cannot find a definition of tradition' and refers to
Luis Kahn's comment that 'tradition cannot be anything but the expression
of the truth'.[171] To Candilis, the responsibility of their generation was to
discover that truth; this is the level of tradition that architecture can find
useful. This point of view is rather abstract, is subject to interpretation, and
above all, is open to alteration in the future. His account of technology is
also remarkable in the sense that he assigns separate responsibilities to
tradition and to technology, and sees no opposition between them, thus
liberating architecture from the obligation to follow either route separately
and unconditionally.

170 George Candilis, 'Address of Mr. George Candilis to the 1st International
Congress of Architecture, Isfahan,' in Bakhtiar 1970, 218.
171 ibid., 220.

Each period, each place in history has its own condition of building. One cannot give a formula or a recipe, the sole, common universal factor is that it creates spaces where it is good to live. Architecture does not demand neither formula or recipe *a priori*, architecture is above all at the service of man and nothing else. ... Technology can only be a means which integrates itself with the architectural intention and nothing else. ... One is not necessarily an architect of the past because one builds in brick, or vice versa a modern architect because one builds in steel.[172]

By the end of the congress, Iranian delegates were less concerned by the possibility of the adoption of modern technologies overshadowing their past heritage and diminishing a sense of national identity in architecture. Technology was deemed a necessity and a timely aid for architecture, which has always existed alongside and in the service of 'tradition'. In this way, the Congress helped change approaches towards the past, its preservation, and the notion of 'tradition' as something that evolves with time and is not bound to physical or visual qualities. Nevertheless, tradition remains an inseparable part of identity. Lastly, the delegates agreed that the educational system should present the student of architecture with timely inspiration and knowledge of the realities of their society both on national and international levels to 'evaluate the past, understand the present and discover the future.'[173]

This congress was to be repeated every four years with new topics and on a smaller scale and with more academic participation, including that of students themselves. The Second International Congress of Architecture was held in 1974. Its title was 'Towards a Quality of Life',[174] which suggested no reference to the past or to historical values. In a period of unprecedented economic growth, in which the idealist goals of industrialisation were being pursued and there was indifference to criticism, the government of Iran continued to transform the built environment. It sponsored

172 ibid., 220–21.
173 These points are evident in the Summary of the Declaration of the Congress, which was given as bullet points at the end of the report. See Bakhtiar 1970, 247–8.
174 Bakhtiar 1974.

the Second International Congress, where an unprecedented number of leading international architects gathered in Persepolis to discuss how best to utilise the benefits of industrialisation to 'grow and change, yet seek to maintain relevance, continuity and a sense of cultural identity'.[175] In doing so, the conference aimed 'to establish values and to provoke a greater consciousness of good design in the transition stage that developing countries are moving into.'[176] It was felt that the outcome of this congress could be useful for many other countries tackling similar questions and threats as they moved toward industrialisation and adopted Western modernity; for a few days, Iran felt like a trendsetter in architecture. If the 2500th anniversary of the founding of the Persian empire had been a political event on an exceptional scale, this congress was its equal in architectural discipline.

The Second Congress hosted over thirty architects from Iran and across the world, including Kenzo Tange, Buckminster Fuller, Fumikiko Maki, Jose Lluis Sert, Paolo Soleri, Moshe Safdie, Georges Candilis, Bruno Zevi, Aldo Van Eyck, Constantinos Doxiadis, Hassan Fathy and James Stirling. The guests travelled across the country before arriving at Persepolis. Like the First Congress, this event included morning lectures and evening seminars, where different aspects of the main question were debated. Themes included 'Continuity versus Change', 'Ecology and the Manmade Environment', 'Appropriate Habitat' and 'Methods and Materials of Expression'. The notion of continuity, and connected issues such as identity and the conflicts of the traditional society of Iran facing industrialisation were discussed on the first day. In the case of the conflict between industrialisation and cultural continuity, the general view was that societies like Iran need industrialisation as much as they do their traditional culture, and that architects can represent the two subjects in the built environment and strike a balance between them. Jacob Bakema saw continuity and change as complementary forces, instead of oppositional. For Nader Ardalan, the paradoxical relationship between continuity and change would only be resolved by a 'new creation', in which the two forces were seen as 'complementary aspects of one unity', consequently providing 'Iranian

175 Homayoun Jabir Ansari, 'Preface', in Bakhtiar 1976, ix.
176 Laleh Bakhtiar, 'Foreword', in Bakhtiar 1976, xi.

solutions to Iranian problems'.[177] This resulted in a call for the study of adaptive technologies and techniques of design and construction in traditional architecture across Iran, which could lead the to new disciplinary developments.[178]

Focusing on various aspects of industrialisation, Buckminster Fuller and B. V. Doshi mentioned an increase in opportunities and experiencing life with more autonomy and more leisure as the benefits of industrialisation. Other suggestions included the decentralisation of industries as a way to establish a balance between urban and rural development and to facilitate widespread socio-economic growth.[179] As the main aim of the congress was to facilitate the adoption of industrialisation as a positive development, most papers discussed the benefits of industrialisation, while few focused on its threats in changing society.[180] But such concerns were highlighted by Kenzo Tange and Nasser Badie,[181] who warned of the consequences of uncontrolled progress, especially concerning its effect on the environment. Felix Candela agreed,[182] as he saw the start of industrialisation as a point of no return and argued that societies should control its speed and scale.

The recommendations of the Congress addressed concerns over haphazard industrialisation, especially with regards to its environmental impact in the planning of new cities. The outcomes of the event could be summarised as calling for regional planning that would remember scale; the decentralisation of industries; and the seeking of domestic solutions for Iran.[183] Here, industrialisation was not the aim, but was a means 'to achieve a higher quality of living for the entire nation', and in fact, to proiritise

177 Nader Ardalan, 'The New Creation', in Bakhtiar 1976, 33–44.
178 Laleh Bakhtiar, 'Foreword', in Bakhtiar 1976, xiii.
179 See Moshe Safdie, 'Towards a Contemporary Vernacular', in Bakhtiar 1976, 219–28.
180 In one way, it assessed the growth of industrialisation in a context that, by the mid-1970s, was outside the immediate context of modernity, and acknowledged how modernisation and industrialisation conflicted with traditional culture.
181 Nasser Badie, 'The Architecture of Industrializing Countries', in Bakhtiar 1976, 9–13. See also Kenzo Tange, 'Protection of the Earth Environment and the Effects of Technological Growth on Architecture and Urban Planning', in Bakhtiar 1976, 21–6.
182 Felix Candela, 'The Problem of Scale', in Bakhtiar 1976, 289–91.
183 Bakhtiar 1976, xvi.

citizens who were less financially fortunate in order to level socio-eco-
nomic imbalance.[184] Echoing the social anthropologist and philosopher
Ernest Gellner's approach to nationalism as being a result of the industrial
age, and despite all the deep sentimental attachments to historical archi-
tecture, the conference showed that Iranian architects were about to move
towards the formulation of a new definition of collectiveness and identity,
that was connected to the conditions of the present as much as it was con-
nected to the past. The role of architectural heritage was not limited to
reinforcing politically appropriate symbolism, but encompassed a wide
range of examples and solutions to benefit present and future needs.

Nevertheless, the resolutions and the recommendations of the Second
Congress remained mostly on the theoretical level until in 1978, when
the government commissioned James Stirling to design the Institute of
Biochemistry and Biophysics in Tehran. As an architect who was already
familiar with the politically influenced architectural environment at the
time in Iran, Stirling used a politically and historically significant archi-
tectural form, the *chāhār tāq*, the celebration of which had expanded
over architectural historiography for the last fifty years in Iran. His
design placed three identical cubical forms side by side on the site, which
according to his earlier sketches were derived from studying the forms
of historic *chāhār tāq*. At the Second International Congress, Stirling
had stated that he believed it was important to design something that the
public could recognise as familiar. This is what he considered the 'art' of
architecture:[185]

The collection in a building of forms and shapes which the everyday
public can associate with, be familiar with and identify with seems to
me to be essential. These forms might be staircase towers, windows,
room shapes, entrances, etc. and the total building could be thought
associated of everyday elements recognizable to a normal man, and not

184 ibid., xii.
185 'We are of the opinion that the shapes of a building should indicate – perhaps
display – the usage and way of life of its occupants and it is, therefore, likely to be
rich and varied in appearance and its 'expression' is likely to be simple or
simplistic.' James Stirling, (1974) 'Materials and Methods of Expression' in
Bakhtiar 1976, 309.

307: James Stirling's early sketches for the Institute of Biochemistry
and Biophysics in Tehran, Ink on tissue paper, 1978.

308: James Stirling's drawing for the Institute of
Biochemistry and Biophysics in Tehran, 1978.

only an architect. … The particular way in which functional symbolic elements are put together may be the 'art' in the architecture.[186]

In the case of this particular design, however, one could hardly associate the incorporation of *chāhār tāq* with the act of bringing in a 'familiar shape' that the public could immediately identify with, and draw a cultural relation from. Additionally, it is not easy to conceptually connect the suggested shape to the brief of the project. Perhaps this idea was better encapsulated in the arrangement of the volumes on the site itself, the design of the courtyards and the geometry of the gardens, as well as the numerous arches that were sketched in his proposal. These are historical architectural elements that might be seen almost everywhere in Iran, but a *chāhār tāq* in its pure and explicit form was and still is quite difficult to find in Iran.[187] Mainly studied by Western archaeologists, especially by André Godard, as a cultural artefact, it only gradually became one of the most significant architectural elements of Iranian architecture and thus to represent continuity in the more politically inclined circles of architectural discipline in the country. From the late 1930s until the end of the Pahlavi monarchy, historians (namely Pope and Mostafavi) had mentioned this form as a Persian contribution to architecture and maintained that this Sassanian element had shaped the core of Islamic architecture in Iran, and hence was a successful representative of the sense of continuity.

What remains in question at this point is why such profound discussions, and such a significant paradigm-shift in architectural theory, did not significantly transform the practice of architecture in the years after the Second Congress, especially in the case of representing national, cultural or traditional identities. One answer might be that apart from such specialised discussions in the particular case of Iran, internationally architecture

186 ibid., 309–10.
187 *Chāhār tāq* in its pure form was used only in pre-Islamic Iran to house Zoroastrian fire temples. After the arrival of Islam, it remained an integral part of the design of many elaborated mosques. Perhaps it is not so impossible to argue that it never completely disappeared in the history of architecture in Iran. However, due to the expansion of the plan of mosques, it is difficult for the untrained eye to identify it as a singular element.

was moving once again towards historicism as a result of the rise of Postmodernism.

The continuation of historicism in Iran might also relate to the specific political conditions in the country, which went through an intense upheaval and a revolution only two years after the Second Congress. The new state had a completely different agenda, ideology, and identity, and needed architecture once again to communicate to society its particular historical ties to a different epoch of the past. As if, perhaps,the new state needed to pass through all previous stages until it found the sort of stability that did not need such historical affirmations or unchanged traditions in order to represent a sense of continuity.

Shahyad Aryamehr: The End of a Tradition (1971)

One of the most significant actions of Mohammad Reza Shah's reign in order to legitimise the authenticity of his monarchy and represent it through a world-class ceremony were the three-day celebrations in 1971 to mark the 2500th anniversary of the founding of the Persian empire. The event aimed to highlight the historical significance of Cyrus the Great and legitimise the reign and authority of Mohammad Reza Shah as his distant heir and the protector of his legacy. The celebrations were exceptional in scale, spectacle, and political significance, as the court invited more than seventy of the highest-ranking rulers of the world and housed them in an extraordinary tent city, adjacent to the historical site of Persepolis.[188] The Shah's iconic speech and tribute at Cyrus the Great's tomb in Pasargad 'invoked a particular form of historical memory', and 'implied a return to a primary authenticity associated with that period'.[189]

In one way, favouring a specific period over the rest of history was ignoring – if not forgetting – thousands of years of history before and after that. In the same way the presence of the public, who had no role in the celebrations except for witnessing the performance, was also ignored and forgotten, as was Ferdowsi's *Shahnameh,* the other significant part of

188 Michael Stevenson, *Celebration at Persepolis* (Zurich, 2008), 19.
189 Marashi 2008, 4–5.

309: The Shahyad Monument photographed during the ceremonies for
the 2500th anniversary of the founding of the Persian empire in 1971.

the national narrative.[190] From this point on, the divergence between the official national narrative, which focused on Iran's Achaemenid heritage, and the more inclusive national myth that included *Shahnameh* and Iran's Sassanian heritage, becomes more evident.

In architectural terms, the significance of the event lies not in the celebration itself or the design of the tent city (as there is nothing left of this but ruins today), but in Shahyad Aryamehr, its memorial monument in Tehran. The design of Shahyad, and especially the way it reflects the memory of the past, has a different tone to previous architectural projects of such national significance. It represents a very significant moment in this review of architectural historicism in Iran since the beginning of Pahlavi monarchy; it is the first time that historical reference incorporated in the design of the building did not fully match with its specific political propagandist aims and more importantly, with the tone of the celebrations.

The twenty-four-year-old designer of the building, Hossein Amanat, had recently finished his architectural studies at the University of Tehran. He must have been in contact with all the debates going on at the time, from more state-based views of the notion of 'authenticity' to its Islamist

190 Ansari 2012, 176.

and leftist definition, and to the appreciation of vernacular architecture that had intensified since Seyhoun's directorship of the Faculty. Also, student trips to historical sites across the country had raised a great sense of fascination in many students. In this sense, Amanat was a true product of the Faculty of Fine Arts at a time when knowledge about vernacular and Islamic architecture, as other aspects of Iranian architecture, had considerably expanded.

This expansion of knowledge 'led to the realization of the arbitrariness of tradition', with Iranian architecture providing multiple aspects of tradition to return to.[191] As some of the most influential figures during this time, Seyhoun and Ardalan were considered as 'the new men of taste, who like the nation and its king, represented themselves as astonishingly modern yet deeply invested in tradition' – including its multiple interpretations.[192] Because of their modern take on historicism, Seyhoun's designs for the Society for National Heritage are often thought of as the beginning of a new tradition and the end of excessive pre-Islamic revivalism[193] in architecture in Iran.[194]

The expansion of architectural knowledge – whether of vernacular or Sufi architecture or even the traditional categories that Pirnia had introduced – transformed the architectural historicism of the 1920s to 1940s. However, it is less easy to argue that any of these approaches completely opposed or ended that historicism. To identify the end to the historicist approach, one should seek a moment when the architect has critically challenged the demand of a project for such historiographical differentiation; perhaps the design of a monument that takes a critical approach towards historicism and despite the necessity of the brief, demonstrates an inclusive approach to various episodes of history. Arguably, as the monument to the 2500th anniversary of the Persian Empire, Shahyad Aryamehr represents

191 Grigor 2009, 164.
192 ibid.
193 See Bani Masoud 2010, 274–5; Ghobadian 2013, 265; Grigor 2009, 146.
194 Since the works of Seyhoun for the SNH were mausoleums of prominent figures who lived during the Islamic era, it was a rational choice for the architect to incorporate Islamic references and concepts. For example, Seyhoun has mentioned that for the mausoleum of Avicenna he drew inspiration from Gonbad-e Qabus, a historic monument contemporary with Avicenna.

310: The Azadi Tower, Tehran.

such a moment. Like many previous examples, it contains historical references, but its inclusive approach to history is a practical critique of the more selective approach, and is one that sees the current and future state of the country as the result and continuation of its history in its totality. It is inspired by both the pre-Islamic and Islamic architectural history of Iran in its iconography and symbolism, even though the event it celebrates aimed to connect pre-Islamic Achaemenid heritage specifically to the Pahlavi monarchy. It was a commendation of the Shah at the peak of his power to Cyrus the Great, at a point when the shah believed that Iran was regaining its ancient glory. As the aim of the celebration was to strengthen these historic ties, one might assume the monument to the event and to the capital would conform to this idea by being inspired by Achaemenid architecture. Yet Shahyad hardly has any such references to the Achaemenid era.

In fact, the most explicit reference to the pre-Islamic history of Iran in this monument is its large parabolic arch, which is inspired by the Sassanian design of an arched iwan, such as those at Taq-e Kasra, south of Baghdad and the palace of Ardeshir Papakan in Firouzabad near Shiraz. It is also similar to the entrance of the Museum of Ancient Iran designed

311: Water canals at Pasargadae.

by Godard. The other pre-Islamic references are the form of a *chāhār tāq*, another Parthian and Sassanian reference, which shapes the volume of the monument, as well as the decorative axial water canal in the green area, an early example of which had been discovered in Pasargadae, Cyrus the Great's capital city. The axial water canal is the only reference Shahyad has to the Achaemenid era. The rest of its historical references refer to the Islamic period, including its larger pointed arch. These types of arches became popular only after the 1st century AH.

Perhaps what has made this monument so popular amongst generations of Iranians is its resistance to the idea of it being an example of 'kingly art', even though it was a memorial to the kingliest event. Covering the space between the two arches of Shahyad, Hossein Amanat employed the traditional technique of *rasmī-sāzī*,[195] which is one of the covering methods

195 *Rasmisazi* is a means of covering the ceiling under arched structures, including domes and arched hallways, which starts from the top of the walls and reaches the top of the ceiling. It is created through the intersection of various arches that give an

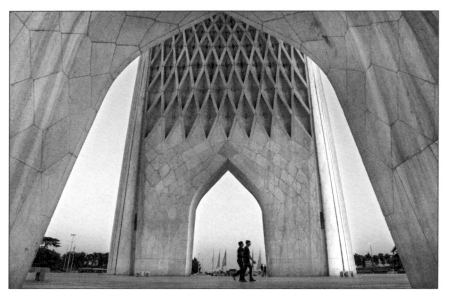

312: Looking between the arches of the Shahyad Monument.

for the space between a dome and its base, or squinches, and the iwan as it connects a curved ceiling to straight walls. This technique is often used as a substitute for the more elaborate covering system of moqarnas. *Rasmī-sāzī* mostly appears in public buildings that do not have a great deal of decoration, such as hammams, caravanserais, and *ābanbār* or small-scale mosques. For monumental buildings, palaces or grand mosques, the more sophisticated and extravagant moqarnas technique is usually employed. In the case of a monument such as Shahyad, one would expect the use of moqarnas, yet the architect employed the more modest technique, which is more familiar to the public. One could argue that the simplicity of *rasmī-sāzī* makes it more appealing to modern taste. However, if the intention was only to celebrate the grandiosity of the monarchy, the creative mind of the architect could have designed a more majestic alternative.

Apart from such references to grand and monumental Islamic

illusion of structure and gradually connect the walls to the roof. In some cases, these elements may be weight bearing, although in most they are purely decorative. *Rasmisazi* can be made from bricks or gypsum.

architecture, Shahyad also references 'traditional' and vernacular life in Iran. The top part of the building has a significant similarity to windcatchers, which have been used since ancient times in vernacular architecture all across the central deserts and the south of the country.[196] Another external reference to past architecture is a small dome on the roof, which with its blue tiles is similar to the domes of mosques. Additionally, the geometrical pattern of the lawn is a take on the geometrical decoration of the dome of Sheikh Lotf Allah mosque in Isfahan. These are the most recognisable references in this building to earlier architecture in Iran. All were interpreted using the most advanced technologies and possibilities available and in this sense, the monument relates to its time. Amanat himself has often said that Shahyad is meant to 'represent the Persian civilisation and culture' as it 'forms a symbolic entrance complex for Tehran'.[197] He has stated that:

> Shahyad has been designed while the truth, essence and the depth of Iranian culture was considered. Meaning that it is designed according to what has happened to this country and the glory which has existed in its history. It is true that it has been designed at the time that Iran was under a certain political condition, but I was looking at all historical periods and the future of Iran when I was designing it.[198]

Shahyad is not a simple sculptural monument in Tehran; it is a complete cultural complex, comprising a library and galleries in the basement, and a smaller gallery in the upper part. After the 2500th Anniversary ceremonies these spaces were opened to the public. Indeed, it was the only venue for the celebrations that Iranians were invited to visit. It could therefore have been as easily despised as loved by the public. Yet as much as the event was increasingly criticised, especially during the demonstrations in the years leading up to the Revolution, the building became more and more

196 See Mohammad Karim Pirnia, 'Bad-gir va Khish-khan,' in Gholam Hossein Me'marian, ed., *An introduction to Islamic Architecture*, 2nd edn. (Tehran, 2005), 331.
197 Amanat Architect 'Shahyad/Azadi Monument,' http://www.amanatarchitect.com/Shahyad/index.php, accessed online 20 May 2013.
198 Hossien Amanat, 'Interview with Hossein Amanat,' Interview for BBC, October 2007. http://www.amanatarchitect.com/Shahyad/index.php, accessed online 4 May 2014.

popular. Considered separate from the memory of the events that it was designed for, many of these demonstrations started from Shahyad square. At the collapse of the Pahlavi monarchy, it was named Azadi Tower – the 'tower of freedom'. Today, it is an icon of Tehran, while of the marvellous tented city at Persepolis, nothing is left but ruins.

One could argue that the monument's popularity is due to its location in Tehran itself. But with the events of the celebrations and the consequent Revolution still being within the living memory of its citizens, there are other reasons at work here too. The inclusive selection of historical references in its design, and the fact that it was a public complex, and the only part of the event shared with the people, all served to make it more appealing to the public. In contrast with the event that brought it into existence, Shahyad represented an inclusive understanding of the historical heritage of Iran. It did not focus on one period, instead it celebrated every major episode; the pre-Islamic, the Islamic and even vernacular architecture. Shahyad did not simply represent the event, but also resisted the fundamental purpose of the event most subtly. Although it is still loaded with historical references, it successfully responded to the social conditions of its time. After the Revolution of 1979, it remained an icon of Tehran as well as the symbolic gate of the city. It has lost some of its glory since its green area has shrunk and it is now surrounded by some of the busiest streets of the capital, but it has never failed to represent its message and retained its historical significance. Its meaning has changed over time, but what greater success can a monumental building have than to surpass its own time, its own historical context, and belong to a new era? This is the opposite of being neglected and rediscovered as an archaeological piece. The question is, where do such multiple layers of significance come from? Is it only because of its historicist reference to what so many generations of people might have shared? Perhaps not.

Projects of Authenticity

Disciplinary developments and expansion in the knowledge of vernacular architecture and philosophical traditions in Iran resulted in the design of several other significant projects, by architects such as Kamran Diba, Nader Ardalan, and Ali Sardar Afkhami during the final two decades

313: Architectural model of the Imam Sadeq University (Iran
Centre for Management Studies, Harvard), 1969–75.

before the Revolution. Influenced by Postmodernism, these projects
transformed architectural approaches toward the notion of identity, and
created iconic buildings that represent a brief period of disciplinary pro-
gress. Ardalan's Iran Centre for Management Studies was designed and
constructed between 1972–5 in Tehran and represents 'a contemporary
interpretation of the classic Paradise garden' and the traditional form and
spacial configurations of schools in Iran.[199] This inward-looking project
encompasses a library building in the centre of a rectangular garden, which
is surrounded by sixteen clusters of residential units for students together
with other administrative buildings. The library is reminiscent of Safavid
pavilion, such as Hasht Behesht in Isfahan. Each student unit is a minia-
ture cosmos, comprising four smaller units that share an inward-looking
entrance area. They have barrel-vaulted roofs, small vertical windows,
and arched entrances. The facades are covered with simple brickwork and
minimal decorative elements, creating echoes of a vernacular complex
from the arid regions of Iran. This was especially so at the time of its
construction, when urban development around the complex was minimal.

The other significant examples constructed during the 1970s are Kamran
Diba's projects. Despite being related to Shahbanu Farah Pahlavi, and

199 'Iran Centre for Management Studies, Tehran, Iran,' Ardalan Associates, http://
www.ardalanassociates.com/iran-center-for-management-studies.html, accessed
online 11 June 2017.

commissioned for the design of her dedicated office in Niavaran, Diba's design approach is far from 'kingly'. He refers to vernacular elements of Iranian architecture and natural patterns as well as the social aspects of design.[200] Diba received his degree in architecture from the University of Harvard and later continued his postgraduate education in sociology. His works are generally inspired by traditional architecture, while he aimed to create a 'modern architecture which is ingrained with traditions and history of Iran'.[201] He designed and constructed Yusef Abad Park – later known as Shafaq Park – as his first public project between 1967–71. This included the first cultural centre (*farhangsarā*) in Iran. The aims of this project were twofold: first, to design a park for the comfort of visitors and a pleasant pathway for passers-through. Secondly, to design a series of buildings for public service and for cultural purposes, including a library, an amphitheatre, some workshops, playgrounds, and a social consulta-tion centre. Surprisingly, the layout of the park is not inspired by Persian garden design. Here, the prominent role of nature and the use of bricks and 'familiar architectural motifs' for the facades are the primary visual char-acteristics.[202] Diba completed the design with six statues by the renowned Iranian sculpture Parviz Tanavoli. These works are placed not on pedestals nor inside protective cases or the buildings. Scattered about the park, they depict human figures engaged in everyday activities, hence, 'combining art and architecture with everyday life'.[203]

Diba's design for the Museum of Contemporary Arts, built between 1967 and 1976, was one of the most significant legacies of the Pahlavi era in Tehran. Construction was completed at a time of economic growth, when Tehran was becoming a metropolis. Diba's idea for establishing a multidisciplinary museum found its necessary powerful patron in the Shahbanu, while Diba's architectural knowledge and personal experi-ence led him to investigate using vernacular architecture as a source of

200 See Reza Daneshvar, *Baghi Miyan-e Do Khiyaban: Chahar Hezar va Yek Rūz as Zendegi-e Kamran Diba Dar Goftogu ba Reza Daneshvar* (A garden in the middle of two streets: four thousand and one day from the life of Kamran Diba in conversation with Reza Daneshvar), (Tehran 2014), 59, 62.
201 Khanizad 2014, 10.
202 ibid., 62.
203 ibid., 11.

inspiration. He used the shape of the mud rooftops in Yazd and Kashan and the skylines of Iranian deserts, decorated with the silhouettes of domes and windcatchers, to shed natural light on the unparalleled international collection of artworks housed in the galleries of his building.[204] A central void and ramped gallery connect the main entrance hall on the ground floor to the basement, where the audio-visual room and the offices are located. The main exhibition spaces are situated parallel to each other and connect through a continuous ramp and stairs that gradually lead to the lower level. The visual significance of the building is due to the use of windows, which are inspired by the shape of windcatchers and placed on the roof of the exhibition spaces and the entrance hall. Natural light enters and hits the curved side of the windows and diffuses as it enters the galleries. Like Yusef Abad Park, the garden of the museum houses a collection of sculptures by international artists. Thus a building inspired by the vernacular architecture of Iranian deserts now shelters valuable Western artworks in the Middle East.

One of the last significant projects during the reign of Mohammad Reza Shah in Tehran was the construction of his capitol complex, Shahestan-e Pahlavi. Covering over 500 hectares in the heart of Tehran, this was to be his legacy and 'a new center for twentieth-century Iran, similar to sixteenth-century Isfahan'.[205] The site was empty land on the 'Abbas Abad hills, which had belonged to Haji Mirza Aqasi, the prime minister of Mohammad Shah Qajar – leafy countryside in the north of Tehran and outside the city walls on the way to Shemiran.[206] It only become part of Tehran after the expansion of the capital during the reign of Reza Shah. In the late 1960s, Victor Gruen and Farmanfarmaian Associates proposed establishing an urban centre within the master plan of Tehran.[207] The hills of 'Abbas Abad had been given to the Agriculture Bank (Bank-e Falahat) during the Pahlavi monarchy, and the land was mostly under the control of the army, as well as a few individual owners, all of whom moved to

204 Reza Daneshvar, op. cit., 116.
205 Davies 1976, vol. 1, 10.
206 Farnahad Consultants, 'Arazi-e 'Abbas Abad; Yek Emkan ya Tahdid dar Markaz-e Tose'eh Shahr-e Tehran,' *Jostarha-ye Shahsazi* 4, (2003), 26.
207 Hamed Khosravi, 'Politics of Demonst(e)ration,' *Collaboration*, San Rocco, 6 (2013), 28–37.

314: The Museum of Contemporary Arts, Tehran.

315: Shafaq Park.

'create a new national center for government of high design quality' and 'the biggest complex of tertiary activities and offices in the world'.[208] In 1973, Luis Kahn and Kenzo Tange and later Arata Isozaki were asked to produce plans for this area. These plans, which were first initiated separately by Kahn and Tange, were meant to be merged later, in collaboration with Isozaki, but were put aside after the death of Kahn in March 1974.[209] Then from 1975 the British company Llewelyn-Davies International became responsible for the design of the area. The design has traces of the previous plans, and was considered a special case and not subject to the existing urban policies of the city.[210]

The plan included a north-south main axis with a grid layout running along the axis, which would house a number of government and cultural buildings, offices, retail stores and hotels while 'motorways would cross the site, but were located within a natural valley, so reducing their visual impact.'[211] Also, 'a key element in the plan was to be a number of large public open spaces, intended to offset the lack of recreational space in the city as a whole'.[212] The focal point of the site was to be the 'Shah and Nation Square' (Maidan-e Shah va Mellat), the name of which alone would echo the memory of Bagh-e Melli and its significance in bringing together state and nation in the built environment. It included 'a vast open space which would provide an appropriate setting for public ceremonials, with monuments and fountains dedicated to the monarch and his consort.'[213]

The overall design of Shahestan was a continuation of the existing urban grid outside the site, with the Shah and Nation Square as a significant forty-five degree turn in the design that breaks the grid. Apart from adding visual importance to the square, it is an imitation of Naqsh-e Jahan Square in Isfahan.[214] Indeed, Isfahan's most significant plaza is the main concept

208 Costello 1981, 170-72.
209 Hamed Khosravi, op. cit., 28-37. See also Farshid Emami, 'Civic Visions, National Politics, and International Designs: Three Proposals for a New Urban Center in Tehran (1966-1976),' (MA thesis, Massachusetts Institute of Technology, June 2011).
210 Costello 1981, 173.
211 ibid., 171.
212 ibid.
213 ibid.
214 Davies 1976, vol. 2, 112.

of the design, and to a less visible degree, the site of Persepolis, as both of these historical sites were gathering places of the government – the state – and the people – the nation. The three main buildings around the Naqsh-e Jahan were 'Ali Qapu, the main palace of the Safavid dynasty on the west and the royal mosque of Sheikh Lotf Allah on the east, while on the south side of the square, the grand Masjed-e Shah and (for public use) bazaar chambers connect the three buildings and frame the plaza. This spatial configuration made a close interaction between the public and government officials possible. The design of Shahestan had a similar concept, especially around the Shah and Nation Square where a new national museum and some public exhibition spaces were located to accompany the prime ministerial office and the Ministry of Foreign Affairs. Of course, this was not limited to the area of this square; the whole project was meant to be a combination of public and official spaces. The project also bore great similarities to the development of the Parade Ground during Reza Shah's reign as it remained as a public square, again filled with governmental buildings as well as museums.

The buildings and the landscaping of Shahestan were inspired by various aspects of architectural heritage, yet such historical inspiration was reflected more in the documentation than in the actual design. According to the two-volume history of the project created by by Llewelyn-Davies International, the comprehensive design of Shahestan was 'inspired by the cultural traditions and especially the great architectural traditions of Iran.'[215] However, the overall design could be seen as a modern urban project. It belongs to the Postmodern era when it seemed almost inevitable to highlight authentic historical values. 'Although this multibillion-dollar project contradicted the redistributive policies of the 5th Development Plan of 1973–78 (see page 145) and was in competition with the bazaar and the new town projects directed to better the lower and middle classes in the city, it gained approval by the shah and received his highest possible attention.'[216] Construction was halted by the Revolution of 1979 and the

215 Davies 1976, vol.1, 5.
216 Hooshang Amirahmadi and Ali Kiafar, 'The Transformation of Tehran from a Garrison to a Primate City: A tale of rapid growth and uneven development,' in Hooshang Amirahmadi and Salah S. El-Shakhs, eds, *Urban Development in the Muslim World* (New Brunswick 1993), 109–37.

new regime soon replaced the existing plan with a different one – albeit with functional and thematic similarities.

The critical question is how the new planning and the buildings that covered the plot more than a decade later could still use the same design approaches, even though they came after an ideological revolution and also had to tackle more recent disciplinary questions concerning the environmental and economic issues. It seems that despite the ideological and political differences of the two states, the preferred approach for the architecture of particular projects that touch upon the notion of collective identity, whether national, cultural, or religious, was still historicist. The mentality has remained unchallenged. These projects and congresses in the last decade of the Pahlavi monarchy show that the architectural representation of national identity in Iran was still primarily influenced by visual representations of the past. Despite theoretical developments in architecture, the question of modernity –which by this time was reduced to the single issue of industrialisation – was still in conflict with tradition and the representation of national identity.

4
Revolution and Continuity

The Post-Revolution Academic Reforms

The Islamic Revolution of 1979 had a deep impact on the ideological approach to architecture and the representation of national identity in Iran. The ideological transformation of the Revolution changed the academic environment quickly and, more gradually, influenced the design sector as well. The post-Revolution academic reforms resulted in the development of a new round of historicism in architecture for the representation of national identity, with the ideological preference of the Islamic Republic resulting in the historical focus turning towards the Islamic and religious architectural heritage as the primary source of inspiration. In terms of interventions in the built environment, the intensive round of constructions and urban developments had to wait for almost a decade until the end of the Iran-Iraq war in 1988; but the first and most significant project, begun only three years after the Revolution, in 1982, was the construction of the Grand Mosque of Tehran in the 'Abbas Abad hills. The 'Abbas Abad hills would later become one of the post-Revolution capitol complexes, and feature some of the most iconic architectural projects in Tehran.

From 1980–83 extensive academic reforms were launched as part of the Cultural Revolution. These were the result of a speech by the leader of the Revolution, Ayatollah Khomeini, made on 21 March 1980, when he spoke of the necessity of 'revolutionizing all universities across the country', 'firing university professors linked to the East or West', and 'developing the universities into a safe environment for authoring and teaching higher Islamic sciences'.[1] Ayatollah Khomeini stressed these issues again on 12

1 SCCR, accessed online 6 February 2014.

June 1980, when he issued the decree for the establishment of the Cultural Revolution Headquarters.[2] The Cultural Revolution Headquarters – later The Supreme Council of the Cultural Revolution (SCCR) – was established in the same year, and focused on 'training university professors and selecting culturally competent professors to teach at the universities, formulating university student admission programs and Islamization of university environment and curriculum changes'.[3] In order to standardise course materials for all universities across the country, the SAMT[4] publishing house was established in 1984 in the city of Qom, as part of the Cultural Revolution, in order to provide textbooks, especially for the humanities.[5]

Consequently, the academic system of architecture underwent drastic reform. As an educator involved in the curricular changes to architecture during the Cultural Revolution, Akbar Zargar has compared the modules of history both before and after the Revolution. In considering the module of architectural history before the Cultural Revolution in particular, Zargar found a lack of related publications, while in those publications that did exist, the emphasis was on ancient architecture across the world. This might have seemed inevitable, since at the time since most prominent experts on the subject were either archaeologists or Western Orientalists. Meanwhile, again according to Zargar, the Headquarters' decision on art history modules was to introduce the history and culture of Iran and emphasise the history of Islamic architecture. The ultimate goal, apart from helping students to understand the fundamental principles and details and the main elements of the architecture of the past, was to give identity to the design courses.[6]

Regarding architectural historiography, Zargar highlighted the

2 ibid.
3 ibid.
4 SAMT is the abbreviation for Sazman-e Motale'e va Tadvin-e Kotob-e Olum-e Ensani-e Daneshgahha (the organization for the study and compilation of the academic books for humanities).
5 Tarikhche-ye Sazman,' SAMT, http://www.samt.ac.ir/index. aspx?siteid=1&pageid=313 accessed online 6 February 2014.
6 Akbar Zargar, 'The place of the history course in teaching architecture', in Ayatollahzadeh Shirazi 1995, vol. 4, 48.

persistence of the Western approach to architecture during the Pahlavi era, when academia had mainly followed Western histories, without enough focus on contemporary architecture in Iran. Under the new system, three modules were introduced at undergraduate level. These were Contemporary Architecture, which focused on the architecture of the West; an Introduction to the Global History of Architecture; and Islamic Architecture. The first of these took one term while the others each had two. All these subjects were initially worth two units in student assessments until 1995, when the value of Islamic Architecture was doubled.[7]

The module on the Global History of Architecture begins with ancient Egyptian and Greek architecture, and carries on to the development of modernist architecture and the International Style. The Islamic Architecture module begins with a brief history of pre-Islamic architecture in Iran, but focuses on the Islamic period.[8] In the graduate school, the most important addition after the Cultural Revolution was a course on the Wisdom of Islamic Arts, which deals mainly with Islamic art from the hermeneutic point of view. The German-Swiss expert on Islamic arts and traditions Titus Burckhardt (1908–84), had been the first to introduce the phrase the 'wisdom of Islamic arts' and this course mainly uses that definition,[9] even though in some cases the teacher may slightly vary the taught material. In Burckhardt's view, Islamic art is based on fundamental realities, which encompass a range of topics such as multiplicity and unity, order, knowledge, and beauty; all of which revolve around the main topic of monotheism.[10] In its quest to understand symbolism and primordial values, this module focuses on the various, albeit sparse, accounts of Islamic art to

7 ibid., 58–9.
8 This is the general design of the two courses in most universities, with details of the courses determined by the teachers. However, this specific course hardly goes beyond the boundaries of Iran and does not discuss Islamic architecture in other countries.
9 Zahra Rahnavard, *Hekmat-e Honar-e Eslami*, 8th edn, (Qom, 2013). See also Abd ol-Hamid Noqrehkar, Bardashti az Hekmat-e Eslami Dar Honar va Me'mari (A reading of Islamic wisdom in art and architecture), (Tehran, 2014); and Alireza Bavandian, Hekmat-e Honar-e Eslami (The wisdom of Islamic art) 2nd edn (Mashhad, 2010).
10 Zahra Rahnavard, 'An Introduction to Islamic Art Wisdom,' *Honarhaye Ziba* 4&5 (1998), 22–32.

be found in Western philosophical traditions and in the works of Islamic philosophers.

The role played by architectural design in representing national identity continued in the post-Revolution period, yet gained a new religious hue from the new ideological emphasis and change in academic direction. The number of institutions teaching architecture multiplied in the post-Revolution period, with the question of representation and the challenges of finding a balance between the forces of modernisation, industrialisation, and progress, and those of the historical heritage and traditional architecture found various new arenas of discussion and investigation. In the early 2000s, and under the Third Development Programme,[11] the University of Science and Technology in Tehran established the Centre of Excellence in Islamic Architecture as a core academic centre to facilitate research and 'to provide the required settings for architectural studies based on Islamic views'.[12] Addressing the 'contemporary crisis in architecture' in Iran, the Centre aims to 'facilitate the required basics towards critical thinking for the creation of Iranian-Islamic identity'.[13] Meanwhile, postgraduate courses on Iranian architecture began in several institutions, including the University of Tehran.

The literary difference between pre- and post-Revolutionary theoretical works addressing the relationship between architectural design and the notion of national identity in Iran can be seen in political definitions as well as in language. As nationalism discovered a dominant religious aspect, the explicit use of the term 'national identity', which had been pre-eminent in most architectural texts, was replaced by terms such as 'identity', 'Islamic identity' or 'Iranian-Islamic Identity'. In all such cases, an essentially ideological question is addressed in terms of its architectural manifestations. For example, in his *An Introduction to the Islamic Identity in Architecture*

11 Designed by various governments both before and after the Revolution, these programmes aimed to improve the economic situation within a specific period of time and through a certain plan. After the Revolution each development programme lasted for five years.

12 'Centre for Excellence in Islamic Architecture,' Iran University of Science & Technology, http://www.iust.ac.ir/index.php?slc_lang=en&sid=89, accessed online 6 February 2014.

13 ibid.

(2008), published by the Ministry of Housing and Urbanism,[14] Abd ol-Hamid Noghrehkar addresses the question of Islamic identity, focusing on the Islamic aspect of Iranian national identity as that most worthy of celebration in the post-Revolution period. The idea of identifying and reviving Islamic identity was also brought up in a meeting between the Supreme Leader of the Islamic Republic and the officials of the Ministry of Housing and Urbanism.[15] The importance of inaugurating a research foundation consisting of officials and academics who would initiate the fundamental research necessary 'to neutralise the crisis and revive Islamic identity' was discussed.[16] Noghrehkar starts his book by addressing this identity crisis in contemporary Iranian society as being the result of years of foreign influence and the lack of home-grown expertise.[17] He sees Iran's Islamic heritage, on both a social and architectural level, as the way to tackle the crisis; and justifies the symbolic role of architectural ornaments on earlier buildings and their metaphorical potential to convey meaning:

> We believe that there is no other way to manifest the spiritual concepts
> and values, but through the symbolic and representative approach
> that could be conceived in forms, however, the deciphering of such
> formal and physical elements is subject to interpretation and is in any
> case subjective. …The abstract elements in architectural creation,
> which have less reliance on the temporal and spatial conditions, have
> more potential to represent those constant values and therefore could
> contribute to the construction of identity. Therefore, … we will look
> at the most significant of these elements such as space, geometry and
> symbolism in a variety of architectural systems.[18]

Noghrehkar mentions the mosque as most suitable to be the iconic centre of Islamic cities[19] and identifies the dome and the minaret as the

14 Noghrehkar 2008.
15 ibid., و (vi)
16 ibid.
17 ibid., ى (x)
18 ibid.
19 ibid., 527.

main representative elements in the architecture of mosques.[20] Focusing on their symbolic values and how they represent the transcendental and earthly aspects of human life,[21] he further suggests increasing the visual presence of mosques in the urban fabric to highlight the Islamic identity of these cities.[22] Returning to early examples of Islamic architecture in Iran, Noghrehkar highlights how the arrival of Islam transformed and developed pre-Islamic architecture; and in speaking of the significance of the architecture of mosques in Iranian collective memory and how the dome structure enhances their visual significance, he focuses on the development of the form of the *chāhār tāq* as the most significant pre-Islamic example to have shaped mosques in Iran. Noghrehkar describes how the form of *chāhār tāq* was essentially used as a space for keeping the Zoroastrian holy fire in pre-Islamic Iran, and how it was detached from urban fabric and public life since most of the fire temples were constructed on high ground outside cities. Therefore, the arrival of Islam contributed to the continuation and development of the ancient architectural heritage in Iran as had it not been for the architecture of the mosques, *chāhār tāq* would have been long forgotten as an architectural element.[23]

The expansion of architectural knowledge and the increasing significance of the role of disciplinary researches resulted in approaching the issue of identity from another angle. In the architectural literature of the post-Revolution period, the notion of 'architectural identity' was introduced as another substitute for national identity. It focused on historic

20 ibid., 520.

21 ibid.

22 For an urban context, he suggests mosques should be constructed within a 400-meter radius of each other. ibid., 527.

23 Acknowledging the overall form of *chāhār tāq* as a pre-Islamic Iranian invention, Noghrehkar does not name any particular dynasty or significant examples but mentions that the form was first used in the design of fire temples. *Chāhār tāq* (which is often described as an invention of Sassanian or Parthian architecture, to hold a dome roof on a square base) finds a different aspect of importance here as the author focuses on how Muslims have adjusted its design in the early mosques and the fact that as an architectural element it has gradually been absorbed into the more complicated designs of mosques. Noghrehkar concludes that the Islamic tradition brought this element into the fabric of cities, and in closer contact with the public once it was incorporated into mosque architecture. See Noghrehkar 2008, 521.

examples that could represent a sort of uniqueness for Iranian architecture, perhaps with a less political tone. Since such uniqueness is the result of the cultural, regional and climatic characteristics of the country, 'architectural identity' became the index of collective identities.[24]

One of the most explicit examples of this is found in the five architectural characteristics of Iranian architecture specified by K. Pirnia. These five points, as well as most of Pirnia's researches, found a very significant place in architectural discipline after the Revolution, and his books were published for the first time in this period. K. Pirnia identified the principles of Iranian architecture.[25] His selection, which was first published in 1990[26] include: *mardomvārī*, which refers to purposefulness and the proportion of buildings being in accordance with the architectural programme, the needs of the user, and the human body; *parhīz az bīhūdegī*, which refers to the economy of design and avoiding wastefulness both in material and space, where each decoration plays a functional role and is not added solely for aesthetical reasons; *niyāresh*, which is the concern for stability and structure of the buildings; *khodbasandegī*, which is the tendency to employ local materials; and finally *darūngarāyī*, which refers to the inward-looking spatial organisation prominent in most buildings, and that fulfils both climatic and social goals.

Re-programming the Capitol Complexes: the Urban Expressions of Change

The creation of a 'capitol complex' in Tehran was one of the first actions

24 See: Behrouz Shahbazi Chegeni, Kazem Dadkhah, and Mahdi Mo'eini, 'Barrasi-e Naqsh-e Olguha-ye Hoviyyatpardaz dar Hoviyyat-e Me'mari-e Mo'aser-e Iran (Review of the identifying paradigms in the identity of the contemporary architecture of Iran),' *Motale'at Tatbighi-e Honar*, 8, Autumn-Winter 2014, 113–22.
25 K. Pirnia taught at the Faculty of Fine Arts at the University of Tehran from 1986 to 1992. Since his health did not allow him to organise his lecture materials himself, Gholamhossein Memarian, who studied under Pirnia for a long time, gathered his lecture materials and his researches together and published them in several volumes. They are still some of the most important reference works on Islamic and Iranian architecture for students in Iran. See Memarian 2005, 6–7.
26 Gholamhossein Memarian ed., Mohammad Karim Pirnia, *Shiveha-ye Me'mari-e Irani* (Styles of Iranian Architecture), (Tehran, 1990).

of each successive regime. The construction of Tup-khaneh Square and the Arg during the Qajar era, and the transformation of the Parade Ground during the reign of Reza Shah are the main examples. Each new capitol complex drew attention away from the previous one, as it housed a new range of government buildings. This would have continued during the reign of Mohammad Reza Shah on an even grander scale in the 'Abbas Abad Hills. Although the project was not realised because of the Revolution, the site provided a suitable arena for the representation of the post-Revolutionary regime.

The early post-Revolution period until the end of the Iran-Iraq war was a period of standstill for urban and architectural developments in Iran. Most of the projects that the Pahlavi regime had initiated in its last years were suspended or cancelled, including James Stirling's two projects, the construction of the so-called Shahestan-e Pahlavi, a new international airport, and Tehran's Metro project.[27] The only nationally significant projects brought to fruition during this early period were the addition of the Malek Library and Museum in Reza Shah's capitol complex in Bagh-e Melli, and the on-going construction of the Grand Mosalla (grand mosque) of Tehran in Mohammad Reza Shah's unrealised Shahestan-e Pahlavi. The plans for a post-Revolution capitol complex started with the idea of constructing a grand mosque as a modernised interpretation of the concept of the Friday mosque (*masjed-e jāmī*). Today,the Grand Mosalla serves for Friday prayers, but its social significance is not limited to traditional practices, as it often hosts other public events, including international trade fairs.

Having stabilised its political authority by the end of the Iran-Iraq war in 1988, the government of the Islamic Republic started an extensive round of construction and urban regeneration. Tehran, in particular, underwent a transformation, especially in the housing sector. Meanwhile, the 'Abbas Abad Hills became 'the governmental centre of the Islamic Republic'.[28] However, the idea, and even the competition for the design of Mosalla here predated this new comprehensive plan. As early as 1982, President Seyyed

27 Ghobadian 2013, 298.
28 'Me'mari-e Tarh,' Mosalla-e Imam Khomeini Tehran, http://musalla.ir/tabid/158/ArticleId/45/-45.aspx, accessed online 12 November 2012.

Ali Khamenei and Ali Akbar Hashemi Rafsanjani had submitted an initiative for the construction the grand mosque of Tehran – Mosalla-e Imam Khomeini – to Ayatollah Khomeini. In order to highlight deeper Islamic values, and to guard against pretension, Ayatollah Khomeini emphasised the need for the simplicity and purity of the design of Mosalla to recall the architecture of mosques in the early Islamic era:[29]

If God wills, [I hope that] you succeed to construct an anti-heresy vision amongst the Muslims, alongside constructing the Mosalla of Tehran. Incidentally, the simplicity of Mosalla must be a reminder of the simplicity of early Muslim's places of worship, and the grandiosity and showiness of the architecture of the mosques of American Islam must absolutely be avoided. May God approve all who are involved in the erection of mosques for Allah.[30]

His direction once again brings to mind the idea that perhaps a modern approach to design, without explicit historic symbolism, could have been an ideal answer. But in Iran, modernism was considered a Western import that disturbed the development of traditional architecture and was not therefore an option for design.

The initial guidelines and requirements of the project were gathered through a survey from 4681 members of the public, an inquiry among the clerics in Qom and among the Imams of Friday Prayers of other cities, and among architectural academics. They collectively agreed on a simple design, yet paradoxically also called for the use of various forms of symbolism and the creation of a sense of grandeur. The international competition for the design of the Mosalla was announced during the Iran-Iraq war at Friday prayers in January 1986 in Tehran.[31] Thirty-six proposals were submitted in the first round, but none of them met the aspirations of the government. The design that was finally accepted, outside the competition, was the work of a Beaux-Arts-educated architect and veteran teacher at the

29 ibid.
30 ibid.
31 'Tarikhcheh-ye Mosalla,' Mosalla-e Imam Khomeini Tehran, http://musalla.ir/tabid/158/ArticleId/44/-44.aspx, accessed online 12 November 2012.

University of Tehran, Parviz Moayyed Ahd. Moayyed Ahd, whose cur-
riculum vitae is decorated with many qualifications and awards, as well as
the design of many significant buildings, opted for what Vahid Ghobadian
in his historical survey of the project, has categorised as a 'traditionalist'
design.[32]

The design of Mosalla recalls the standard design of a sixteenth-cen-
tury Iranian mosque with additional monumental elements, including its
unconventional dome and the enormous free-standing pointed arch in front
of it. Nonetheless, the spatial configuration and geometry of the site-plan
and the existence of courtyards resemble the *masjed-e jāmī'* of Isfahan
and Tabriz on a much larger scale. Symbolism extends to the functional
elements of the complex. There are fourteen minarets, reminding one of
the fourteen members of Prophet Mohammad's family; twelve courtyards
representing the twelve Imams of Shi'ite tradition; and five entrances to
represent the five holy bodies in the Prophet Mohammad's family. The
grand iwan is seventy-two meters high, to commemorate the seventy-two
martyrs of the battle of Karbala,[33] and the height of the dome is sixty-three
meters to celebrate the age of the Prophet Mohammad.[34] The formal ele-
ments, including the arches and domes, are a collection from various archi-
tectural periods in Iran, from the Sassanian hyperbolic arch (which is also
considered as part of the Islamic architecture of the early centuries, after
the arrival of Islam to Iran[35]) to the pointed arches of the Islamic era. One
might look for a *chāhār tāq* or an iwan, both of which were widely adopted
in Islamic architecture and represent a sense of continuity that moderates
the transition from pre-Islamic to Islamic Iran. Surprisingly, the design
has completely transformed these elements, as the main dome chamber is
a steel structure supported by diagonal concrete beams. Additionally, the

32 Ghobadian 2013, 322.
33 During the battle of Karbala, Imam Hossein, the third Imam of Shi'ite Islam, his
family and followers, suffered a devastating defeat at the hands of the army of Yazid
I, the second Caliph of the Umayyad Caliphate. Imam Hossein's army numbered
seventy-two (including himself). This event remains a significant unifying narrative
for Shi'ites today.
34 'Mosalla-ye Tehran,' Mosalla-e Imam Khomeini Tehran, http://musalla.ir/
tabid/158/ArticleId/47/-47.aspx, accessed online 12 November 2012.
35 Ghobadian 2013, 302, where he mentions these arches in the shape of the main
dome not as an imitation of Sassanian, but as early Islamic architecture in Iran.

401a: The Grand Mosalla of Tehran during the 31st
Tehran International Book Fair, 2017.

401b: The external
corridors of the
Grand Mosalla of
Tehran during the 31st
Tehran International
Book Fair, 2017.

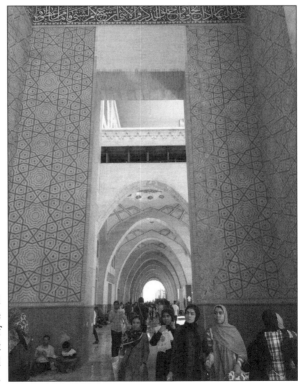

grand iwan has a pointed arch detached from the main dome chamber. The decoration of the external corridors of the complex shows a combination of pre-Islamic and Islamic motifs.

Following the Mosalla project, the Atec and Archolog consulting companies produced a new comprehensive plan for the 'Abbas Abad Hills in 1993; and soon after, the construction of a new 'political and administrative centre of the capital' began.[36] Its design aimed to address the lack of green space in Tehran, facilitate the decentralisation of governmental organisations from the old centre of the city, and to include new administrative, commercial, and hospitality facilities.[37] The proposal also included three metro stations and three highways, dividing the 'Abbas Abad 623-hectare plot into six zones.

Between 2004–05, Naqsh-e-Jahan Pars Consultants produced revisions to these plans. The main emphasis of their new alternative was to increase green space and reduce the number of administrative buildings, while density decreased drastically.[38] These changes were primarily in accordance with the urban development of Tehran since the 1970s and the transformation of the city to a high-density metropolis with a lack of public and green space. To strengthen the connection between the divided zones of the project and to highlight the Mosalla as its main element, a north-south walking axis was designed, connecting the Mosalla to the northern ends of 'Abbas Abad. The plan also included several bridges, to connect various zones over the highways that cut through 'Abbas Abad.[39] Smaller parks with different themes were scattered throughout the project, including the Bagh Museh-ye Defa'-e Moqaddas, or 'Museum-garden of the Holy Defense',[40] located on the main north-south axis. Recalling the

36 'Tarikhcheh-ye Arazi-e 'Abbās Abad,' Sherkat-e Nowsazi-e 'Abbas Abad, http://abasabad.tehran.ir/Default.aspx?tabid=439, accessed 12 November 2013.
37 Farnahad Consultants, ''Arazi-e 'Abbas Abad; Yek Emkan ya Tahdid dar Markaz-e Tose'eh Shahr-e Tehran,' *Jostarha-ye Shahsazi* 4, (2003), 29.
38 'Kholaseh-ye Tarh,' Naqsh-e-Jahan Pars, http://njp-arch.com/, accessed online 12 July 2017.
39 Saman Sayyar, interview with the author, 9 August 2017.
40 Defa'-e Moqaddas (The Holy Defence), refers to the Iran-Iraq war of 1980–88. It remains one the key moments in the solidifying and reformulation of nationalism in post-Revolutionary Iran.

402: Naqsh-e-Jahan Pars, Comprehensive plan for the
re-development of the 'Abbas Abad hills, 2005.

significance of historical maidans in Iran, as the urban representation of shared space between the nation and the state, a new maidan – Maidan-e Farhang (Culture Square) – is planned at the heart of 'Abbas Abad, on the central pathway from Mosalla to Haqqani highway in the north.

The other major urban transformation after the Revolution took place in Bagh-e Melli, where the new government added a number of buildings and changed the function of some of the existing ones. The first addition was the construction of the Malek Library and Museum, an endowment to Astan Qods Razavi.[41] The architect Reza Deyshidi began the design of this complex, which is located in front of the former Police Headquarters,[42] in 1985 and construction finished in 1996.[43] As with the older buildings in the enclosure, the design is highly historicist. However, contrary to the rest of the buildings on the site, it celebrates the Islamic architectural heritage of Iran. In fact, one can hardly consider it as Postmodern architecture – that is, a building that follows the architectural developments of the late 1960s and 1970s – as it is almost an imitation of Safavid architecture. Considering that the main transformation of the Parade Ground happened during the reign of Reza Shah and was his legacy in Tehran,[44] the addition of a new building with a new function, one that demonstrated a different taste in architecture in terms of historical references in such a politically and financially significant moment comes across as a cultural investment on a much more significant level. These additions change the cohesive character of the Parade Ground, which for many decades had celebrated a pre-Islamic heritage, and neutralise the ideologies exhibited by earlier constructions.

Later the Ethnographic Museum changed to the Museum of the Islamic Era and the Police Headquarters became the Ministry of Foreign Affairs.

41 Haj Hussain Malek, one of the major landowners in Khorasan, endowed the plot and the collection is now kept in the Malek Library and Museum of the Astan Qods Razavi.

42 See Ghobadian 2013, 302.

43 'History,' Malek National Library and Museum Institution, http://malekmuseum. org/en/page/5/History, accessed online 29 June 2013.

44 Also, the distinctive architectural trend that started in this territory initiated what was later known as National Architecture, and disseminating across the country, promoted the state's definition of national identity.

403: The Malek Museum and Library.

The Islamic Republic began the necessary refurbishment of the Ethnographic Museum in 189 and relocated Islamic artefacts to this building. The original building, designed by Yevgeny Aftandilian in the early 1950s, had featured an adaptation of the form of *chāhār tāq*,[45] and had been one of the last additions made to Bagh-e Melli during the Pahlavi period. It had come into being in response to Arthur Pope's criticism that Iran did not have enough museums. Ali Hannibal, an ethnologist and a member of SNH, had supported the establishment of this museum,[46] which in its original form coordinated conceptually with Godard's Museum of Ancient Iran – the other building in this area inspired by Sassanian architecture, albeit

45 Mokhtar Taleghani (2002) has dated the construction of the Ethnographic Museum to 1330s AP which corresponds to 1950s CE, while Mozaffari (2007) dates its construction to between 1941 and 1953. Therefore, I use an estimated date of the early 1950s, especially as the focus here is on the re-appropriation of the building in 1989 and its functional transformation from the Ethnographic Museum to the Museum of the Islamic Era.
46 'There are no museums in Iran; and the locals are not taking care of this heritage, hence we are taking it out of the country to protect it for the appreciation of the world. These were excuses by foreigners.' Quoted in ol-Olumi 1976, 7; (cited in Grigor 2009, 30).

with Aftandilian's design having a more modern appearance. This three-storied building has no decoration on the façade, in comparison with the earlier buildings of the Parade Ground. Instead of a cuboid base, the dome is placed on top of a cruciform plan with equal sides. In 1975, following the expansion of archaeological research and in response to the staggering increase in the number of relics at the Museum of Ancient Iran, the government decided to relocate the collection to Golestan Palace and to allocate Aftandilian's building to the display of relics of the Islamic era.[47]

It is not clear whether Islamic relics were exhibited properly before this date or no, but it is clear that the main goal of establishing the Museum of Ancient Iran had been to display pre-Islamic artefacts. These resonated better with the ideological policies of the Pahlavi monarchy. As has been said, Islamic relics were kept in the museum's storage rooms, or were exhibited only on the second floor of the museum. The new Museum of the Islamic Era officially opened to the public in 1996,[48] and together with the Museum of Ancient Iran, became known as the National Museum of Iran. As with the old museum, this new museum had its specific ideological significance too.[49] Its opening came only a year after the ending of the Iran-Iraq war, at which time the Islamic Republic could not finance the construction of a new building for the museum. Nevertheless, it succeeded in making a significant mark by relocating the Islamic collection and bringing it to the centre of public attention.

The next significant urban project transformation took place in 1997, at the historically remarkable Maidan-e Baharestan, which had housed the first building for the national consultative assembly in 1906. The idea of the development of the Maidan, and the construction of a new enlarged parliament building, was first suggested in the mid-1970s. The project started on a limited scale,[50] and it took many demonstrations, a revolution and eight years of war before it was realised, but in 1988, Hossein Sheykh Zeynadin at Bavand Consultants put forward a design for a building for offices of the members of Parliament. (The company was also responsible

47 Mozaffari 2007, 89.
48 ibid.
49 See Mozaffari 2007, 98.
50 Bani Masoud 2010, 467.

for the urban design and upgrading of Jomhuri Street, which has Maidan-e Baharestan on its eastern end.[51]) The building was finished in 1992 and has a simple stretched cubic form, decorated with the addition of two identical two-storey kiosks on the main roof. These additional elements resemble the Qajar palace of Shams al-'Emarah and emphasise the Qajar history of this parliamentary complex.

Later, in 1997, 'Abd ol-Reza Zokayi at Pol Mir Consulting Architects produced a design for a new parliamentary building as the main building of the complex. With no discernible historicist references, the pyramidal shape of this building represents stability and the relationship of the three branches of the state: legislature, judiciary, and executive. Zokayi considers this building as an architectural response to the existing buildings in the area, including the office building of the members of the parliament.[52] In 2001 the Islamic Consultative Assembly finally returned from Mohsen Foroughi and Heydar Ghiyai's iconic Senate building near Marmar Palace to this, its historically relevant neighbourhood near the first Majlis building. The two neighbouring buildings represent the assumption of an ideological connection and suggest an historical lineage with the legacy of the Constitutional Revolution – very fitting as Baharestan was the one maidan that, similar to the history of constitutionalism that it represents, was claimed by both pre- and post-Revolutionary regimes.

Since the Constitutional Revolution, Baharestan has been a locus for claiming civil rights, and is seen as the parliamentary site that symbolically connects the sovereign state to the political heritage of the Constitutional Revolution. Apart from the earliest building for the National Consultative Assembly, other historical buildings in the site, such as Shahid Motahari University (formerly known as the mosque and the religious school of Sepahsalar), are significant in the history of the Constitutional movement and its political consequences up to the Islamic Revolution. Throughout the Pahlavi monarchy, Sepahsalar school was a centre for Islamic education, and later it became one of the influential hubs of the revolutionary

51 'Urban Design and Upgrading of Jomhuri Street,' Bavand Consultants, http://bavand.net/main/, accessed online 13 July 2017.
52 Abd ol-Reza Zokayi, 'Sakhteman-e Jadid-e Majlis-e Showra-ye Eslami (The new building of the Islamic Consultative Assembly),' *Me'mar* 18 (Autumn 2002), 67–75.

activitists for the dissemination of Islamist ideology. It is one of the most historically valuable mosque-school complexes in Tehran. The other significant building located in the area is the Marvi school, a religious school for girls, which was also a significant centre of support for Ayatollah Khomeini's activities before the Revolution. The site also included the small modernist library and archive of Majlis, designed by Houshang Seyhoun. This was the only building from the Pahlavi era in the site, and was demolished as part of the most recent comprehensive and urban regeneration plans for Maidan-e Baharestan.

By 1997, the government had become aware of the need to regenerate the area of Baharestan. Naqsh-e-Jahan Pars, one the most prominent architecture firms in the country, produced the first proposal for the site, which was intended to 'revive the historical ambience of the area, and to eliminate those marginal structures'. Construction started in 1999.[53] The plan was to create a unified urban compound by enlarging the open spaces between Maidan-e Baharestan and the two parliamentary buildings. This required the demolition of the less significant neighbouring buildings, and extended the Maidan eastward, to connect the new Majlis building with the old one and create a capitol complex within Baharestan. The overall site was to be extended southward, bringing the historically and culturally significant building of Sepahsalar mosque and school into the complex. The plan also included the reconstruction of the former Nezamiyyeh garden to create a public space and invite pedestrians into the site.

The urban re-configuration of Baharestan entered a new phase with the support of the Islamic Parliament of Iran and the Municipality of Tehran in May 2011, when new buildings including a library, office buildings, a commissions centre, and residential units for the members of the parliament were added to the brief.[54] As the site holds the memory of many political events, it was felt that its post-Revolutionary narrative would be better represented by the demolition of the old library building, erasing the only mark of the Pahlavi monarchy and creating a post-Revolution capitol

53 Naqsh-e-Jahan Pars 2005, 90.
54 'Kolang-e Tarh-e Jame'-e Tose'eh-ye Majlis-e Showra-ye Eslami Zadeh Shod' (The comprehensive plan of the development of the Islamic Consultative Assembly has started), Islamic Consultative Assembly News Agency, http://www.icana.ir/Fa/News/163391, accessed online 28 January 2013.

404: Naqsh-e-Jahan Pars, Schematic plan for the urban
regeneration of Maidan-e Baharestan, Tehran.

complex. Following the new brief, the upgraded proposal for the new comprehensive plan was a collaboration between Tehran-based Design Core [4s] and Hamburg-based BRT Architekten.[55] In it, the site is to be further extended towards the south, opening the necessary space for the construction of a new library and archive building. Also, the extension of the old maidan into the site receives more emphasis in this version, by virtue of locating the building of the commission centre at the eastern end of the area and replicating a small maidan similar to the original configurations of Baharestan outside the area. In 2012 *Me'mar* (The architect) magazine, published a report on Design Core [4s] Architects, which introduced the Baharestan project and the building of the commission centre for the first time. In this issue of *Me'mar*, the façade of the building is shown as decorated with a pattern created in Kufic calligraphy, of the Surah of Al-Fateha from Quran.[56] Intended as one of the dominant buildings on this site, the commissions centre is currently under construction and subject to alterations, so its final façade and visual significance will only be revealed in years to come.

At the same time as the first round of constructions in Baharestan in 1992, the creation of a new icon for Tehran was introduced by the Tehran Beautification Organisation, with a proposal for a new telecommunication tower. Consequently, the construction of Milad Tower on Gisha Hills started in 1996. The proposal, crowned by the Tower, included a multifunctional complex with a conference centre, a five-star hotel, a centre for international trade, commercial units and other public and administrative buildings needed by Tehran at the time.[57] Although this area is detached from neighbouring urban centres by busy highways, the Tower and its public facilities form an active space in Tehran, but proves that it takes more than a monumental building to be a powerful icon for a city. In

55 For this project, the two companies collaborated while Design Core [4s] was officially responsible for authorising the project. The new Library and Archive building was designed by Hadi Tehrani, the Iranian-German director of BRT Architekten.
56 'Sherkat-e Me'mari va Shahr Sazi-e Haste-e Tarahi [Fazaye Chaharom]'(Haste-e Tarahi [Fazaye Chaharom] Architecture and Urban Design Company), *Me'mar* 74 (2012), 93–4.
57 Bani Masoud 2010, 480.

comparison with Shahyad Tower (now known as Azadi), the validity of this complex as a true icon of Tehran has often been questioned, due to its lack of a sense of cultural affiliation with the visual characteristics of Milad Tower, and to its outdated programme.[58]

It seems that to become the true national monument and an icon of a city like Tehran, with such a turbulent history, a building must have the potential to transcend from urban space and enter the realm of collective memory. Form and visual references to a shared past can stimulate this sense, but a building can still communicate this message to the public without such visual references and through its function; by showing that it was designed for the benefit of the nation and addresses public need. Considering multiple layers of visual and functional differences, this might be the common success factor in becoming an icon for both the Azadi and Milad towers, albeit on different scales. As representations of national identity, iconic buildings are the most powerful examples in urban space. They can visually represent a shared glorified past, or they can highlight and show the current characteristics and concerns of society, reflecting contemporary activities, needs, and the value-systems of a nation-state through the functional considerations of a project that gives it its identity.

Addressing the Question of Identity

The question of defining national identity became increasingly nuanced during and after the 1990s. There was the issue of its architectural representation, along with the development of other aspects of the discipline, with academic discussion around the subject continuing in various events and with various new approaches evident in new architectural projects. Although international connections were limited in this period, theories and practice in architecture worked and developed hand-in-hand, each exerting influence on the other. Architects continued to address the question of identity through projects as well as in their publications; however, both aspects lost most of their connections with recent developments in the fields of archaeology and history.

Supported by the Cultural Heritage, Handicrafts and Tourism

58 ibid., 481.

Organisation (CHHTO), the series of congresses held in the historic city of Bam in Kerman province, launched in 1995, 1999 and 2006, were some of the most significant post-Revolutionary architectural events to investigate the question of identity. This series could be seen as the continuation of the two International Congresses of Architecture held in the 1970s as in both, the relationship between government bodies and academics was similar, with significant official presence and influence. The slight difference between the two series was that during the Pahlavi era, politicians and the monarchs were directly involved, whereas the post-Revolution congresses show the less direct and more systematised presence of political power.[59] Also, the scope of the events was different – in the Bam congresses all the contributors were Iranian professionals and academics, topics were not as thematically organised as in the former series and a wider variety of subjects was discussed.

In the first Bam congress Mostafa Mirsalim, the Minister of Culture and Islamic Guidance, gave the opening address, in which he focused on the issue of an identity crisis in Iranian architecture and the general ignorance of Iran's historical and cultural heritage. Focusing on Iran's Islamic heritage, Mirsalim celebrated the achievements of the Islamic era, praising in particular characteristics that he identified as 'modesty' or the consideration of 'religious aspects' in 'our architecture', all stemming from this period.[60] Additionally, he focused on the case of mosques in Iranian cities and how they form and reshape the urban fabric.[61] Despite the change of reference, this speech sounds similar to previous statesmen's speeches

59 A similar relationship is evident in the case of significant architectural projects.
60 In his speech, Mirsalim avoided using explicit adjectives such as 'pre-Islamic', 'Persian', or even 'Islamic' and 'Iranian', but repeatedly used the words 'our architecture and urban design', 'our cultural heritage' and 'our historical architecture and urban design'. However, the emphasis of the text is on celebrating architecture of the Islamic era. Such ambiguous wording is common in architectural literature during this time; in one way it seems an indirect means of collectively accepting and admiring the architectural heritage of all historical periods, even though on an exemplary and practical level, one can still see an emphasis on particular periods of this history.
61 Mostafa Mirsalim, 'Matn-e sokhanrani-e eftetahiye jenab-e aqa-ye mohandes Mostafa Mirsalim' (His excellency engineer Mostafa Mirsalim's inauguration speech), *Ayatollahzadeh Shirazi* (1995), vol. 5, 2.

during the 1970 and 1974 congresses. Such similarities in treating the past as the core of Iranian identity suggest that architectural concerns regarding the question of identity before and after the Revolution are essentially the same: how to represent a sense of cultural continuity, preserve the architectural heritage and represent national and ideological identity in the face of the inevitable forces of modernity and progress. These unchanged concerns have found differing aspects, various points of reference, and developed with the changes in architectural discipline. The number of articles focusing on the question of identity and its relation to architecture in the first event shows how crucial it was to tackle the issue as a central architectural problem. At least half-a-dozen of the papers published in the five volumes of conference proceedings of the event deal in one way or another with the 'identity crisis' detected since the modernisation of the country, especially during the most recent period. A rupture with tradition, identified since the late Qajar era, and a nostalgic attitude toward the architecture of the past, are common themes amongst them.

Glorifying the past, and a sense of continuity, were investigated rigorously in Hamidreza Khoyi's 'Investigating a Problem: Identity and Our Architectural Path'[62] and in Mohammadreza Araghchian's 'New Life, Old Architecture'.[63] They both looked back nostalgically at the achievements of historical architecture, and acknowledged a meaningful relationship between traditional architecture and its context. For them, contemporary architectural developments have not provided any such harmony. It is not clear if they blame the rapid modernisation of the country and imported architectural trends for this, or the detachment of Iranian society from its traditions. Alternatively, one can consider their criticism as part of a fascination with architectural history and heritage that can be traced as far back as the 1930s. In any case, the common point in all such declarations was a selective appreciation of the past, and the way in which this led to a consideration of architectural modernism as the reason for that sense of a rupture with architectural tradition.

62 Hamidreza Khoyi, 'Barrasi-e yek masa'leh: hoviyat va rah-e me'mari-e ma' (Study a problem: identity and our architecture's path), *Ayatollahzadeh Shirazi* (1995), vol. 3, 211–19.
63 Mohammadreza Araghchian, 'Zendegi-e jadid, me'mari-e qadim' (Our modern life, architecture of the past), *Ayatollahzadeh Shirazi* (1995), vol. 2, 267–71.

K. Pirnia's paper, 'The Iranian Loss of Self and the Decline of Iranian Arts' was perhaps the most explicit in this case, as it criticises the detachment of Iranian society and particularly architecture from the traditions of the late nineteenth century.[64] Without naming any specific aspect of the history of architecture, Pirnia calls for a return to the past as a source of knowledge, rather than of patriotic pride. For him, it is this traditional knowledge and learning from the past that can act as a guide toward a better future for architecture in Iran, instead of the imitation of Western or other architectural traditions. Pirnia focuses on the innovative aspects and functional elements of vernacular architecture in Iran, such as the $r\bar{u}n$[65] and $t\bar{a}beshband$,[66] both of which helped to provide climatic comfort in Iran's arid regions. These traditions were forgotten during the last century, but they could be incorporated in architectural and urban design as part of environmental considerations.

In 'The Constant and Variable Elements in Architecture' Ali Akbar Saremi approached the question from a different angle, as he does not dwell on a nostalgic appreciation of the past.[67] He sees the only possible way forward is to revive the sense of continuity in further historical research, in order to learn from it rather than imitating the past. The process of learning for Saremi is the only way to connect with the past. In one way, while Saremi is interested in traditional architecture, the notion of the development of the tradition seems more important than repeating the tradition itself. Another viewpoint can be found in Eema'il Talai's paper, 'The Effect of Identities and Historical-Architectural Values in Contemporary Architecture and Urban Design in Iran', where he acknowledges the

64 Mohammad Karim Pirnia, 'Khodbakhtegi va foru oftadan-e honar-e Iran' (Self-alienation and decline of the art of architecture in Iran), *Ayatollahzadeh Shiraz* (1995), vol. 1, 225–8.

65 *Rūn* refers to the orientation of the building in relation to beams of sunlight. Iranian traditional architecture suggests that buildings should be constructed on certain orientations (rūn) according to each region's climate.

66 *Tābeshband* is a horizontal structure, built above the window frames that helps to reduce the entry of sunlight into a room. In this way, less heat is generated inside, which helps with air conditioning in an arid climate.

67 Ali Akbar Saremi, 'Anasor-e paydar va moteghayyer dar me'mari-e hayat' (Constant and variable elements in garden design), *Ayatollahzadeh Shirazi* (1995), vol.1, 228–47.

sense of perpetuity that comes from an inventive and unique approach to architectural issues.[68] In his paper, the value of the past is in searching for the originality of its artefacts. To study past examples, one cannot simply look at traditional architecture from a celebratory point of view and imitate its physical appearance, while ignoring the potential to be found within the creative thinking behind it:

> If there is a problem, it is the lack of belief in ourselves and not giving the credit to our original and creative past thoughts. We look at their works as a meaningless shell which is destined to gradually and inevitably diminish.[69]

The last two papers start to go deeper into the issue of the 'identity crisis,' but without suggesting the 'revival' of traditions. They promote learning from the past and the study an historical work not as a singular or abstract edifice, but within its historical and cultural conditions. These two points were also stressed in the First International Congress, which concluded by criticising the empty repetition and 'revival' of the past architecture as a way to keep tradition alive.

The mid-1990s, when the Bam congresses took place, also witnessed the design of some of the most significant urban and architectural projects, including the first post-Revolution capitol complex in the 'Abbas Abad hills. Apart from the Grand Mosalla, the draft plans for which were finalised in 1993 and would occupy almost half the area of the 'Abbas Abad hills, the other major projects for this site included several metro stations, the governor's office, the Ministry of Road and Urban Development, a new building for the National Library and Archive, the Cultural Centres of the Islamic Republic of Iran, two main parks with a number of smaller themed parks in between, and more recently the Tabi'at footbridge, connecting the eastern and the western sides of the 'Abbas Abad hills over the Modarres highway. After the Mosalla, the most monumental buildings on

68 Esma'il Talai, 'Tasir-e hoviyyat-ha va arzeshhaye me'mari-e tarikhi dar me'mari va shahrsazi-e mo'aser-e Iran' (the effect of identities and historical values of architecture on contemporary architecture and urban design in Iran), *Ayatollahzadeh Shirazi*, (1995), vol. 5, 412–17.
69 ibid., 415.

the site are the National Library and the Cultural Centres, both of which were the subjects of significant architectural competitions, in 1994 and 1995. Naqsh-e-Jahan Pars, the architectural firm led by Hadi Mirmiran, won the first competition for the design of the Cultural Centres in 1994. Although the project as it was realised followed a different design, the winning proposal is significant in terms of its responses to the question of national identity.[70] It was an amalgamation of various historical references; from aligning the geography of the site in parallel with the most significant historical sites in Iran, such as Persepolis and Naqsh-e Jahan Square in Isfahan,[71] to using historical elements such as a *chāhār tāq* for its conference centre.[72]

The next, limited, competition was held in 1995 for the design of the National Library, and in this case it was successfully realised on the site. The top five entries had noticeable historical symbolism, while the winning design was one of the most historicist proposals. Indeed, 'to be a monumental building which is a continuation of the glorious technical and artistic history of Iranian-Islamic architecture'[73] was one of the most important criteria that the client, the Governmental and Public Buildings and Utilities Organisation, had demanded. This sense of continuity was to be achieved through the appropriation of 'the latest techniques and technology of engineering [construction]'.[74] Echoing the challenges addressed since the 1970s, this statement once again shows that the official approach

70 Since this book focuses on representations of national identity and the ways in which progressive architecture has responded to this issue, for some of the projects examined here I discuss winning proposals, instead of the final constructed designs. These proposals have significant aspects that are worth mentioning as they show how the architectural response towards nationalism has evolved. The question remains as to why such projects are so rarely realised in the built environment.
71 This alignment in traditional architecture, where it is concerned with climatic benefits for the project, is also known as *rūn.*
72 'Moarrefi-e tarh-haye mosabegheh-ye me'mari-e farhanestanha' (Introducing the design proposals for the architectural competition of the Cultural Centres), Abadi 13, (1994), 4–17.
73 'Moarrefi-e tarh-haye mosabegheh-ye ketabkhane-ye melli' (Introducing the design proposals for the architectural competition National Library), Abadi 17 (1995), 4.
74 ibid.

towards the representation of Iranian-Islamic identity is fundamentally unchanged since the early decades of the century.

However much subject to interpretation, constructed or proved by disparate evidence, history has been at the core of the various understandings of collective identity. In these projects, modernity – not just modern architecture, which was considered merely as an imported concept and architectural trend – remained in an ambiguous zone. It was neither fully adopted nor negated; it was reduced to a practical force, feeding new technologies into designs that would revive the memory of a selected past in a new way. Arguably, the other possible way to understand modernity could have been through the favouring of the present without necessarily negating the past. Giving a crucial value to the present would have been its contribution to the development of architecture in terms of representing a collective identity. It could contribute to the representation of a sort of identity that is closer to the 'selfness' of society at any time, rather than dwelling on a 'sameness' that hardly exists.

In the case of the National Library, most of the entries used historical references in the design of the main volume and its forms. Yet the successful proposal, by Piraz Consulting Engineers, has these references mostly in its functional and organisational aspects, and diverges ever so slightly from the mere visual use of historical elements. The overall volume is inspired by the topography of the hills, and the facades of the building are covered with simple red brickwork. The small windows near the ceilings are inspired by the traditional openings found under the dome structure of mosques, to bring indirect light inside.[75] The other historical references in this design are the octagonal shape used for various spaces, which imitates the most commonly used polygons of traditional plans in Islamic architecture in Iran.[76] Also, the project encompasses several small courtyards, which are another common element in Iranian Islamic architecture. Lastly, the other historical reference is the design of the front garden, which is similar to the historic Garden of Fin in Kashan, as both lay on a slope.

75 ibid., 5.

76 Apart from the numerical symbolism of an octagon, the entrance of most traditional houses has an octagonal shape, hence the term *hashtī* (the octagonal space).

Similar divergence from the visual use of architectural heritage is evident more clearly in Hadi Mirmiran's proposal, which won second place in the competition, where the concept of the design was the spatial realisation of a verse by the Persian poet Naser Khosrow Qobadiani (1004–1088 CE):

Behold how an angel flies from the foul demon
As melted gold rejecting a lump of tar.[77]

The verse exhorts the imagination to consider the strong contrast between lightness and darkness, which resembles the force of knowledge over ignorance. As inspiration it resulted in a design that showed a large, dark horizontal platform for reading rooms on the ground level of the building, pierced by the volume of a central gold vertical space that stretched into the underground levels. The vertical volume, which also employed 'ancient plaques carved with sacred scriptures, preserving for posterity the secrets of the past',[78] housed the library's repository and archives. In this proposal, a glass cover framed the golden plaques and the reading spaces, echoing visually the peak of Iran's famous Mount Damavand, on the coast of the Caspian Sea, while creating a feeling of protection within the building.[79]

Although never realised, this project marks a significant shift in the architectural representation of national identity in large-scale buildings. While the overall developments of 'Abbas Abad established it as the capitol complex of the post-Revolution regime with similarities on political and urban levels to earlier examples in Tehran, the design of this proposal suggests a conceptual shift on the architectural level. As a graduate from the University of Tehran in 1968, Mirmiran's design distantly echoes the influence of Seyhoun as both had a less decorative approach to design. Mirmiran however had expanded his knowledge and understanding of Iranian architecture extensively, focusing on the concepts of transparency and joyousness. Without any prejudice in using various elements or concepts from Iranian architecture, he was cautious about taking direct

77 Naser Khosrow Qobadiani (translation cited in Naqsh-e-Jahan Pars 2005, 231).
78 ibid.
79 ibid., 224–35.

405: Hadi Mirmiran, Sketch of a design for the National Library.

inspiration either from the architecture of the West or in his more suc-
cessful projects, from visual aspects of Iranian architecture.[80] He replaced
the visual references to past architecture – whether 'kingly' or vernacular
– with a conceptual representation of Iranian literary heritage. Here, he
gave space to the Persian language, which has been a crucial aspect of
the national project since the beginning of the twentieth century. Also, by
referring to Mount Damavand, which has long been considered a national
icon, and is celebrated in Mohammad Taqi Bahar's poem *Damavand*, this
project increased the repository of design inspirations.

This architectural approach is also evident in Mirmiran's collaboration
with Bahram Shirdel for the design of the National Museum of Water,
a building that represents the unique understanding of water in Iranian
culture, in constant harmony and duality with its soil.[81] Designed in 1995
for Pardisan Park in Tehran, this project was also not realised, but its design
seems like a step forward in a continuous architectural challenge, many

80 Saman Sayyar, interview with the author, 30 July 2017.
81 Naqsh-e-Jahan Pars 2005, 210.

of whose masters had already left the country. It took more than a decade for architects such as Mirmiran to become leaders in the area of designs that aimed to represent a sense of continuity with Iran's historical heritage without visual imitation, or being limited to a specific time or place. Mirmiran was in fact in search of a developed version of Iranian architecture that would mark the country as a trendsetter on a global level.[82] His famous quote reflects the ideals of architects on the threshold of the twenty-first century, while seeing Iranian architecture as part of world architecture.

> The new trend in the contemporary architecture of Iran, to which
> I belong, tries to create a kind of architecture that continues and
> develops the past architecture of this land, and can assume a worthy
> position for it in the contemporary architecture in the world.[83]

This approach was a central subject, addressed from a variety of viewpoints in the arguments presented in the Second Bam Conference in 1999, especially in Mohammad Mansour Falamaki's seminal paper 'Principles and Characteristics of Creating a Form in the Architecture of Iran'.[84] Falamaki sets out a variety of means for critical analysis in architecture, mentions the lack of critical thinking in Iranian architecture, and suggests a search for the principles of Iranian architecture instead of styles or schools. To Falamaki, since these principles were not documented, they could not produce archetypes, nor dictate a method. Instead, these principles were defined basics, which could lead to the creation of occasional architectural examples that depend on place and time. These conditions, and the decisions by the designer, shape the characteristics of a project, and these characteristics would in time reveal architectural principles. Falamaki

82 Hadi Mirmiran, 'Agar Hoviyyat-e Khod ra Faramush Konim Jayi dar Jahan Nakhahim Dasht' (We have no place in the world, if we forget our identity), *Hamshahri*, 24 April 2007, 22.
83 'Darbareh-ye Sherkat,' Naqah-e-Jahan Pars, http://njp-arch.com/, accessed 10 June 2017.
84 Mansur Falamaki, 'Asl va Vizhegiha-ye afarinesh-e shekl dar me'mari-e Iran' (The origin and the characteristics of form creation in Iranian architecture), *Ayatollahzadeh Shirazi* (1999), vol.2, 85–97.

406: Model of Hadi Mirmiran's design for the National Library.

407: The National Library as constructed to the design
of Piraz Consulting Engineers in 1998.

stressed that it is not possible to speak of a school (*maktab*), nor a style in Iranian architecture, since we cannot identify a specific document theorising Iranian architecture. Comparing the cases of the Safavid maidans in Isfahan, Qazvin, and Kerman, for example, he concludes that the principles that provided the basis and fundamentals for the development of precise and definable characteristics in Iranian architecture were never literarily documented, analysed, or criticised until the late Qajar period.

More importantly, Falamaki believes that maintaining and continuing these principles does not happen through the imitation of examples. These principles only survive as long as the architect is free to select and accept core values and concepts. To Falamaki, this does not require a school or style to emulate, especially as such emulations have been condemned in Iranian arts and mysticism. Although Falamaki did not name the principles in this paper, in 2012 he introduced them in his *Principles and Reading of Iranian Architecture*.[85] But what is central and perhaps most important with regard to the architectural representation of national and collective identities is the formulation of an understanding of Iranian architecture that is independent of the revival of previous works or the imitation of visual reference, and that gives a sort of rational emancipation to the architect.

At the same event, Mohammad Reza Rahimzadeh looked at conditions for the recognition of identity in the arts, and questioned the validity of the association of a 'national', 'Iranian' or 'Iranian-Islamic' identity with a work of art through its symbolism.[86] Rahimzadeh examines various definitions of identity both in Western philosophy – especially in the works of Descartes and Ricoeur – and in Iranian mystical and philosophical literature, with the aim of identifying which definition of identity is more applicable to the two sorts of social structures that he borrows from Edward Said's *Orientalism:* the civil society and the political society.[87] Rahimza-

85 Mohammad Mansour Falamaki, *Principles and Reading of Iranian Architecture* (Tehran, 2012).
86 Mohammad Reza Rahimzadeh, 'Mafhum-e hoviyyat (The concept of identity),' *Ayatollahzadeh Shirazi* (1999), vol. 3, 261–75.
87 Edward Said, 'Orientalism', in Francis Franscina and Jonathan Harris, eds, *Art in modern culture: An anthology of critical texts* (London 1992), 136–144. (Cited in: Mohammad Reza Rahimzadeh, 'Mafhum-e hoviyyat (The concept of identity),' *Ayatollahzadeh Shirazi* (1999), vol. 3, 263–265.

deh establishes identity as the quality that distinguishes an entity through its unique nature and concludes that it is the essence of an entity, based on its characteristics.[88] He mentions symbolism as making a work of art 'responsible to express something that does not belong to it in essence'. Imposed symbolism will diminish a work of art to a 'transmitting apparatus' and leads to 'the detachment of its features from its content.'[89]

Rahimzadeh also questions the validity of adding a particular part to an object that could change or represent its identity regardless of its totality; hence he also questions the association with a particular identity, whether national or historical, through the symbolic use of artwork. Referring to Ricoeur's definitions of *ipse* and *idem*, he focuses on their differences in the way that each concept responds to the passing of time, as he tries to draw similarities between the identity of a person and the identity of an artwork: 'Similar to a person, the artwork would express its self [*ipse*] through time, while the sameness [*idem*] is a quality which will resist the passing of time. The self will form throughout time and will disappear without it.'[90]

Going back to the differences between political society and civil society as Said describes them, for Rahimzadeh what differentiates the definition of identity in the two categories is related mainly to how the element of time has been treated in the construction of the notion of identity. Since political society demands constancy, its definition of identity must be time-resistant. Therefore, it is closer to the idea of sameness (*idem*), which in the case of the arts would conform better with symbolism. On the other hand, for Rahimzadeh the definition of identity in a civil society is the question of how to remain oneself, not how to remain the same. This differentiation enabled Rahimzadeh to address the question of symbolism in the representation of national identity in contemporary architecture in Iran:

> The identity of a work of architecture in contemporary Iran is not
> somewhere out of this place or time that could be added to the design

88 Mohammad Reza Rahimzadeh, 'Mafhum-e hoviyyat (The concept of identity),' *Ayatollahzadeh Shirazi* (1999), vol. 3, 264.
89 ibid., 265.
90 ibid., 266.

in order to give it an identity. Once an architectural work is created, it has already inherited its identity and represents it; there is no need to search for it.[91]

In his paper 'Modernity and the Contemporary Architecture of Iran: A Sociological Analysis of Contemporary Architecture in Iran', Mohammad Parva addresses the issue of modernisation and its conflicts in Iran. Instead of a direct condemnation of modern architecture, Parva focuses on the question of whether modernism was properly adopted in Iran and if social conditions were ready to receive it. He sees the modern architecture of Iran as an imported phenomenon that never had the fundamental social pre-conditions in place, therefore 'architects without being familiar with the theories of modern architecture, have started to promote it.'[92] For Parva, this partial adaptation changed the position of the architect from a consultant and designer to a draughtsman, whose aim is merely to fulfil the criteria set by the client, and who therefore would not aim to develop any further theoretical considerations. For him, the problem is not modernism *per se*, but the conditions through which it arrived in Iran, which led to a sense of rupture with the past. This sense of rupture (which has engaged most Iranian architectural historians) emerged, he argues, because modernist architecture did not integrate into the existing context of Iran due to the lack of a theoretical structure and dialogue.[93]

The declaration of the Second Bam congress did not give design instructions nor emphasise the topic of identity, but stressed the necessity for more practical and case-specific research to produce more accurate knowledge of past architecture in Iran. In comparison with previous events, there were also fewer papers generalising on issues of identity and authenticity. Instead, most addressed these issues from specific theoretical angles. The last two examples, of Parva's and Rahimzadeh's papers, demonstrate that a deeper and more analytical understanding of social conditions influenced the field of architecture during this period. A comparison between

91 ibid., 269.
92 Mohammad Parva, 'Moderniteh va me'mari-e mo'aser-e Iran (Modernity and the contemporary architecture of Iran), *Ayatollahzadeh Shirazi* (1999), vol. 5, 155.
93 ibid., 161–2.

the relative papers on the subject in the three Bam congresses shows how the issue was tackled differently in this second Congress. In the first and the third congresses, papers had a more nostalgic tone, and often called for establishing a sense of continuity through creating 'sameness' with past architecture. The papers in the Second Bam Congress tried to produce a diagnosis of the issue, in a more objective and less historicist manner. Indeed, these papers, along with some of the concurrent design projects, such as Mirmiran's proposal for the National Library, mark the second half of the 1990s as a period of transformation in approaching the question of national identity. Projects and publications from this time not only address the nature of the conflict between the modern and the traditional, but also call for a less historicist understanding of the concept of identity, with less dependence on history.

Nevertheless, the early 2000s showed a new wave of interest in the study of historic architecture and an increase in publications in the discipline in which the notion of national identity, with a different definition and emphasis, once again became a central issue. Most researches on the architecture of the Islamic era, which were first published during the Pahlavi era, were edited, re-published or translated for the first time during this period. Nader Ardalan's *The Sense of Unity* was translated to Persian and published for the first time in 2001, and K. Pirnia's notes were organised and published by his long-time student Gholam Hossein Me'marian in *An Introduction to Islamic Architecture*[94] and *The Study of Styles in Iranian Architecture*[95] in the same year.

The final Bam Conference was held in 2006 and was influenced by the devastating earthquake in 2003 in Bam, when thousands of its citizens died and the city's historic citadel was damaged. The earthquake resulted in swift action to register the citadel of Bam on the World Cultural Heritage list, and necessitated the inauguration of the Third Bam Conference. Following the statement of the second conference, the majority of the papers presented in this round focused on the study of particular cases, and

94 Gholam Hossein Memarian, ed. *Moqaddameh-i bar Me'mari-e Eslami* (An introduction to Islamic architecture), 2nd edn, (Tehran, 2005).
95 Gholam Hossein Memarian, ed. *Sabk-shenasi-e Me'mari-e Iran* (Stylistics in Architecture of Iran), 4th edn (Tehran, 2004).

the diversity of their subjects shows an increasing interest in more focused historical studies, even though the number of papers, either submitted or published, was smaller than for previous events.[96] The event also recommended thirty-six fields in the study of architecture and urban design in Iran, including the investigation of the development of Iranian architectural and urban space in history; the study of the stylistics of architecture and urban design; and the study of literature and arts in architecture and urban design. More importantly, it also recommended the investigation of contemporary architecture and urban design; of the mutual influence of Iranian architecture and world architecture throughout history; the role of industries and technologies in the history of architecture and urban design; the role of criticism in architecture and urban design; and the relationship between architecture and urban design with the geography and climatic conditions of Iran.[97]

Although the declaration of the third Congress, in its thirteen articles, mostly focused on the conservation and restoration of the historical heritage rather than architectural and urban strategies, the final recommendation adds a different dimension to the definition of Iranian architecture. Focusing on the issue of restoration, it calls for a consideration of architectural examples outside the political boundaries of modern Iran. This declaration described such architectural projects as 'the inseparable parts of the cultural body of Iranian architecture,' which also need to be considered and supported. This could be interpreted in different ways: the idea of Iran could be seen as having transformed from a geographical entity to a greater cultural entity, or alternatively, one could interpret it as an attempt to connect the present state of the country to its glorious past.

To a great extent, the conditions in which the historical understanding of Iranian architecture have developed and influenced design theories are similar to most architectural histories, as offsprings of art history and greatly dependent on archaeological research that emphasises the visual and physical characteristics of the object of study.[98] As a visual art, the

96 See Conference secretariate, 'Pishgoftar (Introduction),' in *Ayatollahzadeh Shirazi* (1999), vol. 5, 7–8.
97 ibid.
98 See Andrew Leach, *What is architectural history?* (Cambridge, 2010); Heinrich Wolfflin, *Renaissance and Baroque,* trans. Kathrin Simon (London, 1964); and Paul

main product of architecture is nothing but form, yet, because of its roots in the purpose of the design, an architectural form cannot be limited to its visual aspects. In comparison with other art forms, the unique characteristic of architectural products is that they engage directly and more closely with human activities and with the social context. However, the focus on contextual considerations in architectural historiography is a recent development in the discipline.[99] In 'Notes on the Narrative Method in Historical Interpretation', Michael Hays considers the primary role of the historian 'to be concerned with the larger conditions on which architectural knowledge and action is made possible', instead of producing descriptions, biographies, or even specialised commentaries,[100] Hays sees the primary value of architecture in its imaginary and metaphorical aspects that stretch far beyond the ornamental symbolism attached to a work of architecture. He states that the realisation of every single building is a consequence of all contextual conditions. These conditions such as 'technological, economic, juridical and psychological' are the 'forces that drive [architectural] production] in the city.' Therefore, 'in the careful and close constructions of the historian, architecture appears as a precious index of the social fact, and of history itself.'[101] As the main consideration of this book is to look at the representational modes of national and cultural identities, one could conclude that every building, at any time, could be a representative of actual social conditions, and its 'selfness' an aspect of its identity.

Now that architectural historiography has arrived at the point where it examines the identity of society through the contextual study of its buildings, along with historical references and stylistic similarities, it necessitates enrichment of the design process. in retrospect, contextual studies become a key element in the architectural representation of national identity. Drawing on Ricoeur, one can assume that representing a collective identity through architecture could now include both aspects of the narrative identity of society; the *ipse* that dwells on its 'selfness' and

Frankl, *Principles of architectural history: the four phases of architectural style 1420–1900* (Cambridge, MA, 1968).
99 Andrew Leach, op. cit., 7–8.
100 Michael K. Hays, 'Notes on the narrative method in historical interpretation', *Footprint* 1 (Autumn 2007), 23.
101 ibid.

distinguishes it from others as a result of its unique context, along with the *idem* that represents its 'sameness' through its similarities with other cases in the historical context.[102] Therefore, the establishment of 'sameness' and a sense of continuity by referring to the past in symbolic and decorative terms must be in constant dialogue with *ipse*, to validate itself and provide the potential to see architecture not merely through the lens of its relationship with the past, but also through its relation with its own time and the present.

The period after the Iran-Iraq war witnessed a drastic increase in the construction of public buildings with a variety of design approaches, yet architectural historians have not fully agreed on their categorisation.[103] Ghobadian identifies eight design trends in this period, including Traditionalism, Late modernism, Postmodernism, Organic, High-tech, Green Architecture, Deconstructivism, and Folding.[104] The adoption of a variety of later architectural trends, such as Folding, Deconstructivism, and High-tech is especially evident in the period between the late 1990s to mid-2000s, correlating with the expansion of international relations in the political sphere.[105] Late modern and Postmodern architecture were most popular, especially in public and administrative buildings and in buildings for government clients, showcasing a new version of the existing design challenge between the 'traditional' and the 'modern'.

Among these, the Great Museum of Khorasan by Mohammad Amin Mirfendereski, construction of which started in 2005, is an almost direct

102 'Paul Ricoeur,' Stanford Encyclopedia of Philosophy http://www.plato.stanford. edu/entries/ricoeur/, accessed 24 January 2010. See also Paul Ricoeur, *Oneself as Another*, trans. Kathleen Blamey (Chicago, 1992).

103 Ghobadian 2013, 295–6. See also Mohsen Habibi, *The intellectual trends in the contemporary Iranian architecture and urbanism (1979–2003)* (Tehran, 2006), 54–64; Bani Masoud 2010, 338; and Akram Hosseini, 'Tabyin va Tadvin-e Gerayeshha-ye Me'mari-e Mo'aser-e Iran Pas az Enqelab-e Eslami: motale'e Me'mari-e Salha-ye 1360–1385 Shahr-e Tehran' (Explanation and formulation of contemporary architectural trends in post-Revolution Iran: the study of architecture in Tehran 1981–2006), *Hoviyyat Shahr* 8, (2011), 17–26.

104 Ghobadian 2013, 320.

105 These conclusions are based on the number of buildings analyzed by Ghobadian, and introduced in eight tables he produced for the number of buildings constructed between 1988 and 2013. See Ghobadian 2013, 322, 330–332, 338, 346–348, 360, 370, 384, and 392.

inspiration from the form of 'Emarat-e Khorshid, the eighteenth-century treasury and residential palace of Nader Shah Afshar (1688–1747 CE), the powerful founder of the Afsharid dynasty, in the province of Khorasan. It is a contemporary example of the category of buildings that previously formed National Architecture in the 1920s and 1930s, and shows the continual dominance of historicism in the architectural representation of national identity. Also in this period, the Islamic Republic commissioned more than ten embassy and consulate buildings across the world, which provided a new arena for such representation. These buildings too were divided between Late modern and Postmodern categories.

In recent years the design of Expo pavilions has become another international arena in which to represent Iranian culture and to approach the question of identity and its architectural representation in new ways. Naqsh-e-Jahan Pars's winning proposal for Expo 2015 in Milan is a descendant of the vernacular approach to this question. Following the theme of the exposition – 'Feeding the planet, energy for life' – one design for Iran's pavilion was inspired by the form of traditional water canals, or qanats, the least aesthetically significant, yet functionally influential, element in Iranian architecture and engineering. The design of this slope-like pavilion brought the qanats underground system for channelling water above ground, giving it formal and visual qualities as it shapes the roof. The proposal was not realised, but it would have allowed visitors to experience the forgotten spaces hidden underneath the Iranian landscape that have provided water and facilitated the growth of Iranian culture in its arid environment for centuries.

The design further celebrates this by laying a lush garden surrounded with Cypress trees in front of the slope, highlighting the importance of qanats for agriculture. The proposal associates an aesthetic value with non-monumental and in fact, invisible elements and in this way, marks a turning point in the architectural representation of national identity. It is part of a genealogy in architecture that departs from the selective approach of the 'kingly' art, and which developed through close study of vernacular architecture and cultural diversities, absorbing contemporary architectural trends and pointing toward critical climatic conditions as a present shared agenda that can benefit from wisdom of the past. Here the sense of national pride was raised not merely through the revival of a glorious past, but

408a: Computer-generated image of Naqsh-e-Jahan
Pars's entry for Iran's pavilion at Expo 2015.

408b: Computer-generated image of Naqsh-e-Jahan
Pars's entry for Iran's pavilion at Expo 2015.

408c: Computer-generated image of Naqsh-e-Jahan
Pars's entry for Iran's pavilion at Expo 2015.

by representing a solution for both national and international concerns, one that has been developed for centuries in Iran. Architecture, therefore, becomes a far-reaching language to introduce a nation-state in the international arena.

5

Conclusion: The Value of the Present

> We must know the right time to forget as well as the right time to
> remember, and instinctively see when it is necessary to feel historically
> and when un-historically. … We need it [history] for life and action,
> not as a convenient way to avoid life and action, or to excuse a selfish
> life and a cowardly or base action. We would serve history only so far
> as it serves life; but to value its study beyond a certain point mutilates
> and degrades life…[1]

The modern history of architecture in Iran shows the persistence of his-
toricism in representing national identity as a key design challenge since
the early twentieth century. It has constantly conflicted with the forces of
modernisation and the principles of architectural modernism. The conflict
has become problematic because the rise of nationalism in Iran – with its
dependence on the memory of a shared glorious past – was simultaneous
with the project of modernisation, which mainly focuses on the present
time and the construction of a more prosperous future. Meanwhile, the
study of visual aspects such as façades, and decorations and their symbolic
meanings, dominated the production of architectural knowledge, while
technical and contextual studies have been generally marginalised.

Influenced by the growth in archaeological research, this sort of his-
torical knowledge empowered the recognition of a sense of continuity
in architecture, which seems to have been interrupted in the second half
of the Qajar era. With the establishment of the Pahlavi monarchy, when

1 See Nietzsche, op. cit., 8.

architecture was a powerful agent for the state in the project of nation-building, the necessity of restoring a sense of continuity with the past became crucial, and part of the political agenda. Consequently, historicism and the revival of visual references to historic architecture dominated the representation of the official definition of national identity. Yet the present time, and its potential in creating a sense of belonging to the past, and the current condition of the country, were never fully acknowledged in such representations.

To better explain this issue, two types of architectural design should be distinguished. On the one hand, designs that depart from their contemporary society and innovatively respond to its conditions as these develop throughout time; and on the other, practices that address the representation of society, mainly through its historical heritage by creating a sense of continuity. Throughout the history of architecture in Iran, the examples of the first group include most of the functional constructions that respond to a particular need of society, such as *yakhchāls*, qanat and the use of shaded courtyards. For most of these buildings, the aesthetics of their physical form and decoration – if any existed – was secondary to their main focus of fulfiling their functional purpose. However, when these examples received more attention (mostly through the expansion of archaeological research) in recent decades, their functional and social aspects were rarely acknowledged as representative of Iranian identity of their time. Albeit less valued, in modern architectural histories these cases were placed alongside historical monuments, such as Persepolis, Taq-e Kasra and Naqsh-e Jahan Square to create an inventory of forms, shapes, and ornaments that might be used to enrich new architectural projects with a sense of continuity and identity. Since the establishment of the modern Iranian nation-state, the majority of architectural projects have fallen into the second category of design approach, and represent their present socio-political conditions seen through the lens of history.

The historical survey set out in this book has followed the development of the architectural representation of national identity in Iran since the establishment of the modern nation-state in the early twentieth century up to the present day in order to unfold how it has persistently relied on historicism and establishing a sense of continuity with specific episodes of the past. It has also highlighted cases where the architectural approach

received an alternate treatment, other than variations of historicist visual revivalism. For the first two decades of the twentieth century, the theoretical framework of National Architecture went hand-in-hand with the politics of nationalism at the heart of nationalist circles outside Iran. Calling for a renaissance in art and architecture, Karim Taherzadeh Behzad's *Saramadan-e Honar* (1923) for the first time suggested the sort of revival and progress in architecture that Hassan Taqizadeh and others among the nationalist elite had earlier sought for the country; while the newly established Pahlavi monarchy supported the historicist architectural representation of national identity as an agent to communicate its nationalist ideology to the public.

The emergence of National Architecture was also facilitated by the efforts of the Society for National Heritage on various levels, from the formulation of the official historical narrative to the construction of memorial mausolea for historical figures. The influential reformist members of the Society aimed to construct a sense of patriotism amongst Iranians, mainly by emphasising the memory of a shared glorious pre-Islamic past. As the pilot project, Ferdowsi's mausoleum was especially significant because of the role that Ferdowsi played in the national narrative and more importantly, because of its public funding, as a unique joint venture between the nation and the state. The final design depicts the essential elements of National Architecture, namely the decorative use of Achaemenid columns, but also creates an allegorical relationship between the character of Ferdowsi and Cyrus the Great, by imitating the form of the latter's tomb.

The outstanding examples of National Architecture during the mid-1930s, forming the locus of Pahlavi power, were constructed in the Parade Ground of Tehran. The former Parade Ground was chosen for its incomparable historical urban significance, and for its role in the life of Reza Shah. The first transformation of the Parade Ground into the National Park drew public attention to the site. Its second transformation, as Tehran's capitol complex, neutralised the significance of such Qajar-era public and governmental centres as Maidan-e Tup-khaneh and Golestan Palace. The buildings that covered the area of the Parade Ground displayed the distinctive visual characteristics of National Architecture by representing Iran's most significant pre-Islamic monuments, such as Persepolis and Tegh-e Kasra. Initiated by leading European and Iranian architects, National Architecture

soon disseminated outside the enclosure of the Parade Ground, throughout the country.

These urban transformations were simultaneous with the project of modernisation and industrialisation that was being pursued by the government within government buildings. However, the fulfilment of the two goals were expressed in different design approaches in the built environment, revealing the challenge of creating a cohesive socio-political balance. This sort of conflict is also evident in the almost paradoxical ambitions of the same group of reformist officials active in the Revival Party and the Society for National Heritage. On the level of policy-making, the Revival Party aimed to modernise the country and transform traditional and religious society by reconstructing and updating Iran's culture and improving its economic situation. On the cultural level, the Society for National Heritage was responsible for developing a sense of nationhood and cultural advancement, and the reconstruction of memories of a glorious past as a fundamental aspect of national identity. This is evident in all aspects of the Society for National Heritage's activities, from the abolition of the French monopoly on archaeological excavation and the establishment of the first national museum to the construction of 'national pilgrimage sites,' and the compilation of the official history of Iran by its members, such as Hasan Pirnia.[2]

Such contradictory and selective attitudes towards modernity, which consequently were transmitted to the architectural productions of the time, is an aspect of Conflictual Modernisation, one that most countries outside the immediate context of modernity and with deep historical heritages have also faced.[3] In these cases, the acceptance of modernisation is often considered equal to Westernisation, and caused conflict with traditional life. But the situation seems slightly different in the case of Iran, as the conflict was not only between existing traditions and the means of modernity, but also with the simultaneous modernising and cultural

2 Grigor 2005, 53.
3 Le Goff 1992, 38: 'Without entering into the details of this conflict, it can be said that historically, it appears in three forms: in the nineteenth century, as a reaction to European imperialism, whether colonialist or not; after the WW2, in the framework of decolonialization and the emergence of the Third World; and in the 1970s with the boom in the oil market.'

reforms launched by the elites of the country. The former was looking to the future, while the latter was looking at the distant past. At this point, the strategic role of architecture, both in fulfilling the means of modernisation and in communicating a national narrative, brought it to the centre of the conflict as perhaps one of the most telling examples of Conflictual Modernisation. Modernist buildings sprang up across the country to house the new means of modernising the infrastructure, with an updated approach to design that was devoid of historical and traditional references. The best examples of this are the national railway stations, the construction of which started in the early stages of the Pahlavi reforms. The railway stations could in fact represent national values in practical terms, as the railway system made possible the movement of goods and people to the most remote cities of Iran, and could therefore facilitate a sort of cultural homogeneity. However, the system and its stations were never considered as representative of Iranian national identity.

The role of representing and promoting Iranian national identity was allocated to a category of buildings that were loaded with historical references and initially covered the Parade Ground of Tehran. Even though these buildings were to accommodate new programmatic elements, such as banks and ministries and a museum, their facades were not representatives of their function, nor of contemporary developments in Iran as a progressive country. The facades and volumes of these buildings represented the most glorious episodes of Iran's history, and these buildings became the representatives of modern Iranian national identity.

The celebration of the pre-Islamic dynasties, namely the Achaemenid and Sassanian, as integral parts of the national narrative, was backed up and promoted by the works of Western historians and archaeologists. As Ansari put it, 'Iranian nationalists sought to make their own history, but not in circumstances of their own choosing.'[4] This was not the first time that European archaeologists, art historians, and wayfarers conducted research in Iran, but it was the first time that the Iranian government and the SNH supervised such researches. Establishing a close relationship between these researchers and Iranian officials is one of the most significant contributions of the Society in intensifying interest in the pre-Islamic past.

4 Ansari 2012, 4.

Pope's lectures in 1925, almost a year before Reza Shah's coronation, mark a critical point in solidifying a nationalist ideology and have been called a significant moment in the 'history of Iran's self-awareness'.[5]

In his lecture, by praising the Achaemenid and Sassanid kings, Arthur Pope immediately associated the art and architecture of these periods not with people or their culture, but with their kings. He called the art of Iran a 'kingly art' and described it as being most suitable for kings.[6] Pope's historical focus was very much in the service of the twentieth-century nationalist narrative, starting as it did with the Achaemenid era when Iran was unified under a powerful Persian establishment. He neglected earlier Iranian architectural examples, such as the Elamite Ziggurat of Chogha Zanbil, which had already been discovered, and minimised the period of Greek domination (312–63 BCE) and the Parthian dynasty (247 BCE-224 CE). Additionally, by criticising the ignorance of the Qajars in terms of caring for such a priceless heritage, and bridging the gap between the new age and ancient history, Pope enthused the new government and the future Shah with a sense of responsibility for the future preservation of that heritage.[7] In technical terms, however, after this lecture, his description of Persian art as decorative rather than representative was hardly remarked upon.

In this regard, the importance of architecture was increasing, as with the support of the Society, archaeologists were uncovering ever more relevant historical knowledge. The demands for the construction of new buildings, especially in the capital, was the best opportunity for the incorporation of this historical knowledge. Here the German and French archaeologists Ernst Herzfeld and André Godard were highly influential. Collaborating with the Society, they provided some of the earliest modern histories of architecture in Iran even as, similarly to Pope, their approach to their

5 Sadiq, 'American Pioneers in Persian art' (cited in Gluck 1996, 2).
6 For a well-educated Orientalist, whose knowledge of 'Persia' far exceeded the monuments of ancient Iran, such an observation is quite reductive, especially as we know that one of the distinguishing characteristics of architecture in Iran is its functionally-responsive quality and its concentration on climatic considerations and contextual needs.
7 In this respect, Pope did not completely ignore the Islamic history of Iran as he also mentioned the Safavid period, but he hardly put equal emphasis on it.

architectural findings was essentially from the archaeological point of view, and focused on the physical description of edifices. Their publications became the primary examples of architectural historiography in Iran and set the trend for focusing on the monumental and visual aspects in future studies.

The characteristics of National Architecture in terms of its design had its roots in the Beaux-Arts architectural tradition imported into the country by architects mainly educated in the French system, including André Godard. It was cultivated and established through the activities of SNH, financed by the government, and later widely disseminated as a disciplinary approach throughout the educational system. The works of Pope, Herzfeld and Godard helped the formulation and systematisation of the Beaux-Arts approach in National Architecture. If Pope managed to focus attention on the visual aspects of the pre-Islamic heritage, Ernst Herzfeld established the design of Persepolitan columns as the main characteristic of this architecture,[8] providing the Iranian version of the Classical Orders of ancient Greece and Rome.[9] He also produced drawings of the various parts of Persepolis, as well as reconstructions that remained for many years the most reliable source. The design of Ferdowsi's tomb and the buildings in the Parade Ground of Tehran, especially the National Bank and the Police Headquarters show significant similarities with these drawings. The Persepolitan columns in their facades have the role of the 'Detached Supports' of Beaux-Arts architecture, and act as successful representational elements.

Godard's contribution started with his introduction of architectural types in Athar-e Iran and continued in architectural practice with his role as advisor to the municipality of Tehran and as the architect of the Museum of Ancient Iran. More importantly, as the first head of the Faculty of Fine Arts at the University of Tehran, Godard modelled the School of Architecture on the Beaux-Arts educational system and design tradition, and brought archaeological knowledge to the Faculty. Because of Godard, these two

8 Herzfeld, *Iran in the Ancient East*, 239.
9 Persepolis became the main historic reference mainly because of the centrality of the Achaemenid empire in the national narrative of the time, as well as because of its historical and archaeological significance in the West.

disciplines matched perfectly to establish a new Iranian architectural style and to represent Iranian national identity; with archaeology providing the source of inspirations and typologies, and the architectural system incorporated this knowledge to formulate the characteristics of National Architecture.

The establishment of the University of Tehran and the Faculty of Fine Arts as one of its first schools once again shows the importance of arts and especially architecture for the Pahlavi regime. As higher education in Iran was based on the French model, the role of Beaux-Arts architecture was solidified in the representation of national identity. During Godard's directorship, this architectural tradition and educational system greatly influenced the curriculum, especially in the history and drawing classes. The Iranian archaeologist Mohsen Moqaddam taught the history of ancient Iran and classical architecture, while drawing classes focused on archaeological sites, especially Persepolis, and provided the necessary material and inspiration for the design syllabus. These drawing classes, for most students, were their first encounter with such sites, and increasingly stimulated their fascination with historical architecture in Iran which immediately became the paragons for their own designs, in visual terms. Drawing classes also contributed to the building-up of a repository of architectural elements, types, and fragments to use in composition practices, which were also the basis of the design courses. This process gave Iranian examples the same validity that the Greco-Roman orders played in the production of neoclassical architecture at the Beaux-Arts. Consequently, the values associated with the architecture of the past remained mainly visual.

The historicist approach that gradually dominated the discipline in Iran was first challenged in the academic environment in the early 1950s, with the intensive round of modernisation that followed the nationalisation of the oil industry, the rise in oil revenues, and the appointment of Mohsen Foroughi as the second director of the Faculty of Fine Arts. Foroughi was a modernist architect and one of the founding members of the Society of Persian Professional Architects (Anjoman-e Arshitektha-ye Irani-ye Diplomeh) as well as of the first architectural journal in Iran, *Architecte*.[10]

10 Iranica: Mina Marefat, Richard N. Frye, 'Foroughi, Mohsen,' X/2, 113–116 accessed online 5 July 2014.

His educational background at the École des Beaux-Arts, infused with his knowledge and interest in modern architecture, resulted in a significant inclination towards modernism in the School of Architecture. Nevertheless, this interest in modernist architecture – which was shared with many of the teachers at the School, including Heydar Ghiai, 'Abd ol-'Aziz Farmanfarmaian, and Yevgeny Aftandilian – did not make for a systematic reform in the educational system. Modern architecture was taught and treated as raw material, like the Persian orders, yet the process of design and the ultimate approach to the discipline was still under the influence of the Beaux-Arts paradigm. And much as modern architecture might have appeared as representative of the evolution of Iranian society at the time, it hardly appealed to public taste as representative of the 'self-ness' of Iranian society. Also, from the official point of view, modern architecture and the historicist approach of the Beaux-Arts were used for completely different purposes: the means of modernisation and projects representative of the advancement of the country, such as the new train stations, were purely modernist buildings; while the monumental and administrative buildings in the urban centre of power were realised celebrations of the distant past.

Foroughi himself had observed this divide and his designs, such as the branches of the Bank-e Melli that were constructed across Iran, represent his attempt to bring the two trends together. His projects are examples of modern architecture in Iran while their facades display subtle historicism through the incorporation of tile works and the use of Persepolitan proportions. These buildings are clear examples of the challenge of modernity in Iranian society, despite governmental support – or more accurately, they are the result of an inconsistent approach to modernity, which is characteristic of a Conflictual Modernisation. This conflict demonstrates the extent to which nationalism in Iran was based on drawing a connection with the past to construct a sense of continuity and 'sameness'.

Eventually, the interest in modernism – not just as a trend but as a social approach to architecture – decreased, as was shown in the early 1960s by the appointment of Houshang Seyhoun as director of the Faculty. He was deeply interested in the historical architecture of Iran, although in comparison with his teacher André Godard, his approach was less imitative. Upon his arrival, and with minor curricular changes, he made a significant move

toward discarding modern architecture as a separate trend and providing a more inclusive approach to design and history. His contribution was to facilitate the course trips that helped students study notable historic monuments as well as examples of vernacular architecture from the most remote corners of Iran. In this regard, and despite a lack of professional research, Seyhoun's *Regards Sur l'Iran* put a focus on the value of vernacular and the non-monumental architecture.

Mohammad Karim Pirnia extended this approach after leaving academia, through his extensive investigations of traditional architecture and its modes of production. He introduced people-appropriateness (*mardomvārī*)[11] as a characteristic of Iranian architecture, by which he meant the correspondence of the proportions of a building to human dimensions, and considerations of functional requirements in design.[12] *Mardomvārī* is the opposite of the 'kingly' considerations that referred to the monumental size and singular positioning of buildings in a site. Corresponding with the concurrent general cultural transformations after the White Revolution, these developments challenged the idea of Persian art as being merely a monumental and 'kingly art', as it had been promoted earlier by Pope and Godard. From the 1960s, vernacular architecture became the centre of attention in academia. Seyhoun also incorporated historical elements and motifs in in his projects in ways that would not have been possible without contemporary modes of production and construction technologies. This approach became an integral part of architectural discourse after his time. Additionally, Seyhoun's view of the past was not limited to formal and visual aspects – symbolic meanings were a primary source of inspiration in his work. In fact, as Seyhoun himself has said, he was looking for a way to represent symbolic meaning in historical elements, rather than mere imitation.

In the meantime, the official tendency of the government was still towards monumental edifices and the use of 'kingly' characteristic in Iranian architecture to represent Iranian national identity, both in the built environment and on an international level. A comparison between the works of Seyhoun and Mohammad Karim Pirnia with Mohammad

11 See Me'marian 2005, 27–41.
12 ibid., 1–10.

Taqi Mostafavi's publications demonstrates this divergence. Mostafavi's memorial publications for the coronation of Mohammad Reza Shah and the celebration of the 2500th anniversary of the Persian empire are similar to Pope's *Persian Architecture* and ultimately, Hasan Pirnia's division into periods of the history of Iran, aiming to construct a selective historical narrative of continuity. In both publications, Mostafavi focused on the pre-Islamic heritage and on recurrent architectural elements found throughout history in Iran, and the ways in which their re-appropriation could contribute to a sense of continuity with a selective past. He identified several recent buildings that represented this continuity as the most successful contemporary works (including all the buildings in the Parade Ground), all of which incorporated the historicist principles of National Architecture in their designs.

Mohammad Karim Pirnia's researches and publication for the Fifth International Congress of Iranian Art and Archaeology in 1968, Seyhoun's activities, and Nader Ardalan's *Sense of Unity* (1973), all show transformations of interest in academia and independent research. These works expound a broader study of the history of architecture, one that resulted in the periodisation of history according to architectural developments and not political events. They also attempt to create a theory of Iranian architecture. Increasing attention on the 'vernacular' and the 'traditional' aspects of architecture resulted in a growth of interest in the notion of 'authenticity' in the academic environment during the late 1960s in Iran. This was enhanced by the simultaneous rise of a global critique of architectural modernism and the rise of socialism, which empowered the Left in Iran.

Even without associating any of these authors with any side of this social debate, the difference of approach between an 'official' history of architecture and the more independent and academic view is evident. Yet the initial points of agreement between both sides remained intact: first, the existence of a sense of continuity throughout the history of Iranian architecture until the mid-nineteenth century, when the imitation of Western architecture disrupted Iran's architectural development. Second, the necessity of producing an authentic architecture that was worthy of and suitable for the context of Iran. To this end, both fronts remained historicist, and still dependent on maintaining a sense of continuity through learning from

– if not imitating – historical architecture. One cannot criticise examining the history of architecture (especially in the case of Iran with its diversity of examples yet such limited knowledge of them), and the design of something in close relation to this specific context with an historicist approach. Nevertheless, incorporating knowledge of the past ought to amount to more than extracting forms to incorporate into new projects. Similarly, to think of identity in architecture must involve more than dwelling on the similarities one object has with others.

In terms of the architectural representation of national identity, the academic reforms of the University of Tehran between 1963 and 1968 brought another round of developments to this discourse. The transformation of the Beaux-Arts system to the American system not only provided the platform for a more up-to-date educational system but was also a way to question the validity of historicism. The most important contribution to the development of architectural discipline and the discourse on National Architecture was that the issue was now open to discussion, criticism, and even international consultation. The last decade leading to the Revolution of 1979 represents the expansion of the gap between the official and the academic understanding of 'authenticity' in the architectural representation of national identity. This is evident in the most significant event of the decade, the celebration of the 2500th anniversary of the founding of the Persian empire, which focused on the representation of the Iranian nation-state. This event redirected the official definition of national identity, from literary heritage and the *Shahnameh* to the historical narrative; it also placed its focus on the Achaemenid Empire and the character of Cyrus the Great in order to legitimise the monarchy and reinforce a sense of continuity that could bridge over most of Iranian history. Yet according to Hossein Amanat, the monument of the celebration in Tehran, Shahyad-e Aryamehr, had an inclusive approach to history as it represents a diversity of forms from a variety of periods, regions, and genres of Iranian architecture. The historical references incorporated in the design of the monument show hardly any reference to Achaemenid architecture. This may be the reason why, despite the harsh criticism that the event received, its monument has remained a popular icon in the capital up to the present day.

Apart from such nuances in approaching the past, which continued in the post-Revolutionary era, government and academia both tried to come

up with ways to represent national values in architecture and to formulate an updated version of Iranian architecture. This approach was strengthened through the mediation of Western specialists as a third party whose interventions both sides had been sceptical about before. The First International Congress of Architecture is one of the most significant events that addressed the architectural challenges of Conflictual Modernisation. The success of the event showed how tackling this issue benefited by approaching the problem from both internal and external viewpoints, and more importantly, how a more profound knowledge of global developments in the discipline could help to solve local challenges. Of course, by this time, the two sides in this conflicted relationship had found different labels, of 'tradition' versus 'technology'. The connotations of the two terms were still the modern, and the past. The past was understood as representative of Iranian identity, which was reduced to the celebration of traditions that in turn express a sense of continuity. On the other side of the quarrel, modernity had been reduced to the appropriation of new technologies, focusing on the instrumental and extremely selective use of modernity, primarily as an imported discourse. All sides of the discussion had an effective presence in the event, from Shahbanu Farah Pahlavi and the minister of housing to architects, academics, and their international counterparts. But again, the view of the public as the main audience for architecture was not considered; not just at this event but ever since.

By this time a new definition of 'tradition' had been introduced that was slightly different to the conventional definition of the term and referred to the interpretation that Seyyed Hossein Nasr gave for it. Both Nasr, in his introduction to *The Sense of Unity,* and Ardalan suggested that a tradition is only valuable as long as it is still valid and part of present life. The declaration of the First International Congress highlighted this, stating that 'to respect tradition is to build the dwellings, the cities and the environment in the total condition of our epoch and at the same time anticipate the future.'[13] It also considered technological advancements as a characteristic of each epoch, conditional and appropriate to their context.

The Second International Congress of Architecture almost initiated a point of settlement in the discourse between continuity and modernity;

13 Bakhtiar 1970, 247–8.

continuity was rationalised through the lens of 'new creation' and considered valid as long as it would serve present needs, while modernity was reduced to technological and industrial advancement. The highlight of this event was the call to adopt a comprehensive approach to industrialisation, considering its threats as well as benefits. These two congresses were milestones in the development of the discourse and as Hossein Amanat described it, architectural development during the last years of the Pahlavi regime 'was a good start.'[14]

Just as conflicts around modernity and the production of an authentic architecture were settling down, the political upheavals of the late 1970s once again resulted in architecture being used as a powerful agent to bring a new official ideology into the public realm. They led to the rise of another wave of architectural production to introduce and represent the government of the Islamic Republic of Iran and the new official definition of national identity, by making its presence visible in the built environment. Although the main focus of the ideological narrative of the government had considerably altered from the pre-Islamic heritage to Islamic culture and history, the architectural approach to the representation of the official definition of national identity was in principle similar. The representation of historical visual references remained the primary design apparatus of communication, albeit not in the format of the Beaux-Arts, but of Postmodern architecture. This not only provided a way of defining the new government in opposition to the previous regime but also enabled the government to connect to the wider Muslim world, as the definition of Iranian national identity moved towards a more religious and cultural one. One of the earliest examples of this, the Grand Mosalla of Tehran, represents the ideological transition of the country simultaneously in its function and in its façade.

Postmodernism, which had already found a significant position in shaping monumental buildings in the last decade of the Pahlavi monarchy, only became more influential in the post-Revolutionary decades. The infusion of modern techniques with traditional architecture now seemed a less conflictual approach for the simultaneous representation of technological

14 Hossin Amanat, 'Goftegu ba me'mar-e borj-e Azadi,' interview by Bijan Rohani, Radio Zamaneh, July 16, 2008, http://www.amanatarchitect.com/shahyad/index.php, accessed online 19 March 2013.

advancement and the nationalist ideology in the built environment.[15] The evident divide that had separated these categories of projects in the first half of the century was replaced by a more inclusive approach to design, one that determines the visual characteristics of the governmental and monumental buildings even today. Although limited to the Islamic era, the functional range of historical architecture used as the source of inspiration widened, from the monumental mosques of Safavid Isfahan to the modest *yakhchāl* buildings of the arid regions. It facilitated the transmission of historicism to a wider range of projects, both smaller scale and even private, transcending the confinements of a capitol complex. However, the limited knowledge of architectural history in Iran, the development of which slowed during the Iran-Iraq war and the post-War period, hardly improved the modes of implementation beyond the imitative use of visual references, such as in the new National Library in Tehran, where the traditional octagonal shape of Iranian entrance halls (*hashtī*) is repeatedly used to locate the entrance halls here.

During the 1980s and 1990s, the development of the discipline was mainly a domestic affair that is best represented in some of Hadi Mirmiran's designs. His proposal for the new building for the National Library opened new vistas for the architectural representation of national identity by looking into Persian literary heritage for inspiration. In this project, Mirmiran surpassed the historicist revival of architectural elements by referring to an external concept, and created new forms and unique visual characteristics to represent a sense of continuity and identity. This design does not explicitly recall a historical precedent and expands the boundaries of design inspiration, giving a timely and conceptually suitable architectural response to the brief of the project. Mirmiran's design approach is similar to Seyhoun's in some of his designs for the Society for National Heritage, including the tomb of Khayyam in Nishabur. Similarly, it is followed in some of the later projects of Naqsh-e-Jahan Pars, including the proposal for Iran's Pavilion at Expo 2015. Although successful in competitions, such a design approach does not often have a great chance of being constructed. In terms of built projects, the historicist approach still

15 See: Charles Jencks, *What is Post-Modernism?* (London, 1986), 12–14.

seems more successful than such conceptual alternatives and investigating why this is could be a new line of research.

This historical survey of the discourse of the architectural representation of national identity in Iran over the last century unfolds fundamental similarities between the two modern governments in Iran as they face the challenges of modernisation. While the history of architecture before and after the Revolution of 1979 shows general contrasts in selecting historical episodes as sources of inspiration, it is not accurate nor fair to say that each regime has exclusively propagated a section of history that better legitimises their political narrative. Also, it is not possible to paint the intention of every architect with the same brush, nor to think that architects are incapable of subtly justifying their favoured alternative as a desirable choice for their powerful clients. Nevertheless, what is certainly evident is the interest in the selective use of the past and of historicism in design, which stem from the politics of nationalism in Iran. The review of significant projects and theoretical accounts in this period shows the consistency of historicism during the last century, which could be considered as the continuation and development of National Architecture. This was supported by the expansion of archaeological knowledge and was later systematised by the educational system and in the academic environment.

Successful or otherwise, these developments show the necessity for a more inclusive approach towards architectural history, one that does not merely look for visual references. Instead what is needed is an approach that investigates how similar design challenges have been addressed in the past, and more importantly, how previous developments have brought the discipline to its present situation. Additionally, despite constant challenges and oppositions, modernity and contemporary architectural theories and techniques have proved to be an integral part of the amalgam that shapes the architectural representation of national identity and its sense of 'self-ness'. It has not been possible for architects to overcome the challenges of this external element. After all, National Architecture as a design approach is based on Beaux-Arts architecture as an early modern Western tradition, and was transformed with every theoretical and technical advancement, while never fully ignored the forces of modernity. It inherited the effects of Conflictual Modernisation, but has been in search of a balance between the forces of modernity and historical heritage and traditions. This ideal

balance can be achieved through the successful processing of each part of the conflict in relation to each other, as it passes through the filter of a critical and analytical approach towards the present day and its necessities and preferences. Indeed, there is a lesson for National Architecture embedded in Achaemenid art and architecture beyond the shape of its columns, as Mostafavi quoted from Roman Ghirshman:

> This art, which combines winged Assyrian bulls, statues placed on the side of halls, Hittite in the colourful Babylonian manner and borrowings from Egyptian styles, remains, in essence, a representative example of the national culture of Iran. ... Whatever was brought from the outside was changed and mixed with other elements to produce a new art ... All this, whether borne of innovations or borrowed from other nations, was molded into a distinctly Persian style.[16]

Architects may consider identity as something purely related to the past, that must be disinterred and re-appropriated with the most up-to-date architectural technologies of the time. In this way, they will remain entangled between the two ever-opposing forces of the old and the new while their creativity will wither. Instead, by reflecting on the present as the only instance where the two forces are compelled to be in unique agreement, they create something representative of the 'selfness' of the time and the only part of a collective narrative identity that they are responsible for: their time. That is the result of an inclusive appreciation of the past.

16 Mostafavi 1967, 26.

Bibliography

Sources used most frequently in writing this book are given in short form as author/date in the footnotes, with full publication details provided in the Bibliography. Sources cited less frequently are given in full only in the relevant footnote.

Adle 1992
Adle, Chahryar, and Hourcade, Bernard, eds, *Téhéran: Capitale Bicentenaire* (Paris, 1992)

Amanat Architect
http://www.amanatarchitect.com

Amanat 2007
Amanat, Hossien, BBC Persian interview with Hossein Amanat, October 2007. http://www.amanatarchitect.com

Ansari 2012
Ansari, Ali M, *The Politics of Nationalism in Modern Iran* (Cambridge, 2012)

Ardalan 1973
Ardalan, Nader, and Bakhtiar, Laleh, *The Sense of Unity: The Sufi Tradition in Persian Architecture* (Chicago, 1973)

Ayatollahzadeh Shirazi 1995
Ayatollahzadeh Shirazi, Baqer, ed., *Majmūe-ye maqālāt-e congereh-ye tārikh-e me'māri va shahrsāzi-e Iran, Arg-e Bam* (Collection of congress papers of the history of architecture and urban planning in Iran), 5 vols (Tehran, 1995)

Bahr ol-Oloumi 1976
Bahr ol-Oloumi, Hossein, *Kārnameh-ye Anjoman-e Asār-e Melli az*

Āghāz ta 2535 Shāhanshāhi (The Report of the Society for National Heritage from the beginning until 1976), (Tehran,1976)

Bakhtiar 1970

Bakhtiar, Laleh and Farhad, Leila, eds, *The Interaction of Tradition and Technology: Report of the Proceedings of the First International Congress of Architecture, Isfahan, 1970* (Tehran, 1970)

Bakhtiar 1976

Bakhtiar, Laleh, ed., *Towards a Quality of Life: the role of industrialisation in the architecture and urban planning of the developing countries: Report of the Proceedings of the Second International Congress of Architecture, Persepolis, 1974* (Tehran, 1976)

Bani Masoud 2010

Bani Masoud, Amir, *Iranian Contemporary Architecture: In Search of Tradition and Modernity* (Tehran, 2010)

Bavar 2009

Bavar, Cyrus, *The Advent of New Architecture in Iran* (Tehran, 2009)

Behnam 1994

Behnam, Jamshid, 'Negāhi be tajrobeh-ye shast sāleh-ye Nezām-e dāneshgahi dar Irān' (A review of the sixty-year academic experience in Iran), *Goftegoo* 5 (Autumn 1994), 100

Behzad 1923

Behzad, Karim Taherzadeh, *Sarāmadan-e Honar* (The masters of art), (Berlin, 1923)

Bosworth 1983

Bosworth, Edmond and Hillenbrand, Carole, eds, *Qajar Iran: Political, Social and Cultural Change, 1800–1925* (Edinburgh, 1983)

Costello 1981

Costello, Vincent F., 'Tehran,' in Pacione, Michael, ed., *Problems and Planting in Third World Cities* (New York, 1981)

Davies 1976

Llewelyn Davies International, *Shahestan Pahlavi*, 2 vols (Tehran & London, 1976)

Durand 1805

Durand, Jean-Nicolas-Louis, *Précis of the Lectures on Architecture:*

With, Graphic Portion of the Lectures on Architecture, trans. David
Britt (Los Angeles, 2000)

Gellner, 1983

Gellner, Ernst, *Nations and Nationalism* (Ithaca, 1983)

Ghalamsiyah, 2002

Ghalamsiyah, Akbar, ed., *Yadname-ye Ostad Doctor Karim Pirnia
(1301–1376)* (Memoirs of Master Doctor Karim Pirnia), (Qom, 2002)

Ghobadian 2013

Ghobadian, Vahid, *Styles & Concepts in Iranian Contemporary
Architecture* (Tehran 2013)

Gluck 1996

Gluck, Jay, Siver, Noël, and Gluck, Sumi Hiramoto, *Surveyors of
Persian Art: a documentary biography of Arthur Upham Pope and
Phyllis Ackerman* (Ashiya, 1996)

Grigor 2004

Grigor, Talinn, '(Re)Framing Rapid Modernities: American Historians of
Iranian Architecture, Phyllis Ackerman and Arthur Pope,' *ARRIS:
Journal of The Southeast Chapter of the Society of Architectural
Historians*, 15 (September 2004), 39–55

Grigor 2005

Grigor, Talinn, 'Cultivat(ing) Modernities: The Society for National
Heritage, Political Propaganda, and Public Architecture in Twentieth-
century Iran,' (PhD diss., Massachusetts Institute of Technology,
2005)

Grigor 2009

Grigor, Talinn, *Building Iran: Modernism, Architecture, and National
Heritage Under the Pahlavi Monarchs* (Pittsburgh, 2009)

Habibi 1999

Habibi, Mohsen, *Az Shār tā Shahr* (From Ville to City), 8th edn (Tehran,
1999)

Hekmat 1976

Hekmat, Ali-Asghar, *Sī Khātereh az Asr-e Farkhundah-e Pahlavi* (Thirty
memories from the auspicious Pahlavi era), (Tehran, 1976)

Iran 1969

Iran (Tehran: Ministry of Information, 1969)

Iranica: *Encyclopedia Iranica.* http://www.iranicaonline.org

Iranica: Morteza Momayyez, 'Faculties of the University of Tehran ii.
 Faculty of Fine Arts' IX/2
Isenstadt 2008
Isenstadt, Sandy and Rivzi, Kishwar, *Modernism and the Middle East*
 (Seattle, 2008)
Keddie 1999
Keddie, Nikki R., *Qajar Iran and the Rise of Reza Khan 1796–1925*
 (Costa Mesa, 1999)
Keddie 2012
Keddie, Nikki R., *Religion and Rebellion in Iran: The Tobacco Protest of
 1891–1892*, 2nd edn (New York, 2012)
Khajavi 1946
Khajavi, Gholamreza, 'Tarikhcheh-ye Daneshkadeh-ye Honarha-ye Ziba'
 (The history of the Faculty of Fine Arts), *Architecte* 1, (July-August
 1946)
Khanizad 2014
Khanizad, Shahriyar, and Moayyed, Farzaneh Ehsani, *Kāmrān Dība va
 Me'māri-e Ensān Dūstāneh* (Tehran, 2014)
Kiani 2007
Kiani, Mostafa, *Me'māri-e Dore-ye Pahlavi-e Avval: Degargūni-e
 Andishehā, Peydāyesh va Sheklgīrī-e Me'māri-e Dore-ye Bīst
 Sāleh-ye Moāser-e Irān 1299–1320* (Architecture during the first
 Pahlavi period: transformation of ideas, emergence and formation of
 the architecture of the contemporary twenty-year period in Iran 1930–
 1941), (Tehran, 2007), Document no. 26,446–450.
Le Goff 1992
Le Goff, Jacques, *History and Memory* (New York, 1992)
Madanipour 1998
Madanipour, Ali, *Tehran: The Making of a Metropolis* (Chichester, 1998)
Marashi 2008
Marashi, Afshin, *Nationalising Iran: Culture, Power, and the State,
 1870–1940* (Seattle and London, 2008)
Melli 1972
Anjoman-e Asar-e Melli, ed., *Majmū'e-ye Enteshārāt-e Qadim-e
 Anjoman* (The Collection of the Society's Old Publications), (Tehran,
 1972)

Memarian 2005

Memarian, Gholamhossein, ed., *Mohammad Karim Pirnia, Sabkshenāsi-e Me'māri-e Irān* (Mohammad Karim Pirnia, Stylistics of architecture of Iran), (Tehran, 2005)

Menashri 1992

Menashri, David, *Education and the Making of Modern Iran*, (Ithaca, 1992)

Mofid 2005

Mofid, Hossein, and Raeiszadeh, Mahnaz, *Mājara-ye Me'māri-e Sonnati-e Irān dar Khāterāt-e Ostād Hossein Lorzādeh: as Enghelāb tā Enghelāb* (The story of the traditional architecture of Iran through the memories of Master Hossein Lorzadeh: from the revolution to the revolution), (Tehran, 2005)

Mokhtar Taleghani 2002

Mokhtar Taleghani, Eskandar, *Mirās-e Me'māri-e Modern-e Irān* (The Heritage of Modern Architecture in Iran), (Tehran, 2002)

Mostafavi 1967

Mostafavi, Mohammad Taqi, *Persian Architecture at a Glance* (Tehran, 1967)

Mozaffari 2007

Mozaffari, Ali, 'Modernity and Identity,' in Knell, Simon J., McLeod, Suzanne, and Watson, Sheila, eds, *Museum Revolutions: How museums change and are changed* (London 2007)

Nabavi 2003

Nabavi, Negin, *Intellectuals and the State in Iran: Politics, Discourse, and the Dilemma of Authenticity* (London, 2003)

Naqsh-e-Jahan Pars 2005

Naqsh-e-Jahan Pars Consulting Engineers, *Mirmiran's Architecture* (Tehran, 2005)

Noghrehkar 2008

Noghrehkar, Abd ol-Hamid, *An Introduction to the Islamic Identity in Architecture and Urbanism* (Tehran, 2008)

Pirnia 1968

Pirnia, Mohammad Karim, 'Sabk Shenāsi-e me'māri-e Irān,' (The Stylistics of Architecture in Iran) in M.Y. Kiani and A. Tajvidi, eds,

The Memorial of the Vth International Congress of Iranian Art &
Archaeology, vol.1 (Tehran, 1968)

Pope 1928

Pope, Arthur Upham, *Persian Art and Architecture* (New York, 1928)

Pope 1930

Pope, Arthur Upham, *An Introduction to Persian Art Since the Seventh*
Century AD, (London, 1930)

Pope 1965

Pope, Arthur Upham, *Persian Architecture, The Triumph of Form and*
Colour (London, 1965)

SAMT

Sāzmān-e Motāle'e va Tadvin-e Kotob-e Olūm-e Ensāni-e Daneshgāhhā
(Organization for the study and compilation of the academic books for
humanities)

http://www.samt.ac.ir/index.aspx

Scarce 1991

Scarce, J., 'The arts of the eighteenth to twentieth centuries,' in Avery, P.,
Hambly, G., and Melville, Ch., eds, *The Cambridge History of Iran*
(Cambridge, 1991), vol. 7

SCCR

History of the Supreme Council of the Cultural Revolution (SCCR),
http://en.farhangoelm.ir/SCCR/History-of-Supreme-Council-of-the-
Cultural-Revolut.aspx.

Shafei 2005

Shafei, Bijan, Soroushiani, Sohrab, and Daniel, Victor, *Karim*
Taherzadeh Behzad Architecture (Tehran, 2005)

Shafei 2015

Shafei, Bijan, Soroushiani, Sohrab, and Daniel, Victor, *André Godard*
Architecture, (Tehran, 2015)

Shahrokh 1994

Shahrokh, Shahrokh, and Writer, Rashna, *The Memoirs of Keikhoshrow*
Shahrokh (Lampeter, 1994)

Smith 2010

Smith, Anthony D., *Nationalism* 2nd edn (Cambridge, 2010)

The Ministry of Culture and Islamic Guidance (Tehran, 2001)

Asnādi as Bāstānshenasi dar Irān: hafriyāt, 'Atiqāt va banahā-ye tārikhi

(The managerial services and information secretariat of the President's office – Documents on archaeology in Iran: excavations, antiquities and historical monuments)

Zoka 1970

Zoka, Yahya, Tārīkhche-e Sākhtemanhā-ye Arg-e Saltanati-e Tehrān va Rāhnamāye Kākh-e Golestan (The short history of the buildings in the royal citadel of Tehran and the guide to Golestan Palace), (Tehran, 1970)

Picture Credits

101a: The Institute for Iranian Contemporary Historical Studies,
ع-1-3815-0
101b: The Institute for Iranian Contemporary Historical Studies,
ع-1-1698-0
102: The Institute for Iranian Contemporary Historical Studies,
ع-1-3775-0
103: Redrawn for the author by Leila Ghazisaeed, 2017. © The author
104a: The Institute for Iranian Contemporary Historical Studies,
ع-1-3904-1
104b: The Institute for Iranian Contemporary Historical Studies,
ع-1-4707-0
105: Redrawn for the author by Leila Ghazisaeed, 2017. © The author
106a: The Institute for Iranian Contemporary Historical Studies,
ع-1-3896-1
106b: Photography by Fazel Khakbaz, 2017. © The author
107: The Institute for Iranian Contemporary Historical Studies,
م-275-131376-0
108: Redrawn for the author by Leila Ghazisaeed, 2017. © The author
109: Author's photograph, 2018
110: The Institute for Iranian Contemporary Historical Studies,
ع-1-3802-0
111: The Institute for Iranian Contemporary Historical Studies,
ع-3-4705-0
201: Author's photograph, 2017
202: Public domain

203: The Institute for Iranian Contemporary Historical Studies,
ع-1-5776-0

204: Author's photograph, 2017

205: Author's photograph, 2017

206: The Ernst Herzfeld papers. Freer Gallery of Art and Arthur M.
Sackler Gallery Archives. Smithsonian Institution, Washington, D.C.,
FSA A.06 05.0843

207: The Ernst Herzfeld papers at Freer Gallery of Art and Arthur M.
Sackler Gallery Archives. Smithsonian Institution, Washington, D.C.,
FSA A.06 05.0856

208: The Ernst Herzfeld papers at Freer Gallery of Art and Arthur M.
Sackler Gallery Archives. Smithsonian Institution, Washington, D.C.
FSA A.06 05.0857

209: Photography by Fazel Khakbaz, 2017. © The author

210: Photography by Fazel Khakbaz, 2017. © The author

211: Photography by Fazel Khakbaz, 2017. © The author

212: Photography by Fazel Khakbaz, 2017. © The author

301: Photography by Fazel Khakbaz, 2017. © The author

302: Photography by Fazel Khakbaz, 2017. © The author

303: Author's photograph, 2017

304: The Institute for Iranian Contemporary Historical Studies,
ع-3-1906-0

305a: Author's photograph, 2018

305b: Author's photograph, 2018

306: Author's photograph, 2017

307: Canadian Centre for Architecture, AP140-S2-ss1-D53-P6-1

308: Canadian Centre for Architecture, Ap140-S2-SS1-D53-P13-1

309: The Institute for Iranian Contemporary Historical Studies,
م-275-131441-0

310: Photography by Fazel Khakbaz, 2017. © The author

311: Author's photograph, 2016

312: Photography by Fazel Khakbaz, 2017. © The author

313: Courtesy of Nader Ardalan

314: Photography by Fazel Khakbaz, 2017. © The author

315: Author's photograph, 2017

401a: Author's photograph, 2017

401b: Author's photograph, 2017
402: Courtesy of Naqsh-e-Jahan Pars, 2005
403: Photography by Fazel Khakbaz, 2017. © The author
404: Courtesy of Naqsh-e-Jahan Pars, 1997
405: Courtesy of Naqsh-e-Jahan Pars, 1995
406: Courtesy of Naqsh-e-Jahan Pars, 1995
407: Photography by Fazel Khakbaz, 2017. © The author
408a: Courtesy of Naqsh-e-Jahan Pars, 2015
408b: Courtesy of Naqsh-e-Jahan Pars, 2015
408c: Courtesy of Naqsh-e-Jahan Pars, 2015